LEGENDARY ARTISTS

and the Clothes They Wore

LEGENDARY ARTISTS

and the Clothes They Wore

TERRY NEWMAN

HARPER
DESIGN

An Imprint of HarperCollins Publishers

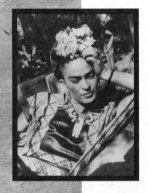

CONTENTS

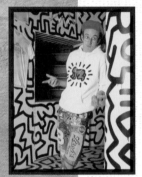
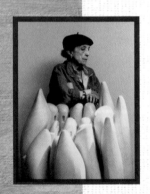
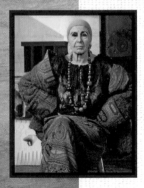

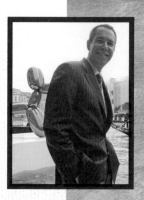
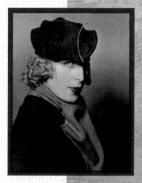
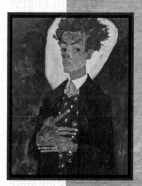
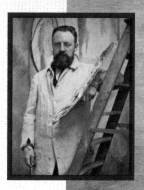

INTRODUCTION

I want to die with my blue jeans on.

— Andy Warhol, *The Philosophy of Andy Warhol from A to B and Back Again*, 2007

Legendary Artists and the Clothes They Wore explores the personal style statements of such celebrated artists as Frida Kahlo, Keith Haring, Salvador Dalí, and Marcel Duchamp, examining how their strong signature looks and creativity have influenced fashion. The art world is all about self-expression and the power of an image; by these criteria, the appearance and flair of artists are as interesting as their expertise. In a 2008 interview with the *New York Times*, Louise Bourgeois at age ninety-six reflected: "There are things with clothes that you want to show off and there are things you want to hide." The job of artists is to critique culture, unload their psyches into their work, and make edifying masterpieces the rest of us can revere. What they wear while doing these things is interesting, too.

Nothing in art is more important than identity, and examining the identities of our favorite artists gives us an added layer of insight into their characters and temperaments. The clothes they wear divulge their personal aesthetic as well as clues about how they live, what they

love, and to some extent where they come from; Frida Kahlo's Mexican art and wardrobe both act as an exact representation of personality, embodying her strength and fragility as well as her political and personal principles. Artists are intuitive and original; they can't help but be themselves. Studying their wardrobes is a way to understand what makes them tick. What artists wear to work and to go out, how they collaborate with fashion, and how fashion appropriates their art are all fuel for thought.

It may seem a little simplistic or far-fetched to examine art through fashion—to see the clothes artists wear and the work they create as parts of a single equation. However, exploring artists' wardrobes can yield rewarding insights into their profound means of expression. Jean-Michel Basquiat's work integrated the codes of uptown and downtown New York—graffiti tags and poetry, celebrities and skulls all represented his artistic message. He drew what he was about—it's one reason his paintings captivate so many. And his clothes told his story too. He famously wore designer outfits but jumbled his slick Armani and Yamamoto suit jackets with ripped Levi's denim, dreadlocks, and dirty canvas sneakers. David Hockney is a master of color, and his own wardrobe follows suit: sunflower yellow plaid trousers, sky blue jackets, and cherry bow ties are typical attire for the northern England native, who loved to paint the sapphire swimming pools and blond sunshine of California.

Some artists are driven to generate fabulous fashion as an offshoot of their main vocation and do so without compunction or preciousness. Yayoi Kusama had her own clothing line at Bloomingdale's in the 1980s, long before her 2012 collaboration with Louis Vuitton and Marc Jacobs. She explained her concept in a July 2012 *Women's Wear Daily* interview: "I was selling some fashion clothes at that time, but I have been making things since I was very little. Be it a sculpture or be it clothes, for me it is the same thing. It's my creation. I don't see any difference. It is part of my art." At the age of eighty-plus, she still looks very much like a walking canvas herself, covered in her unforgettable polka-dots. Kusama's personal flair and creative compositions are a symbiotic and cohesive force.

Many artists put themselves into their art. One of Egon Schiele's main subjects was, of course, the man himself; his painting *Self-Portrait with Peacock Waistcoat* (1911) perfectly reveals the iconoclastic dandy loved by so many style and art watchers. His angular frame, creative dress, and haughty expression were the essence of fashion, hip enough to inspire the likes of David Bowie—the cover of Bowie's 1977 album, *Heroes,* is a direct homage to Schiele, including his characteristic finger flex and stare. Artists can also provide fashion history lessons: in the 1960s, Yoko Ono wore white patent go-go boots and hot pants; in the 1970s, surplus khaki military uniforms and berets but also floppy hats and breezy kaftans; and in the 1980s, *Blade Runner*-esque wraparound shades and minimalist black outfits. Her conceptual work similarly signals the cultural moment—from *Bed-Ins for Peace*, protesting the Vietnam War, to her *Wish Tree* installations of the 1990s to her role in the Artists Against Fracking campaign in the early 2000s, her crusading is current, exactly like her wardrobe.

Certain artists and fashion designers see the other's world as being very different from their own. Some designers most thought of as "artistic" run a mile from being labeled as such. The Belgian king of avant-garde style, Martin Margiela, explained his views in a rare interview for *Knack* in 1983: "I detest the fact that that fashion is sometimes compared to art. That is a pretence that a designer cannot have. Fashion is something that is closely linked to the moment and society, which changes under all kinds of influences and at a rapid pace. I design clothes for people to wear." Pierre Bergé once said, "Fashion is not art, but fashion cannot live without art"—yet when you look at the life and oeuvre of Bergé's partner, Yves Saint Laurent, you can't help but feel that he was an artist at heart. Like a prima ballerina, he made his skills look effortless; the simple sweep of a line on his sketchbook translated into catwalk gold. Art certainly propelled Saint Laurent—Picasso was his favorite, but he paid homage to others, including Matisse, van Gogh, and Mondrian. Rei Kawakubo, who has done more than most in the fashion world, declared in a 1998 *New York Times* interview with Suzy Menkes: "Fashion is not art. You sell art to one person. Fashion comes in a series and it is a more social phenomenon.

It is also something more personal and individual, because you express your personality. It is an active participation; art is passive."

In general, though, fashion designers are captivated by the sartorial magnetism of artists as well as by the work they produce. Robert Mapplethorpe's laid-back, streetwise grace has become a metaphor of cool that informs the catwalk, most recently as muse to the spring 2017 Raf Simons menswear show, where look-alike boys were styled with leather caps and buckled chains, while the collection itself featured Mapplethorpe pictures printed onto the clothes. Famously, the canvases of Piet Mondrian motivated a 1966 collection by Saint Laurent, who translated the Dutch painter's clean, bold, linear brushstrokes onto a classic shift dress; the designer said, "The masterpiece of the twentieth century is a Mondrian." The shift dress is a perfect shape to show off such an orderly, assured pattern, and an uncomplicated yet elegant line is a timeless Saint Laurent fashion missive. Shape and pattern are thus complementary and harmonious.

I told [Elizabeth Peyton] that I tend to think of artists as being divinely inspired somehow. In terms of creativity, part of my intimidation was, "I'm a designer. I make clothes and bags and shoes. I have a job that involves making creative choices, but I'm not a divinely inspired human being like an artist!" And she said, "You can still like what you like, and, you know, we like clothes, too!"

—Marc Jacobs, *Interview* online, November 30, 2008

This wasn't the first time Mondrian had been embraced by fashion. Back in the 1930s, the Polish-French designer Lola Prusac was moved by his work and directly inspired to create geometrically patterned leather handbags for Hermès. Mondrian's personal fashion sensibility reveals the precision of a dapper gentleman: the shape of his mustache and his finely cut suits communicated a meticulousness that corresponds to his graphically pure abstract works. This reciprocal

cycle is ever fruitful in both fashion and art. In 1974, Warhol screen-printed Saint Laurent's portrait, and Warhol's pop art Factory has inspired generations of hip with his own punk-beatnik stylings: monochrome stripey T-shirts, tight jeans, and sunglasses is an easy Andy silhouette.

Today more than ever, the empires of fashion and art stand shoulder to shoulder: the fashion industry is an important patron of the art world, and at times that relationship hazes with stylish ingenuity. Miuccia Prada's pink, neon-lit *Double Club* installation in collaboration with Carsten Holler—first shown in London in 2008 and then in 2017 at the juggernaut melting-pot fair, Art Basel Miami, has proved that art can be quite a happy and creative bedfellow with fashion, producing new ideas and enjoying mutual benefaction. The Fondazione Prada has championed creatives for more than twenty years and in 2015 opened a new Milan venue designed by the Dutch architect Rem Koolhaas to launch art exhibitions, as its Venice Palazzo outpost has done since 2011.

> I used to think that art was high and fashion was low, and that one was more moral than the other. This is a complex from the sixties, because I was born in the protest movements of '68. But art is so important for me, and now I want to stop making this separation.
>
> — Miuccia Prada, from "Miuccia Prada Interview: Fondazione Prada, Milan" by Alistair Sooke, the *Telegraph* online, 2009

Miuccia Prada doesn't just show artists in the conventional manner; her fashion catwalks are full of art. In 2018, she invited four favorite creatives or artistic teams—Ronan & Erwan Bouroullec, Konstantin Grcic, Herzog & de Meuron, and Rem Koolhaas—to reinterpret her much-loved nylon fabric for the line's pre-fall collection. Earlier that year, her summer womenswear collection featured eight women comic-book artists. And hers isn't the only fashion house to own an arts center: the Fortuny Museum in San Marco,

Venice, is a setting not just for Mariano Fortuny's exquisite dresses (much admired by Proust) but also for his paintings and photography as well as displays of work than span art history from Sandro Botticelli to Marina Abramović.

The fashion world also awards artists. The Hugo Boss Prize, administered by the Guggenheim Foundation, has supported new names in the art world for more than twenty years. Since 2005, the Italian fashion house Max Mara has given its Art Prize for Women in conjunction with the Whitechapel Gallery in London.

It's a two-way street, and art equally loves the fashion industry. When the Swiss artist Meret Oppenheim rendezvoused with Elsa Schiaparelli in 1936 and pitched a fur bracelet for the Italian designer's upcoming winter collection, little did she know that this offbeat concept would lead to the creation of her most famous work of art: *Le Déjeuner en fourrure* (Luncheon in Fur). As the story goes, she bumped into Picasso at the Café de Flore in Paris while wearing the accessory, and he speculated aloud that anything could be covered in hair. This spurred Oppenheim to coat a cup and saucer in animal skin. More recently, the Japanese artist Takashi Murakami has worked on projects with the fashion lines Comme des Garçons, Vans, Billionaire Boys Club, and Supreme, making limited-edition T-shirts, skateboard decks, and slip-on sneakers, among other must-have collectibles. And in an intriguing postmodern twist, 2017 saw the launch of Barbara Kruger's performance artwork *Untitled (The Drop)*, in which she created—in collaboration with Volcom— hoodies not unlike Supreme's skatewear clothing, commenting on the brand's free appropriation of Kruger's own font-heavy, logotastic visual style. Generally, artists don't have a problem branching out into fashion: it's still about making a distinctive statement.

In Robert Shore's book *Beg, Steal, and Borrow*, he makes the case that all art is just copying—or, in the words of Picasso: "Art is theft." Trendsetters such as Maria Grazia Chiuri, with her appreciation of Niki de Saint Phalle and Leonor Fini while at the House of Dior, synthesize artistic imagery and recalibrate original work into wardrobes, advancing a new approach to making clothes. But, in

fact, its origins are decades old: in 1913, the Bloomsbury Omega studios united the avant-garde and fashion in a way not seen before, hand-dying fabrics for clothing and furnishings and adorning them with original printed artwork.

Around the same time, Paul Poiret was changing the shape and subtext of what women wore. In his 1931 memoir, *King of Fashion*, he wrote: "Am I a fool when I dream of putting art into my dresses, a fool when I say dressmaking is an art? For I have always loved painters, and felt on an equal footing with them. It seems to me that we practice the same craft, and that they are my fellow workers." In 1910, Poiret started working with Raoul Dufy, commissioning the artist to produce prints for his bohemian creations; their creative association developed into a method for fashion and art to come together ever since.

In the digital age, it almost goes without saying, modifying a thing already made is very often the starting point for the creative process. In the future—partly because such appropriation and modification have become so easy—fashion-and-art collaborations may no longer be a side dish of art history. Pigeonholing what is art and what is fashion seems less interesting in the twenty-first century, but there are important precedents. Back in the 1940s, sculptor Henry Moore happily designed textiles without worrying that it might mar his reputation. Salvador Dalí hand-painted and signed neckties. Designer Hussein Chalayan once said, in a 2009 *Independent* newspaper feature, "You might say I'm an artistic designer, I suppose . . . so what? I'm definitely an ideas person. But I've never been interested in labels. They're only there to make it easier for people to understand someone's output. They're restrictive and mean nothing."

In the 1930s, Sonia Delaunay insisted that the clothing she produced did not simply reconfigure her paintings; her fashion wasn't about layering images onto a dress. The theory behind her vision was holistic: she thought about the art and the dress together and made them work as one. "For me," she said, "there was no gap between my painting and what is called my 'decorative' work." And although

crafting clothes is not something all artists do, they frequently use their physical selves to extend their imprint on the world: from Julian Schnabel in his pajamas to Gilbert and George in their buttoned-up "Responsibility Suits," who they are is articulated not just by the art they make but also by the clothes they wear.

Sometimes the equation can be a little more nuanced. As Louise Nevelson explained in a 1972 interview at the Archives of American Art: "I think you very carefully can identify a person by their appearance. It's important. It's not skin deep. It's much deeper. And consequently, in youth I had this kind of flamboyance and wore good clothes and wore attractive things. So, I think it was taken for granted that a woman of that sort couldn't be totally dedicated. So, I think that because of their, not mine, their preconceived ideas that an artist had to look—that the older and the uglier they looked, the more they were convinced that there was a dedication. Well, that again is preconceived clichés. That's what I've been trying to break down all my life, and I still am."

An artist's story can be told through the clothes they have worn. René Magritte's hats, Cecil Beaton's suits, or Richard Avedon's glasses all convey very characteristic hints of their personae. Looking at their clothes is like discovering an unwritten chapter in their biographies; it helps us find out where they were in their lives and how they evolved. In August 2016, the *Guardian* cited the late Robert Rauschenberg, who said, "I like the experience that says that a shirt changes when it gets in the sun a little, or when you go swimming in it, or when the dog sleeps on it. I like the history of objects. . . . All material has history, all material has its own history built into it."

The charisma of great artists is enduring. Their wardrobes, though more ephemeral, as well as their work, have been carefully scrutinized by the searching eyes of designers, and the messages they bear have been incorporated into the ever-shifting narrative of fashion. This book explores the line of art and fashion and how it synchronizes to satisfying effect.

ROBERT MAPPLETHORPE

The whole **point of being an artist is to learn about yourself. The photographs I think are less important than the life that one is leading.**

—Robert Mapplethorpe, *Robert Mapplethorpe: Look at the Pictures*, 2016

R obert Mapplethorpe's beauty and cool-chic aura were destined to become a touchstone for kindred spirits and fashion designers who came under his ethereal, poetic sway. Born in Queens, New York, in 1946, he was a photographer whose camera caught life and showed its unfathomable edges: he shot the extremities of gay sex but also the curve of a lily in all its concentrated splendor. In a *Vanity Fair* interview, Bob Colacello, the first editor of Andy Warhol's *Interview*, described Mapplethorpe when they first met in 1971 as wearing a "black, belted trench coat, a purple-and-white silk scarf tied around his neck, his hair a crown of angelic Pre-Raphaelite curls. . . . He was pretty but tough, androgynous and butch."

Such juxtapositions were central to Mapplethorpe's psyche—he could be shy but liked going to parties; he'd had a strict Catholic upbringing but enjoyed underground exploits in notorious nightclubs

Opposite:
Robert
Mapplethorpe,
New York City,
c. 1969.

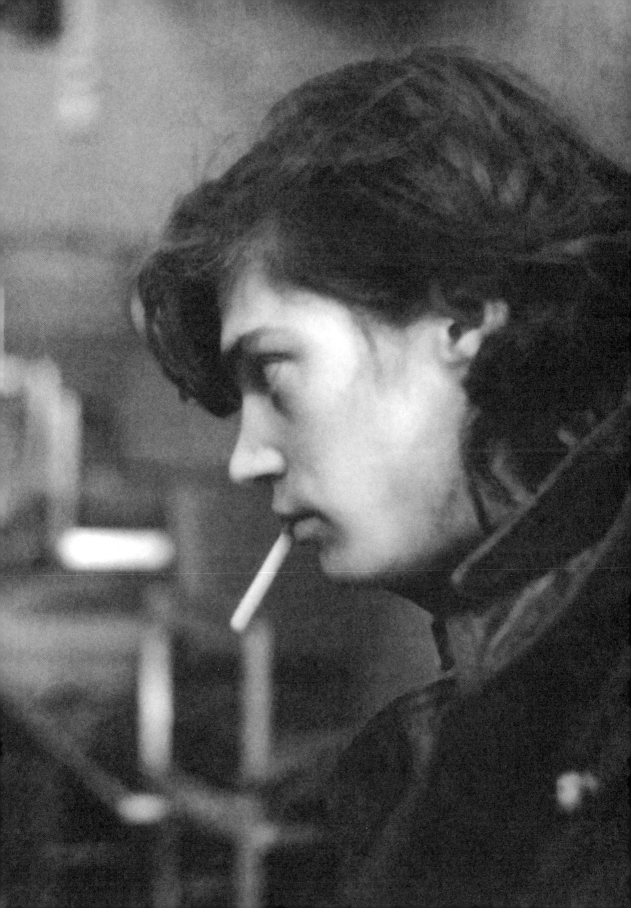

such as the Mineshaft and the Toilet. He wore thrift store buys, including old sailor hats and Victorian coats, but spent time with international designers, mixing and matching pieces from their collections with his secondhand wardrobe treasures. Mapplethorpe's first boyfriend, David Croland, recalled that "for his birthday in Paris on November 4, 1971, Yves Saint Laurent and Pierre Bergé took Robert to dinner and then to the Rive Gauche boutique and let him pick out anything in the store. He chose a simple black shirt. He said it was the cheapest thing in the store, but that's what he wanted. . . . Robert learned a great deal about European style and fashion. Robert always responded to real elegance."

In *Robert Mapplethorpe: The Photographs*, author Paul Martineau describes the artist's fledgling work at the Pratt Institute, where he studied from 1963 to 1969, as comprising a number of clothing sculptures, including a pair of denim jeans stuffed with socks and wired for an electronic erection. Another early piece, *Untitled (Blue Underwear)*, presents a pair of underpants stretched over a wooden frame and was shown at his first exhibition, *Clothing as Art* at the Chelsea Hotel in 1970. The pants are Mapplethorpe's, and they are turned inside out in all their scandalizing glory.

Mapplethorpe was a keen collector of colored glass. In a 1985 *Vogue* interview, he said, "I started getting interested in modern glass, mostly from Italy and Scandinavia, when I began still lives of flowers in 1977. I got involved with collecting vases because I was doing the flower studies and I needed something to put the flowers in."

At this time, he made his art from what he could find. Mapplethorpe also produced jewelry, using silk macramé threaded with colored glass beads and feathers, and leather-lace chokers decorated with skulls. Among his fashionable clients was Maxime de la Falaise, who invited him to a tea party at her uptown Manhattan residence for her daughter, Lou Lou de la Falaise (Yves Saint Laurent's muse), and Lou Lou's friends, including Marisa Berenson (whose grandmother was Elsa Schiaparelli). Robert brought his necklaces and charms for them to buy, which they happily did, reportedly for fifty dollars each. For her twenty-third birthday in 1969,

> Much has been said about Robert, and
> more will be added. Young men will adopt
> his gait. Young girls will wear white
> dresses and mourn his curls. He will be
> condemned and adored. His excesses damned
> or romanticized. In the end, truth will
> be found in his work, the corporeal body
> of the artist. It will not fall away.
>
> —Patti Smith, *Just Kids*, 2011

Patti Smith wrote that Mapplethorpe made her a "tie rack with the image of the Virgin Mary." It wasn't until late 1970 that he would own his own camera and begin taking photographs regularly, at first incorporating his images into collages and mixed-media work.

In a March 1985 interview in American *Vogue*, Mapplethorpe said, "a portrait is partly about the subject and partly about me. It's a combination of the two." He took pictures of the fashionable crowd he became part of: Yves Saint Laurent, Karl Lagerfeld, and Ossie Clarke all sat for him, as did downtown movers and shakers, including Dianne Benson, the owner of Dianne B and Comme des Garçons boutiques in the 1980s. Clothes and how they signal character were part of the essence of a Mapplethorpe portrait. For Benson's shot, her hair is styled in an oversized quiff, and she wears an ornate Jean-Charles de Castelbajac jacket bedecked with appliqué birds: quintessentially of the early 1980s. Photographed in 1984, Karl Lagerfeld is shown in profile, his ponytail and smart jacket prefiguring the icon he would later become; the same year, Mapplethorpe captured the spectacular form of Grace Jones custom-painted by his friend Keith Haring. A smiling self-portrait from 1974 would be appropriated by the designer Helmut Lang for his advertising campaigns in the 1990s, and Lang would also use Mapplethorpe's 1982 picture of the artist Louise Bourgeois.

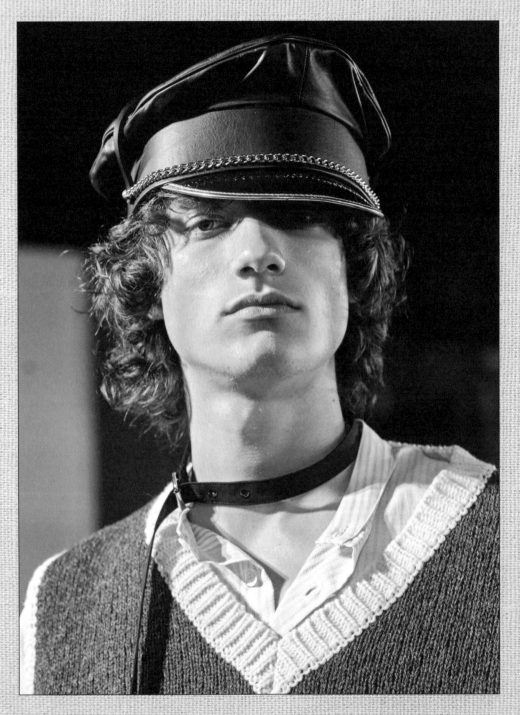

Backstage at Raf Simons's autumn/winter 2016 menswear runway show, Pitti Uomo 90, Florence, Italy, June 2016. A collaboration between Simons and the Robert Mapplethorpe Foundation, this collection featured look-alike models wearing signature Mapplethorpe leather caps as well as clothing adorned with images from the Mapplethorpe archive.

As a young man, Mapplethorpe's own sartorial mix featured leather jackets, caps, and jeans but also a bohemian fusion of floppy fedoras, neckerchiefs, and bell-bottomed denims. He wore poet shirts knotted at the waist, talismanic necklaces he made himself, knee-high suede boots, vests, velvet trousers, military hats, and occasionally, as an older and super-successful artist, a formal shirt, tie, and tux. After he became ill with HIV/AIDS, he often sported a skull-ornamented cane. Famously, in 1980, he shot twin self-portraits, one in makeup and another in full drag.

It was not just Mapplethorpe's look but his art that inspired Raf Simons's summer 2017 menswear collection. Simons had been contacted by the Robert Mapplethorpe Foundation with a view to working together and said afterward in an interview with *Dazed Digital*: "I wanted to do a show where every boy [was] the representation of one work. I wanted to approach it very curatorially, like you would a museum show, which was often done by other people when it comes to Mapplethorpe's work—but always in a gallery: always in the same kind of context and form. So, I thought the-biggest challenge for me would be not to show his work in a gallery but in relation to my own environment. And they [the foundation] immediately found that very challenging and interesting." The models who walked the catwalk were mirror images of Robert Mapplethorpe at his most seductive, wearing fetish chokers and motorcycle jeans, draped in shirting half on, half off. The clothes themselves were fabric frames for twenty-first-century glimpses of Mapplethorpe and his art.

When Sam Wagstaff—the art collector who would later become Mapplethorpe's lover—visited the artist at his studio in 1972 for the first time, "He encountered a work composed of a black motorcycle jacket with an audiotape of a pornographic film projecting from the pocket, hung next to a pair of leather pants with a loaf of bread protruding from the open zipper."
—Paul Martineau
Robert Mapplethorpe: The Photographs, 1977

JEAN-MICHEL BASQUIAT

People say Jean-Michel looks like art.

— Rene Ricard, "The Radiant Child," *Artforum*, December 1981

In 2017, Yusaku Maezawa, the owner of the online Japanese streetwear store Zozotown, bought Jean-Michel Basquiat's *Untitled* for $110 million at Sotheby's in New York. The same year, Urban Decay launched their × Basquiat makeup line represented by model Ruby Rose, who sports a Basquiat tattoo. Supreme, the skatewear brand, produced a hoodie with the artist's image on it in 2013. The twenty-first-century fashion and style world cannot get enough of Basquiat—the man, the myth, or the merchandise.

It isn't surprising. "The Radiant Child," as the poet Rene Ricard called him in a 1981 *Artforum* essay—later the title of a 2010 documentary about Basquiat made by his friend, the filmmaker Tamra Davis—shines brighter than ever. His paintings have jaw-dropping, blockbuster appeal in the art world, and Basquiat's personal aesthetic has transcended trends for over thirty years. He died in 1988 of a drug overdose at the age of twenty-seven, but his moment in "style time" shaped the edges of fashion's under- and overground and is still relevant and highly desired.

Opposite:
Jean-Michel
Basquiat,
New York City,
1985.

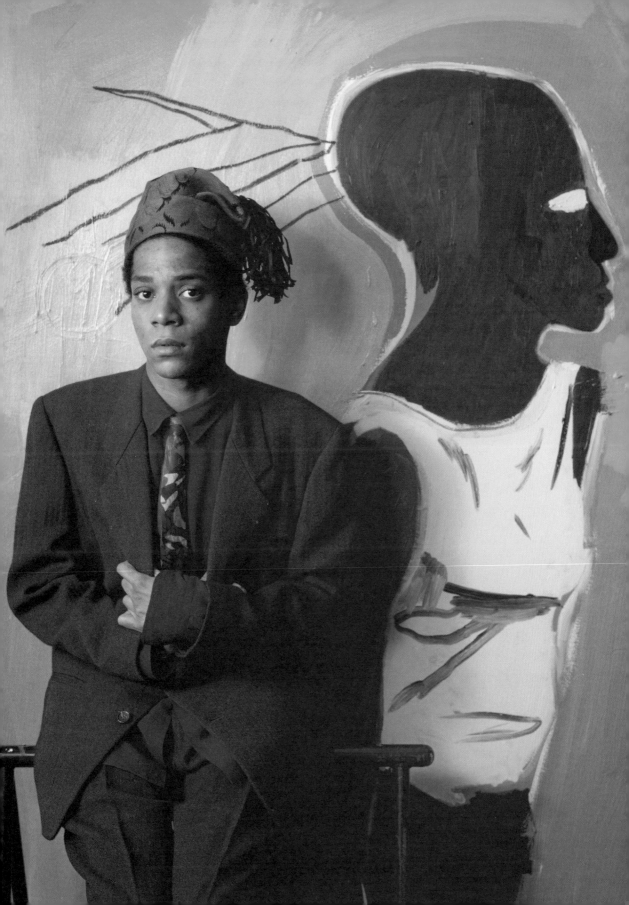

His art was brave and bold; his fashion sense followed suit. He created a perfect storm in the spring of 1987 when Rei Kawakubo asked him to model for Comme des Garçons in Paris. He walked the catwalk in two looks, both gray, double-breasted suits—one with a jigsaw-cut lapeled jacket teamed with cuffed trouser hems, the other more classic, worn with a white shirt and matching bow tie—both paired with shiny leather Mary Jane pumps. His street-style jangle made a fine juxtaposition with Kawakubo's disciplined creativity. He loved his old thrift-store finds and designer clothes. He adored Yohji Yamamoto, Issey Miyake, and classic Wayfarer shades, but he also liked to wear scruffy canvas sneakers and tailoring together. Mixing and matching uptown and downtown was his trademark. His "SAMO" graffiti tag and hip-hop roots melded easily with the avant-garde.

In the tenth grade, Basquiat dropped out of Edward R. Murrow High School to attend City-As-School, a progressive high school in New York City's West Village that was also attended by Beastie Boy Ad-Rock, actor Mekhi Phifer, and conceptual artist Ryder Ripps.

Glenn O'Brien, who produced the cult film *Downtown '81*, starring the artist, described Basquiat in an interview in *Nowness*: "He has it as a teen . . . wearing a third-hand Air Force jumpsuit and dead banker's cap-toe shoes, having no fixed address." Even before he had cash, Basquiat's cool had currency. He built his reputation in the world of the street; in 1976, when only seventeen, he started scrawling on the D-train to Brooklyn with a black magic marker, just trying to get his name out there. Basquiat fused elements of African American music into the DNA of his rookie art practice, as it also informed the way he wore his clothes.

Born in Brooklyn in 1960, Basquiat became a junior member of the Brooklyn Museum when he was just six. His mother, Matilde—of Puerto Rican descent—spoke to him in Spanish and encouraged his artistic inclinations. His father was an accountant who fled from Haiti after the dictator Papa Doc Duvalier jailed his parents and killed his brother; the elder Basquiat drove a Mercedes and earned enough to buy the family a brownstone in Boerum Hill. His parents split up when Basquiat was seven, and despite his middle-class background, he left

I was a really lousy artist
as a kid. Too abstract
expressionist; or I'd draw a
big ram's head, really messy.
I'd never win painting
contests. I remember losing
to a guy who did a perfect
Spiderman. I really wanted
to be the best artist in
the class, but my work had
a really ugly edge to it.

—Jean-Michel Basquiat, *Interview*, January 1983

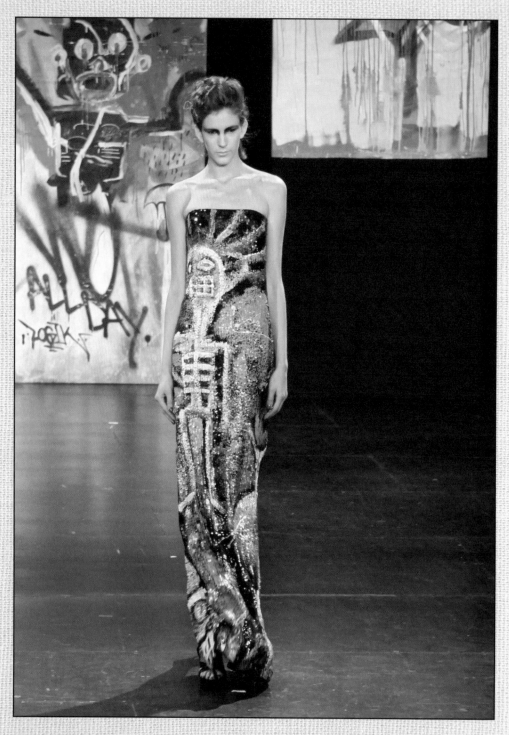

Douglas Hannant fall 2010 collection, New York Fashion Week, New York City, February 2010.
Made with hand-painted sequins, this column dress was inspired by Basquiat's work.

home at fifteen. With nowhere to go, he lived in Washington Square on and off. Interviewed in *Vanity Fair* a year after Basquiat's death, the legendary rapper Fab Five Freddie said that when the artist's first graffiti tag, SAMO, began appearing around Manhattan "[it was] aimed at the art community. Because he liked that crowd, but at the same time resented that crowd." The ebb and flow, the anger and inventiveness of Basquiat's work pulled together the contradictions in his life.

He always experimented with what he wore—painting T-shirts and sweats that he sold on the street to pay rent when he was starting out, and when he grew rich, wearing Armani while working in his studio. When his ex-flatmate and lover Alexis Adler put a collection of his work from 1979–80 up for sale at Christie's in 2014, it included sweatshirts and streaked duster coats with a "transistor" logo. Her assortment of

Basquiat came up with looks that no one else had seen before, and he had such charisma and held his head so high that he carried them off. . . . He loved luxury, but he never treated anything like it was precious. And it added to his charm.

—Tamra Davis, director of *The Radiant Child, New York Times*, July 2010

photos, taken while they lived together, show Basquiat wearing a football helmet and watching a young George H. W. Bush on a TV encased in a fridge; a rare shot she took spotlights a Basquiat avant-garde hairstyle with a bald front and locks left long at the back; he "wanted to look like he was coming and going at the same time," explains Adler.

Basquiat's dreads later became a key element of his style, but in 1976, when photographer Nicholas Taylor shot a roll of film at the Mudd Club, it shows his head neatly shaven with a tiny mohawk strip. From moment to moment, the artist shifted and shook up the way he looked and wore his clothes. Although immersed in graffiti, he never looked like a typical tagger. Later in his career, he wore a pair of pajamas and a bird's nest on his head to a gallery opening. His art evolved like his style, taking unexpected and intrepid turns.

FRIDA KAHLO

Feet, what do I need them for,
if I have wings to fly?

—Frida Kahlo, diary entry, 1953

Frida Kahlo's work is an amalgamation of folk art, semi-surrealism, and autobiography, and her wardrobe was a fiesta, too. She said in a November 1938 *Vogue* article, "I never knew I was a surrealist till André Breton came to Mexico and told me I was." Breton may or may not have been correct about that but was brilliantly exact when he called her art "a ribbon around a bomb."

Her clothes perfectly matched her character. She often wore a traditional Mexican wardrobe of the *huipil*—square-necked tunics embroidered with tapestry, beads, flowers, and gems—and starchy lace Juchiteca headdresses that enveloped her face. Her clothes were marvelously multitextured. Flouncy, floor-sweeping satin skirts were matched with frilled aprons wrapped around her waist; she wore her hair in braids, plaited with multicolored wool and blossoms, and rings on every finger. Kahlo's dress wasn't costume, though; rather, it was a statement about her heritage and identity. She didn't limit herself to traditional Mexican clothing but carefully mixed and matched cultural attire from Guatemala and China as well as silk chemises from Europe

Opposite:
Frida Kahlo,
c. 1950.

26

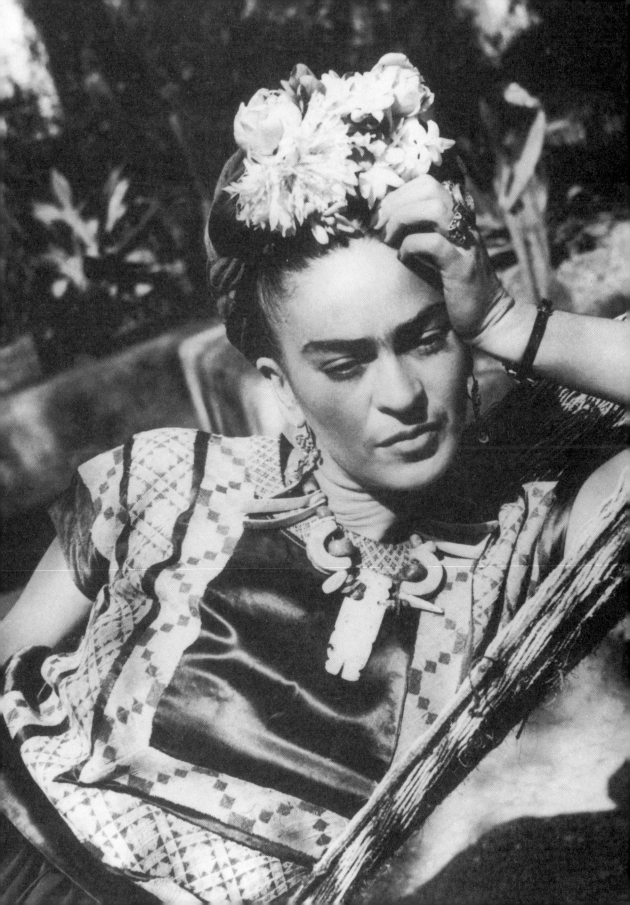

and America. Gold cat's-eye sunglasses are classic Kahlo, but she wore them only with her favorite Chinese blouse, embroidered in gold and sequined with dragons and pre-hispanic sea green stone necklaces.

Appearances Can Be Deceptive, a 2012 exhibition at the Frida Kahlo Museum in the Mexico City district of Coyoacán, was the first to display Frida's wardrobe, which had been off limits for more than fifty years by order of her husband and fellow artist, Diego Rivera, since her death in 1954. Hidden in her bedroom at her home, La Casa Azul, had been three hundred-plus pieces of clothing, along with jewelry and accessories. Among them were painted corsets, works of art in their own right, that depict otherworldly swirls but also, in one instance, the hammer-and-sickle motif of the Communist Party. A 1954 painting, *Marxism Will Give Health to the Sick,* shows Kahlo wearing a brown leather buckled corset reminiscent of the one worn by Aimee Mullins in the spring/summer 1999 Alexander McQueen show. Mullins, a world-class Paralympian athlete and an amputee, also wore a carved prosthetic leg made for her by McQueen. Kahlo made something of a fetish of her own prosthetic leg, often wearing a red leather boot embroidered with Chinese motifs and decorated with two bells hanging from the ribbon laces on a blue velvet thread. She had contracted polio as a child, leaving her with a withered leg; then at eighteen she was seriously injured in a bus accident. Her bad leg was removed in 1953 after she developed gangrene. As the exhibition reflected, Kahlo's dress was partly a means of disguising her disfigurements. In her biography of Kahlo, Hayden Herrera said that when Kahlo "put on the Tehuana costume, she was choosing a new identity, and she did it with all the fervour of a nun taking the veil."

Earlier she had dallied with a more androgynous self. Family albums from 1924 show her wearing a full man's suit, her cropped hair

At a July 2017 event organized by the Dallas Museum of Art, between 1,100 and 1,500 people dressed as Frida Kahlo gathered to commemorate what would have been her 110th birthday and attempt to set a Guinness World Record for the most Frida Kahlo lookalikes in one place. To qualify, everyone had to wear flowers in their hair, a below-the-knee dress, and a red or pink shawl, and give themselves a unibrow.

Some of the gringa—women
are imitating me and trying
to dress a la Mexicana . . .
and to tell you the truth
they look absolutely impossible.
That doesn't mean that I look
good in them either. . . .

—Frida Kahlo, in a letter to a friend, 1933

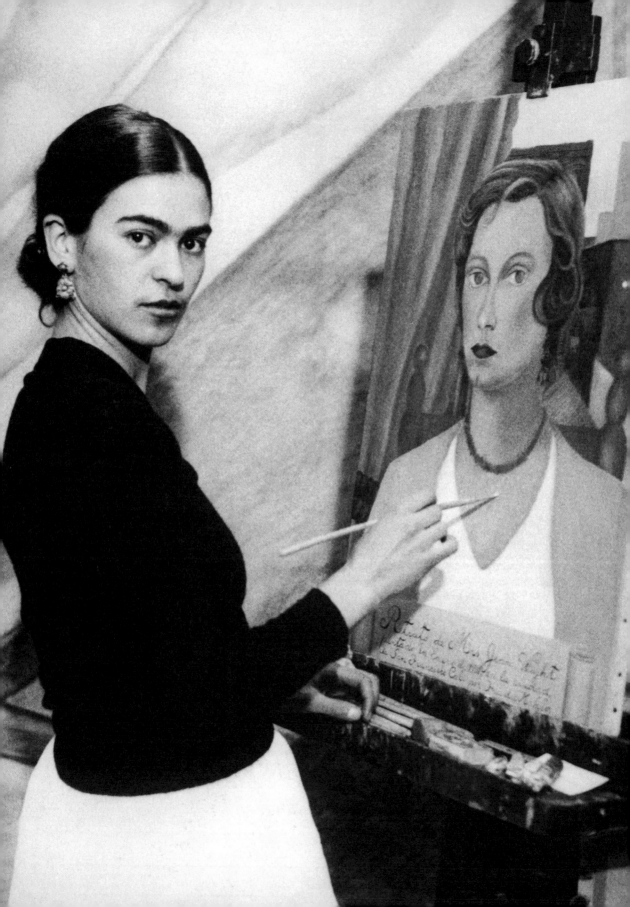

plastered down. Her play with clothes often revealed her emotional equilibrium: when Rivera began an affair with her younger sister, Cristina, Frida cut her hair. Her diaries describe another tumultuous marital episode in 1939, when Rivera asked her for a divorce—she cut her hair again, wore baggy trousers and jackets, and became in her own words "desexed." Her body image was fluid and honest. She once said, "The most important part of the body is the brain. Of my face I like the eyebrows and eyes. Aside from that I like nothing. My head is too small. My breasts and genitals are average. Of the opposite sex, I have the mustache and in general the face."

Kahlo's adoption of Mexican traditional dress was a kind of theatrical dream as well as a powerful personal statement about her heritage. In the 2012 Kahlo Museum exhibition, the writer Carlos Fuentes described how Frida's arrival at Mexico City's Palacio de Bellas Artes would be announced by the sound of her jewelry: her outfits were ceremonial, almost a ritual accompaniment to her creative philosophies. She was born in Coyoacán in 1907, but she often told people she was born in 1910, the year of the Mexican Revolution. Choosing to wear traditional dress showed how central this political and cultural identification was to her, as if sewn into her character. Because so much of her work is self-portraiture, she's been dubbed the "Selfie Queen," but at their essence her paintings conveyed what she thought about image, clothes, character, and life. The symbolism in the clothes Kahlo wore, and in what she painted, was equally true and heartfelt.

Kahlo has become a totem, adored by her diverse fan base, including Madonna, who aptly said, "She wanted to establish her identity, and she could do it with clothes. Her clothes made her stand out. [Her choices] were out of sync with what other people were doing."

Kahlo's unique appearance and liberated originality have made her a perennial reference for the world of fashion. Her intrepid individualism in mind, body, and art have been themes and variations in designer collections starting as early as 1938, when Elsa Schiaparelli designed *La Robe Madame Rivera*, and myriad collections since, including Lacroix couture in 2002, Gaultier in 2004, and Comme des Garçons in 2012.

Opposite: Kahlo painting a portrait of Mrs. Jean Wight, 1931.

DAVID HOCKNEY

I spent most of my life living in bohemia,
and I expected to spend my whole life there.
But bohemia has almost disappeared.

—David Hockney, *David Hockney* (2014), directed by Randall Wright

In the December 1969 issue of British *Vogue*, Cecil Beaton profiled David Hockney, noting as background: "It was in New York in 1961 that he [Hockney] first dyed his hair with 'champagne ice,' bought himself spectacles as large as bicycle wheels, and generally created for himself an astounding appearance." Born in 1937, Hockney was seventeen and in the second year at his home town's Bradford School of Art in northern England when he produced a self-portrait, collaged on a newsprint sheet from the *Times* of London, that showed the emerging essence of his sartorial flair. He wears boyish, Harry Potter–like round spectacles, a sky blue blazer, yellow tie, and a shrugged-on scarf that hangs slightly askew. Although mismatched socks, bold color clashes, stripes worn unflinchingly with spots, suspenders, and bow ties—just a few Hockney fashion trademarks—were still on the horizon, his elemental style was already in place.

To describe Hockney's fashion sense on a page makes his outfits sound clownish, but the true appeal of his attire stems from a relaxed

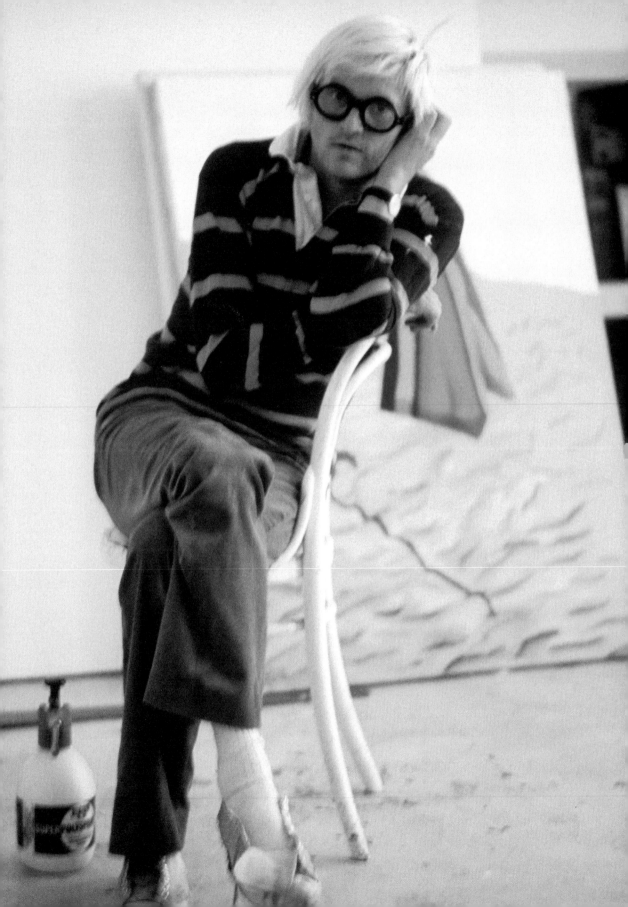

casualness that is hard to pin down. Suits with windowpane checks that might seem a little brash in theory mellow on him into off-the-cuff day-to-day-wear. He enhances his clothes with easy confidence. Anyone can throw on a candy pink striped shirt, blue polka-dot tie, and tweed blazer, paired with canary-colored hair, but it doesn't always work the way it does for Hockney.

Hockney's relationship with Celia Birtwell and fashion designer Ossie Clarke was profound. The married couple were London's hot fashion team in the late 1960s and early 1970s, Birtwell creating magical prints that endure to this day and Clarke designing dresses that would inspire Yves Saint Laurent, among others. Hockney was their best man in 1969, and his portrait of the pair, *Mrs. Clarke and Percy* (1970–71), is one of his seminal images; he gave it to them as a wedding present. In another striking and loving image, created around the same time, Ossie looks remarkably sexy in a traditional Fair Isle sweater.

Hockney sold his first painting—it depicted his father—for ten pounds at the Yorkshire Artists Exhibition in Leeds, England, in 1957. Hockney hadn't expected to sell anything and asked his father if it was okay to do so. "You'll do another; take the money," was his advice.

It wouldn't be the first or last time Hockney made friends with the elite of fashion. Yves Saint Laurent was a devotee of his art, and in 2010 the Fondation Pierre Bergé–Yves Saint Laurent dedicated its fourteenth exhibition to Hockney's *Fleurs Fraîches*—a collection of images the artist created on his iPhone and iPad. Fashion designer Paul Smith, reminiscing about Hockney to British *Vogue* on the occasion of Hockney's Tate retrospective in 2017, recalls, "My wife was at the Royal College of Art and remembers him graduating, and causing an absolute outrage because instead of wearing the mortar board and gown he had a gold lamé jacket on and had dyed his hair blonde."

Esteem abounds between the fashion world and Hockney. Fashion guru Zandra Rhodes's textile print *Medals, Bows, and Stars* from 1964 was inspired by the artist she knew while they were both studying at London's Royal College of Art; ever since, designers have taken cues from both Hockney's work and his wardrobe. Vivienne Westwood conceived a David Hockney Jacket—tailored yet artfully

As soon as I got to New York in 1961, I realized that this was the place for me. It was a twenty-four-hour city in a way London wasn't. It didn't matter where you were from. I absolutely loved it, and then when I went to LA I liked that even more. So, when swinging London was going on, for most of it I was actually in California.

—David Hockney, the *Guardian*, January 2012

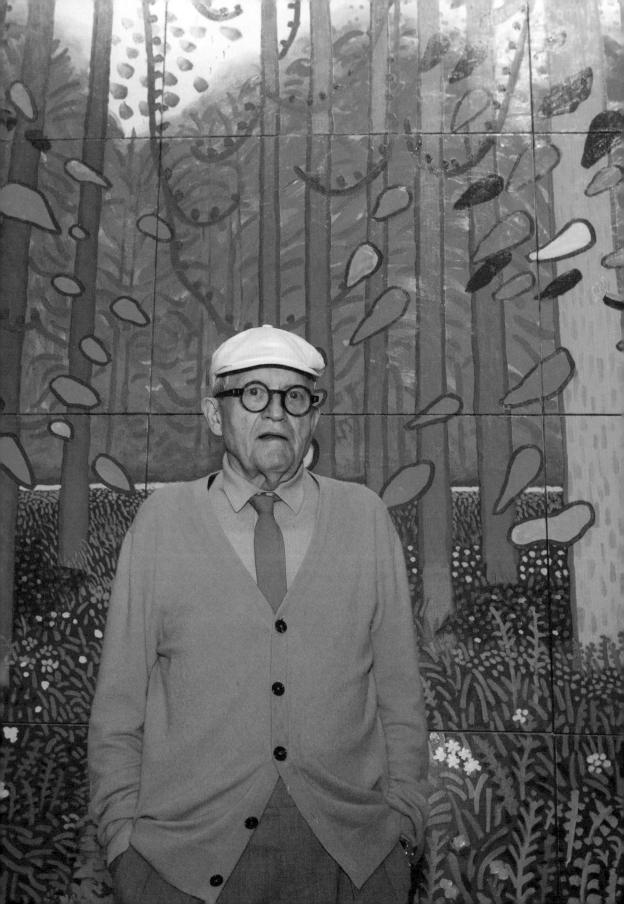

messed-up womenswear that on the wearer looks like it's been thrown on in Hockney's perfectly askew style. Burberry, the English heritage brand, has chased Hockney's allure, with Christopher Bailey, the house's designer at the time, openly referencing him for his 2013 Writers and Painters collection. He explained the appeal in a *Guardian* interview afterward: "I once saw David Hockney on Jermyn Street, wearing a cream linen suit with a perfect green paint smudge on it, I love the way Hockney wears color, so that you're never completely sure how deliberately the look is put together."

```
We say people don't dress as well now
as they used to, but in my portraits,
there's more variety in clothes than
you would have thirty years ago. You'd
see a lot more suits and ties.
```

—David Hockney, "This Much I Know," *Esquire* online, June 2013

The 1971 Artists Collection of knitwear for Ritva was designed by Mike Ross and Ritva, a Finnish knitter, in collaboration with several artists including Hockney, Patrick Caulfield, and Allen Jones. The collection included a Hockney sweater with multicolored blue sleeves and a patch appliquéd onto a purple background bearing a Hockney image of a palm tree, a minimal villa, and two clouds floating against a vivid blue California sky. It's the nearest Hockney has come to designing a piece of fashion—an example is stored in the Victoria and Albert Museum archives in London. The piece was sold with a Perspex box so it could be exhibited when not being worn, making an even closer connection between fashion and art.

Opposite: David Hockney at the unveiling of his painting *The Arrival of Spring in Woldgate, East Yorkshire, 2011* (twenty eleven) at the Centre Pompidou, Paris, September 2017. Hockney donated the enormous thirty-two-panel work to the museum, where it was displayed as part of a traveling retrospective of his art.

SALVADOR DALÍ

What is an elegant woman? An elegant woman is a woman who despises you and who has no hair under her arms.

—Salvador Dalí, *The Secret Life of Salvador Dalí*, 1942

Salvador Dalí, surrealism, and fashion go hand in hand in hand. The make-believe consciousness of illusory art and the fantasy of designer wear engage in a reflective and reflecting relationship. Dalí's first illustration for *Harper's Bazaar* in 1935, *Dream Fashions*, depicted "imaginative suggestions for this summer in Florida." He suggested to readers that coral corsets, a face mask of roses, and a pair of glossy leather stockings might be interesting wardrobe staples for the beach. Dalí's inventive approach was always looking to the future. In a January 1939 editorial for *Vogue* titled "Dalí Prophesies," he predicted that "jewels of tomorrow will wind up and come to life, like exquisite mechanical toys. Bracelets creeping on arms, diamond rivers flowing around necks, flora and fauna clips opening and closing."

In 1950, when Christian Dior asked him to create the "costume for the year 2045," Dalí drew a ruched silk dress with pannier draping and a breast on either hip, decorated with embroidered silver sun faces.

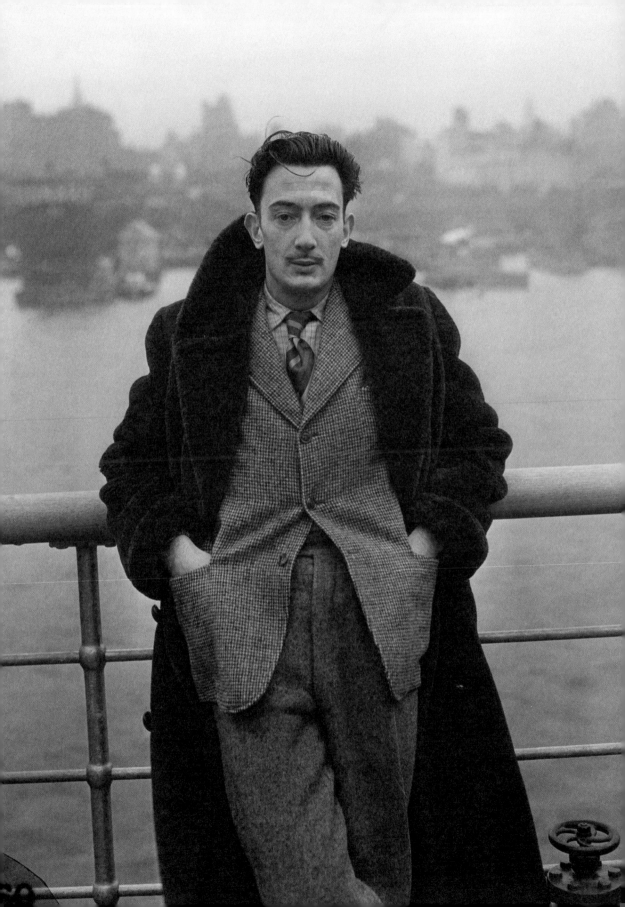

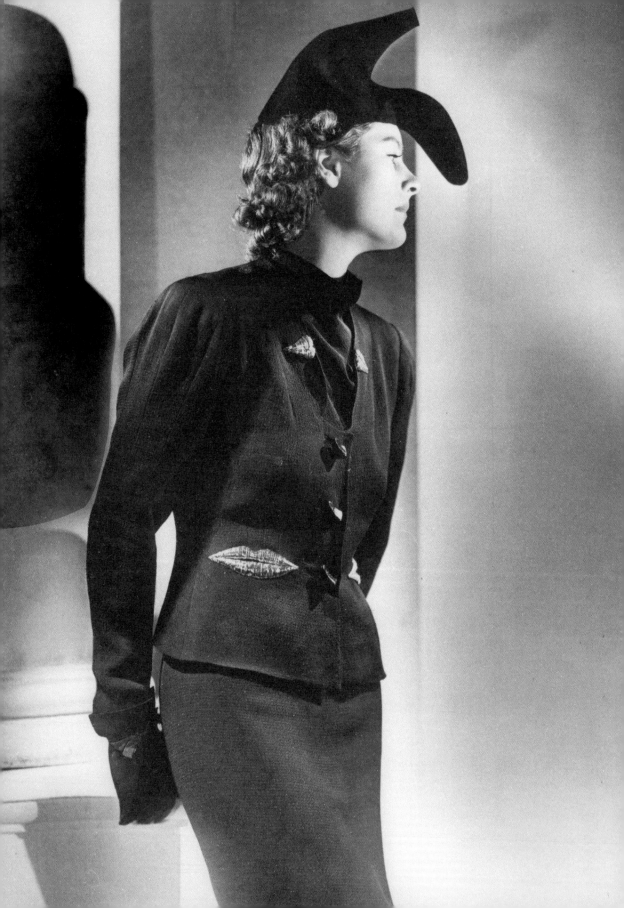

It was accessorized with a burgundy velvet crutch and a turban hat with an insectoid antenna sprouting from the forehead. This marvelous outfit in some way prefigures the 1997 Lumps and Bumps collection by Comme des Garçons fifty years later. Dior had already manifested his admiration of Dalí in 1949 when he created a Dalí Dinner Dress, featuring a black-and-gold brocade leaf print over a halter-neck bodice and gathered skirt. It's as understated as the 2045 dress is not, but nevertheless plays with detailing that echoes the spirit of Elsa Schiaparelli, who had been Dalí's leading fashion collaborator.

Schiaparelli and Dalí together had attempted to forecast the future with an array of radical designs, including the famous Lobster Dress and the black wool shoe hat of 1937 and the silk-and-rayon trompe l'oeil–print Tears dress of 1938. The designer and artist were evenly matched forces with futuristic philosophies; in June 1932, Janet Flanner, the Paris correspondent for *The New Yorker*, wrote, "A frock from Schiaparelli ranks like a modern canvas." Dalí's concepts worked readily with her innovative designs.

Born in Catalonia, Spain, in 1904, Dalí began to attract notice in 1922 as an art student in Madrid, where he studied at the Real Academia de Bellas Artes de San Fernando until he was expelled in 1926. When he arrived, he wore his hair long and strode around in knickerbockers accessorized with silk socks, a cape, and a cane. He was a glamorous dresser all his life; however, he learned at the academy to merge his sartorial showmanship with the elegance of a well-tailored suit and to pomade his hair. He adopted and wore this uniform for the rest of his life, looking like the epitome of an English gentleman. He had a variety of signature suits—from the traditional tuxedo to three-piece pinstripes and tweed—always worn with a tie and pocket square. Against this look he juxtaposed the madness of his

Dalí suggested that the white organdy Lobster Dress that Elsa Schiaparelli designed in 1937 would look best spread with mayonnaise; the Italian couturier declined to add this final flourish to the gown.

When Dalí was exhumed in 2017 as a result of a paternity case, his mustache was still intact, arranged as always pointing upward.

Opposite: Inspired by a drawing by Dali, Elsa Schiaparelli designed this shoe-shaped hat and jacket with an appliqué in the form of a lip in 1937.

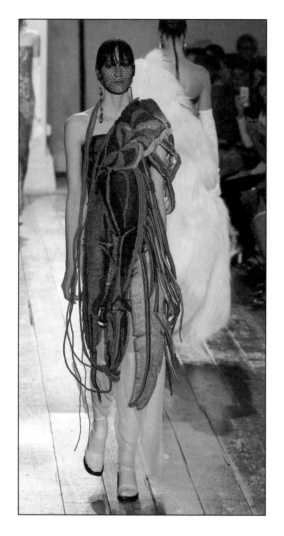

Above:
A model in an orange sequined lobster dress, Maison Martin Margiela haute couture fall/ winter 2014– 2015 presentation, Paris Fashion Week, July 2014.

trademark mustache, which he never tired of twisting into that celebrated upward spiral.

When he and his wife, Gala, came to New York for the first time in 1934, they got off the ship in matching fur coats, his shrugged over a suit. They often coordinated outfits; for example, wearing matching unisex wide jersey pants when at the ocean. For visits to their cottage at Port Lligat in Cadaques, Spain, his favorite leisure wear was a blue and brown cowboy shirt worn with a red *barretina*—a Catalan hat that looks like a paper bag. This was as casual as he got. In the 1960s, Dalí began wearing a favorite panther-skin coat accessorized with his pet Colombian ocelot, Babou; in the 1980s, he wore an ocelot coat.

When Dalí chose to make an entrance, he did it magnificently. In 1934, at the Bal Onirique party in New York, given in his honor by the socialite Caresse Crosby, he wore "a pair of spotlit breasts supported by a brassiere." In 1936, he wore a deep-sea diving suit and helmet, accessorized with a billiard cue and a pair of Russian wolfhounds, to the London International Surrealist Exhibition. His outfit indicated that he was "'plunging deeply' into the human mind," Dalí explained; however, he ended up unable to breathe and had to discard the helmet. The same year he took part in an exhibition at the Galerie Charles Ratton in Paris, showing his Aphrodisiac Jacket, which was covered in shot glasses. On display also were pieces by fellow surrealists, including Man Ray's blanket-wrapped sewing

machine and Meret Oppenheim's fur-covered teacup and saucer. But only Dalí wore his art to parties, making a modern art-meets-mode statement. He would use the Aphrodisiac Jacket again to fuse art and fashion when he was commissioned to design Bonwit Teller's windows on Fifth Avenue, presenting a model with a head of roses standing between a red lobster telephone and a chair decorated with the jacket.

> Don't bother about being modern. Unfortunately it is the one thing that, whatever you do, you cannot avoid.
>
> —Salvador Dalí, *Diary of a Genius*, 1964

Dalí's subversive influence on fashion began with his own work. Along with the pieces he designed with Schiaparelli, jewelry was another forte. With New York jewelers Alemany & Ertman he created a brooch called *The Eye of Time* as a gift for Gala in 1945. Over the years it has reappeared on many catwalks: in 2016, Alessandro Michele for Gucci showed it on men's suit pockets, and the relaunched House of Schiaparelli featured it on dresses in its autumn couture show in 2015. His 1949 *Ruby Lips* brooch, created with real rubies and pearls for teeth, has become a classic Dalí motif, not least because it echoed his *Mae West Lips Sofa* sculpture from 1937. Lips on the catwalk have become another way fashion pays homage to the Spanish surrealist: shown on jackets and dresses at Yves Saint Laurent in 1971, as prints on skirts at Prada in 2000, on shoes in 2012, and again in 2014.

The ultimate surrealist motif, however—thanks to Dalí's crustacean-enhanced telephone of 1936—is, of course, the lobster. The shellfish has appeared on the catwalk more times than it's possible to mention. Most beautifully, the Artisanal collection by Margiela in 2014 showed an asymmetrical, beaded chiffon lobster dress that went beyond cartoon reimaginings with its exquisite craftsmanship.

ELIZABETH PEYTON

People like fashion for its immediacy,
democracy, and idealism. That's what gives
it its power. And the same applies to
Elizabeth's work. She is really brave and
not afraid to collapse the boundaries
between high art and popular culture.

—Andrew Bolton, curator, The Costume Institute at the Metropolitan Museum of Art, 2013

E lizabeth Peyton splices a new-wave view of the world to a delicate, dreamy style. She wears modern designers, appropriating them with the tender enthusiasm of a keen admirer. Similarly, her portraits are love letters to the subjects she paints. Her work captures the "brightness and brevity" of youth, noted the Whitechapel Gallery in its writeup for Peyton's first retrospective, *Live Forever*, which traveled the world in 2008.

Peyton is among the few painters who have managed to connect the digital generation with the elegance of figurative art in a way that's stylish and interesting. In part it's because of the people she paints, including cult musicians such as Kurt Cobain and Jarvis Cocker and alternative poets such as John Giorno; she has also made art of such post-cultural moments as Daniel Day-Lewis and Michelle Pfeiffer

Opposite:
Elizabeth Peyton
at the New
Museum Spring
Gala, New York
City, April 2018.

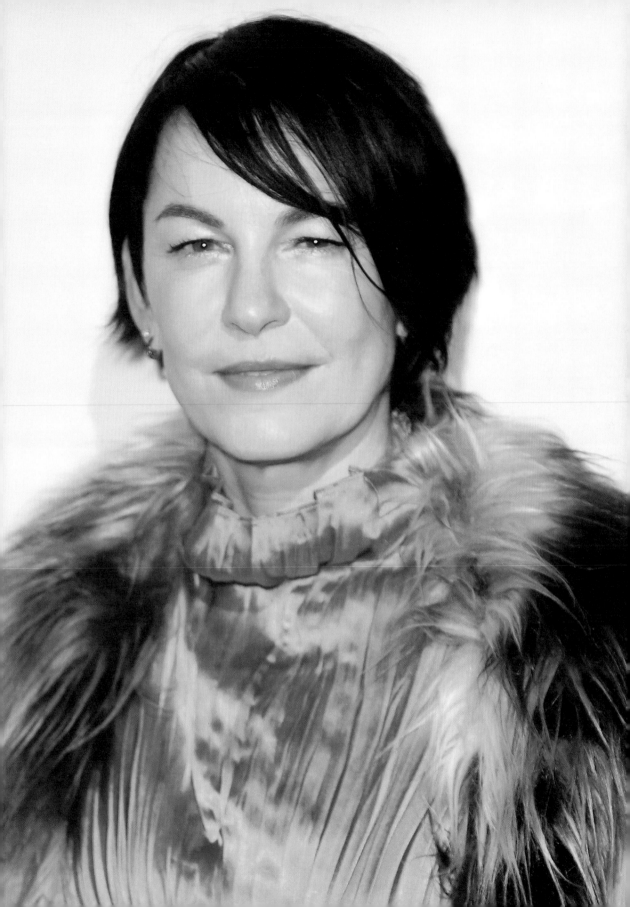

I am interested in all the
decisions that make you decide
what to wear. I like the meeting
between the designer and the
buyer. It is a kind of imagining
the possibility of how life
could be and also makes everything
look better. It is a way of
self-expressing how you feel.
In relation to art, what I feel
right now, not for ever.

—Elizabeth Peyton, Alain Elkann Interviews online, 2014

hugging in a scene from Martin Scorsese's film, *The Age of Innocence*. Known for painting her friends, she said in *The New Yorker*: "I really love the people I paint. . . . I'm happy they're in the world."

Born in Connecticut in 1965, now based in Berlin and New York, Peyton was immediately adopted by the fashion crowd. Her work captures the current zeitgeist and aesthetic drift, and the clothes she wears are equally revealing of twenty-first-century cool: unpredictable but spot-on. Peyton's favorite shoes are Chanel pumps, "A pair of black suede lace-ups with gold piping. They're the simplest, simplest thing," she said in a 2003 interview in *The Gentlewoman*. As a younger woman, she wore her hair cropped and elfin; in a recent shoot by Inez and Vinoodh, it's higher, quiffed, and worn with a leather jacket. *New York Times* critic Ken Johnson claims that "she moves in a small, exceedingly privileged, bohemian circle"; however, her wardrobe isn't full of overt labels. Like her work, it's all about things she's found to love, whether dressing up in Dries van Noten or down in faded jeans and cardigans.

Peyton has a great love for European monarchs. Tattooed on her arm is a Napoleonic eagle she copied from a piece of stationery found in a hotel in Fontainebleau.

As a child, Peyton learned to draw with her left hand because she was born with only a thumb and forefinger on her right.

The fluid modernity of Peyton's subjects sits well with fashion and its love of reconfiguring past-tense influences. Marc Jacobs and Sofia Coppola are both huge fans, and Peyton's work delves into the retro "Virgin Suicides" aesthetic created by Coppola, which both the artist and Jacobs love. Jacobs has celebrated his admiration by producing a Peyton sweatshirt in his 2013 resort collection—it features her portrait of himself as a young man—and also by collecting her work. She in turn has painted him numerous times. Their adoration is mutual and public, and Peyton said in 2008 that she thinks of him as a kindred spirit: "All that pain that Marc goes through always brings him so much farther in terms of his ability to create. He's very much like an artist." Conversely, it's been said that the incandescent loveliness of her line mirrors the look of fashion illustration.

Her friendship with Belgian designer Dries van Noten is also creatively fruitful. She wears his clothes, saying they "feel full of references and honesty," and has painted the designer, too. In 2017, he explained how Peyton's 2001 portrait of Al Gore, *Democrats Are More Beautiful,* was "the starting point" for his men's collection of spring/summer 2009, its influence seen "in the fine candy stripe in the shirting and the fresh varsity-style conservatism." When van Noten was presented with the Couture Council Award for Artistry of Fashion in 2008, she sat by his side at Cipriani, a new best friend.

What Peyton chooses to paint is as carefully curated as her wardrobe. She began her career by exhibiting a series of portraits of historical figures, including Napoleon and Ludwig II, at the Chelsea Hotel in 1993. The art world found this choice hard to understand, as the personalities seemed so archaically irrelevant, but it meshed with what was going on in fashion at the time—which was all about the outsider and the ironically unfashionable. She painted the subjects in a way that made them look like members of a Brit-pop band: slim, otherworldly, and slightly effeminate. At that moment in post-grunge time, style magazines were full of skinny boys and girls in heroin-chic mode. As Calvin Tomkins pointed out in *The New Yorker* in 2006, "The androgyny in her early work was in tune with the culture it came out of—all those rail-thin boy rockers wearing eye shadow and skintight clothes had their counterparts in the art world's transgender performance artists."

Peyton's current look is neutral and understated: black outfits are the norm, although for a big night out, she makes a statement. At the 2018 New Museum gala at Cipriani in New York, she wore an orange satin evening dress and a glam-rockish long-haired fur gilet. A 2016 exhibition titled *Speed, Power, Time, and Heart* (named after the buttons on a treadmill) includes a new work of David Bowie drawn from YouTube videos she watched of the music star after his death. It's not surprising that she should be so moved by a man who deciphered pop culture and harnessed it in cutting-edge ways; in both her art and her clothes, Peyton also reimagines the world around her.

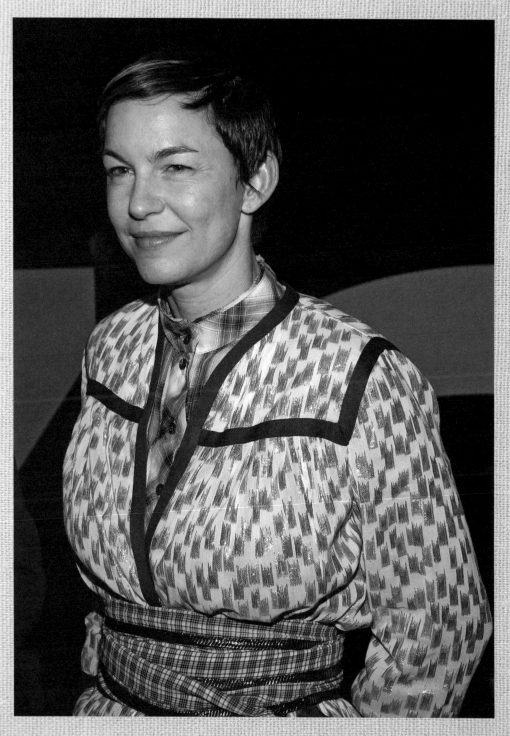

Elizabeth Peyton at the preview of her exhibit *Live Forever: Elizabeth Peyton* at the New Museum, New York City, October 2008.

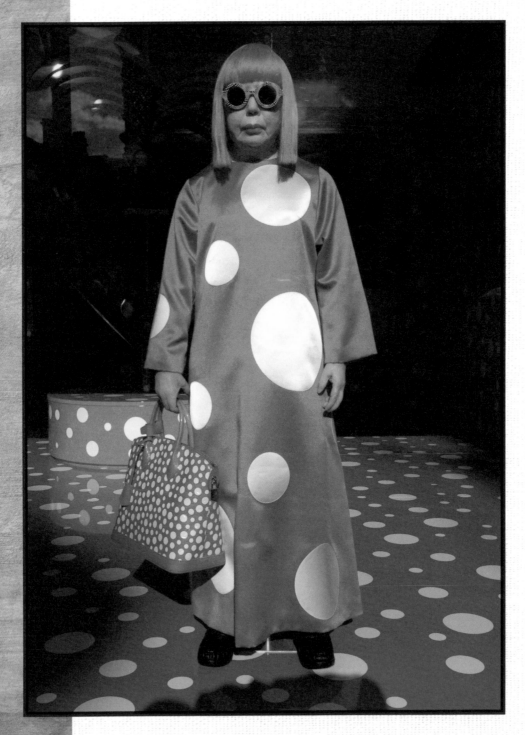

Yayoi Kusama in front of a window display at Selfridges, London, 2012.

SIGNATURE LOOKS **HAIR**

The hairstyles of the artists shown here are as much an expression of themselves as their work. Nan Goldin's photographs are provocative and confrontational, and her wild, often unkempt, red ringlets signal defiance and rebellion. Barbara Kruger's typeface choices are bold and graphic; her massive head of curls is similarly unapologetic. Eva Hesse's deeply intuitive connection with her sculptures, such as *Untitled Rope* (1970), point to an organic sensibility mirrored by her long locks, often worn free. In the same way, Yayoi Kusama's vivid artwork is as captivating as her bright psychedelic tresses.

YAYOI KUSAMA

In 1960s New York, the Japanese conceptual artist Yayoi Kusama became celebrated as a provocateur, best known for her installations. Karen Carpenter at Central Park's Sheep Meadow in 1969 was one of her events; a photograph of her there shows a bikini-clad reveler covered in signature polka dots, her hair dark and long with bangs. In Woodstock, New York, in 1967 one of her "Happenings," Horse Play, presents Kusama in a dotted onesie, with a pony similarly decorated, and her hippie-long hair under a brimmed hat. As a political activist, Kusama spread an antiwar message, and as a style figure she launched the Kusama fashion label. Her collections, sold at Bloomingdale's, featured avant-garde detailing such as strategic cutouts on the breast and behind. In this century, she is a full-fledged fashion muse. In her eighties, her hair has gone through many color transformations, from bubblegum pink to cobalt blue, orange, and tomato red—all courtesy of a short bobbed wig. She still wears clothes with her favorite dotted motif. In 2012, Marc Jacobs at Louis Vuitton joined Kusama's sensibilities to Parisian glamour, collaborating with her to create silk dresses, handbags, shoes, and coats using her signature dot patterns.

NAN GOLDIN

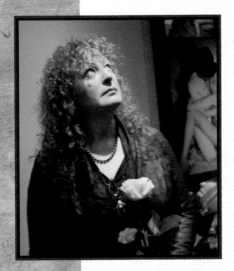

Photographer Nan Goldin's hair is a curl-fest that looks like a 1970s perm. It's usually auburn in color but peroxide banana yellow has also been a past shade of choice. On anyone else it would look a little trashy; on Goldin it looks perfect, even when a slight frizz sets in. Like the wealth of imagery she creates, her visual poems of being, life doesn't always come perfectly blow-dried, but we live and love it anyway. Neil Winokur's 1982 portrait shows Nan in a windowpane-check cotton dress, pearl earrings, and matching necklace. Her chestnut brown hair is tied in a loose ponytail, and she looks far younger than the twenty-nine she is in the image. Later self-portraits present a different picture. *Nan One Month After Being Battered, 1984* presents Goldin post–domestic abuse, with bruised eyes—but with pearls still in place and shiny hair flowing across her shoulders like Charles II. *In My Hall, Berlin* (2013), she stands proud in a black bra, her jeans slung low, tummy unfurled over the waistband, and hair spiraling protectively down her back—red hot to match her lipstick.

BARBARA KRUGER

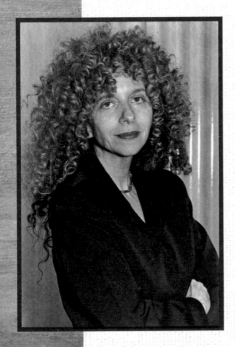

Barbara Kruger's work is a postmodern message for the post-grunge generation. Her *I Shop Therefore I Am* (1990) is a graphic masterpiece, a Futura font touchstone for likeminded alternate-truth seekers. In 1997, she plastered the Malcolm X quote "Give your brain as much attention as you do your hair and you'll be a thousand times better off" on New York buses and reused it in her *Belief+Doubt* installation at the Hirschhorn Museum and Sculpture Garden in Washington in 2012 and 2016. She said in a *Complex* interview that she loved the quote because "it's both serious and funny. It's both critical and pleasurable. I think that's a great way of making meaning." Kruger's hair is a helix of corkscrews with its own postmodern twist—reminiscent of a 1980s mall-kid vibe yet confrontationally carefree. She's also a fan of *Tabatha Takes Over*, an old Bravo television series in which the host troubleshoots hair salons that need a revamp.

EVA HESSE

At sixteen, Eva Hesse left the Pratt Institute and went to work part-time at the teen fashion publication *Seventeen* before continuing her studies at Cooper Union. While at *Seventeen*, she spent spare hours at the Museum of Modern Art and the movies, and just before she left the magazine, her illustrations won its art competition and were published. She was definitely hip, though her friend the artist Sol LeWitt advised her in a 1965 letter, "Don't worry about cool, make your own uncool." At the time, she had just returned to New York from a year in Germany and was wearing her hair in a glossy beehive, chic and unruffled—being unfashionable wasn't something she needed to worry about and she didn't. She smoked, wore capri pants, and was a downtown artist who happened to be a woman. Her dark hair went through many changes: from waist length and tied in a ponytail to short and middle-parted, but whether she wore it up or down, it was always with a beatnik nonchalance and occasionally topped with a beret or hairband. Her work, however, is anything but blasé: her sculptures were typically created with unconventional materials such as latex, rope, cheesecloth, papier-mâché, and enamel. Still working out new ways to create, Hesse died from a brain tumor at the age of thirty-four in 1970.

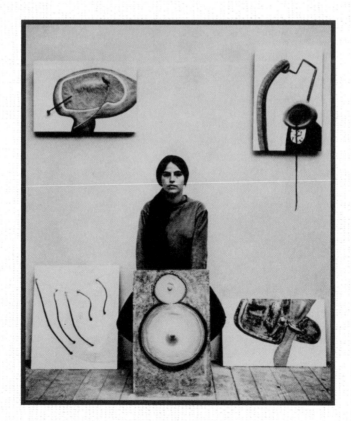

Opposite, top: Nan Goldin at her exhibition *Poste Restante*, c/o Berlin, October 2009. Opposite, bottom: Barbara Kruger, New York City, April 1989. Right: Eva Hesse at the Allen Memorial Art Museum, Oberlin College, Oberlin, Ohio, c. 1965.

ANDY WARHOL

I always thought that most artists were
women—you know, the ones that did the Navajo
Indian rugs, American quilts, all that
great hand-painting on '40s clothes.

—Andy Warhol, *Interview*, June 1977

Fishnets, wigs, heels, and mascara; leather jackets, sunglasses, and tight black jeans: the bold swagger of the underground that unfolded in New York during the 1960s was intrinsic to Andy Warhol's art and message, and he wanted to share it. In January 1964, he revealed his newly decorated studio and workspace, the Factory—plastered wall to wall in shiny silver foil—with a party that everyone from Judy Garland to the photographer Gerard Malanga lined up to get into; the buzz went on for years.

A commercial and conceptual artist, Warhol gave the world a silk-screened image of thirty-two *Campbell's Soup Cans* in 1962, and he captured the rich and famous in the same medium: his portraits of Marilyn Monroe and Elvis Presley are hallmark Warhol. Warhol's life was fashionable, and he was one of the first mainstream artists to shine an unapologetic spotlight on the counterculture of gay New York and to broadcast an alternative pop prophecy to the world. A culture groupie,

Opposite:
Andy Warhol,
New York City,
c. 1980.

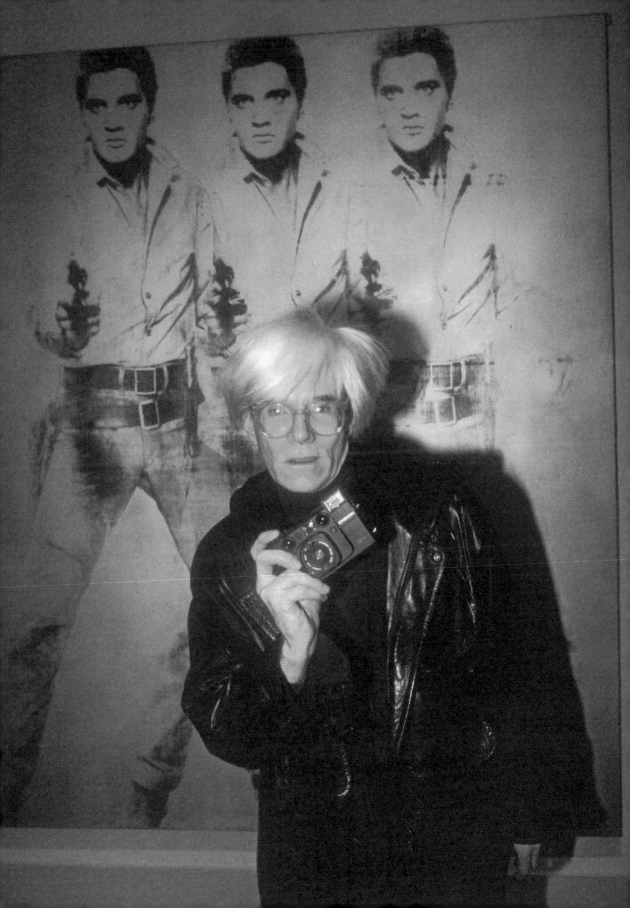

he collected fan magazines and celebrities alike; he found drag queens and made them into superstars. In 1969, Warhol started *Interview* magazine, which featured everyone from Cher to Sylvester Stallone to Divine on the cover and their intimate confessions in its pages.

"Andy's attitude toward life is that it should be a party that works," said the writer Victor Bockris, interviewed in 2009 for the online PlanetGroupEntertainment. "Work should be a party. Everything should be a party. He really tried to take that mentality into everything he did." Warhol partied with all types: outsiders-on-the-inside such as transgender actresses Candy Darling and Holly Woodlawn, who inspired Lou Reed's "Walk on the Wild Side" lyrics—as well as a luminous parade of celebrities. Bianca Jagger, Jerry Hall, and Paloma Picasso are just a few of those with whom he spent nights out at Studio 54 between 1977 and 1980. Warhol welcomed people from all walks of life into his inner circle: as long as you were fabulous you could be part of his world.

> The English know how to give you a new body with a suit, putting the stuff in all the right places.
>
> —Andy Warhol, *The Diaries*, November 18, 1980

Born in Pittsburgh in 1928, Warhol began making his own kind of art at the age of seven with cutout paper dolls. His first commission, at age twenty-one, was an illustration for "Success Is a Job in New York," a feature article in *Glamour*'s September 1949 issue—a quirky line drawing of a career girl at the top of a ladder wearing a beret with a feather; her legs are crossed and she's holding a cigarette holder. His chic and sweet editorial work—pastel-hued drawings of Louis-heeled curlicue shoes, lipsticks, hats, flowers, and unicorns—was published regularly in top style magazines including *Harper's Bazaar*. In December 1954, Warhol designed the magazine's cover, which depicts a photo of a woman in a hooded evening cape–dress with a sprinkling of hand-drawn blue and white stars in pop style. Warhol's early 1960s cartoons of Popeye and Superman were used for window displays at Bonwit Teller. In his work

as a commercial artist, he bonded from the start with fashion and sustained that connection throughout his career.

The first thing Warhol noticed about a woman was her handbag. His favorite perfume was Halston, and his favorite person may have been the designer himself. The 2014 exhibition *Silver and Suede* at the Andy Warhol Museum in Pittsburgh celebrated the two men's creative connection; that same year in a *Financial Times* interview, Halston's niece, Lesley Frowick, said, "They were very much in awe of each other, and they appreciated each other on so many different levels."

In 1972, Halston designed a sleeveless, draped, asymmetrical-hemmed silk dress featuring a 1964 Warhol flower print. For his part, Warhol was open about his esteem for the man who created Jackie O's famous pill-box hat, once remarking, "To get into [Studio] 54 you either have to go with Halston or wear Halston." The easy fusion of fashion and art was standard for Warhol. Just before he died, he gave permission to designer Stephen Sprouse—a Halston protégé who served as the designer's right hand at age eighteen—to use his Camouflage print in Sprouse's autumn 1987 and spring 1988 collections; and the artist was buried in a Sprouse suit. Warhol was, Sprouse revealed in a 2001 *Guardian* interview, "a big inspiration and supporter."

Warhol created a ten-part television show called *Fashion*, which ran on Manhattan Cable in 1979. The first feature, *Make-Up*, showed the viewer how to apply lip gloss and eyeliner.

Warhol owned more than forty wigs, which were reportedly made in New York with hair imported from Italy.

In 1966–67, inspired by *Warhol's Campbell's Soup Cans*, the food manufacturer produced a screenprinted paper pop art dress. These "Souper" dresses cost consumers a dollar plus two can wrappers; today they're collectors' items. Since then, the iconic imagery has been reused and reimagined time and again on wardrobe staples. Yohji Yamamoto adorned his Y-3 T-shirts and tote bags in 2016 with a personal Yohji can print, while Dolce & Gabbana created its own version with an Amore soup-can print on skirts for spring 2018. The post-pop art collective the Rodnik Band—its designer, Philip Colbert, was called "the godson of Andy Warhol" by style commenter

A hooded Andy Warhol–print cape worn with a matching skirt, sheer top, and sunglasses in the show of Stephen Sprouse's spring/summer 1998 collection, New York City, fall 1997.

> I have paint clothes. They're the same
> kind of clothes I wear every day, with
> paint on them. I have paint shoes and
> paint shirts and paint jackets and paint
> ties and paint smocks, and a great smock
> from Bendel's. And carpenter aprons.
> And paint hankies.
>
> —Andy Warhol, conversation with Glenn O'Brien, *Interview*, June 1977

André Leon Talley—showed a classic sequinned version of the "Souper" dress in 2011; in 1984, Inès de la Fressange wore an organza version by Jean-Charles de Castelbajac on his catwalk. Warhol told Glenn O'Brien in a 1977 interview that *Campbell's Soup Cans* was his favorite piece of art.

However, the fashion world loves more than just his soup-can paintings. Gianni Versace's crystal-encrusted Warhol print gown from 1991 is a fashion personification of what Warhol represented, and Versace considered them kindred spirits. In 2017, Raf Simons, at the helm of Calvin Klein, announced a two-year deal with the Warhol Foundation to utilize archival imagery on all Klein collections. "Warhol's genius goes much deeper than cheerful Campbell's Soup paintings," Simons explained. "He captured all sides of the American experience, including sometimes its darker sides. Warhol's art tells more truths about this country than you can find almost anywhere else."

Warhol's imitable style is as recognizable today as it was back in the 1960s, when he emerged as a new kind of New York fashion icon. Dyed platinum fright wigs, polo-neck sweaters, glasses with both dark and transparent lenses, and blazers all are key Warhol wardrobe staples. So were tuxedos and bow ties for the red carpet, or leather jackets with monochrome beatnik-striped T-shirts when he dressed like a twin with Factory superstar Edie Sedgwick. Warhol was himself a piece of art—and of his own creation.

LOUISE BOURGEOIS

Louise is French, so she knows how to be
a woman and how to use lipstick without
over-thinking it. Naturally, as all her
senses are very refined, so is her idea of
how she wants to look.

—Helmut Lang, from "Dear Louise" by Nancy Spero and Helmut Lane, *Tate Etc*, autumn 2007

ouise Bourgeois liked noticeable clothes that said something. For a Robert Mapplethorpe shoot in 1982, she wore a dark, rock-and-roll-ish monkey fur jacket accessorized with one of her pieces, *Fillette*—a large plaster penis covered in latex—tucked under her arm. Mapplethorpe described the experience as "surreal," saying, "You couldn't, sort of tell her too much, she was just there." In a 2008 *Guardian* interview about the shoot, Bourgeois said, "People seem to like it very much because they thought Robert and I were both 'naughty.'" In 2009, her portrait was taken by the Dutch photographer Alex Van Gelder; the famous image shows her wearing a cocoonlike, ultra-luxe white fur jacket and a black beanie pulled over her head. The two had been friends since the 1940s, based on their mutual love of African art. He declared that Bourgeois wanted him to take her picture because he was "sexy, and she liked sexy people." Her playful relationship with

Opposite:
Louise Bourgeois
with her marble
sculpture *Eye to
Eye*, 1970.

60

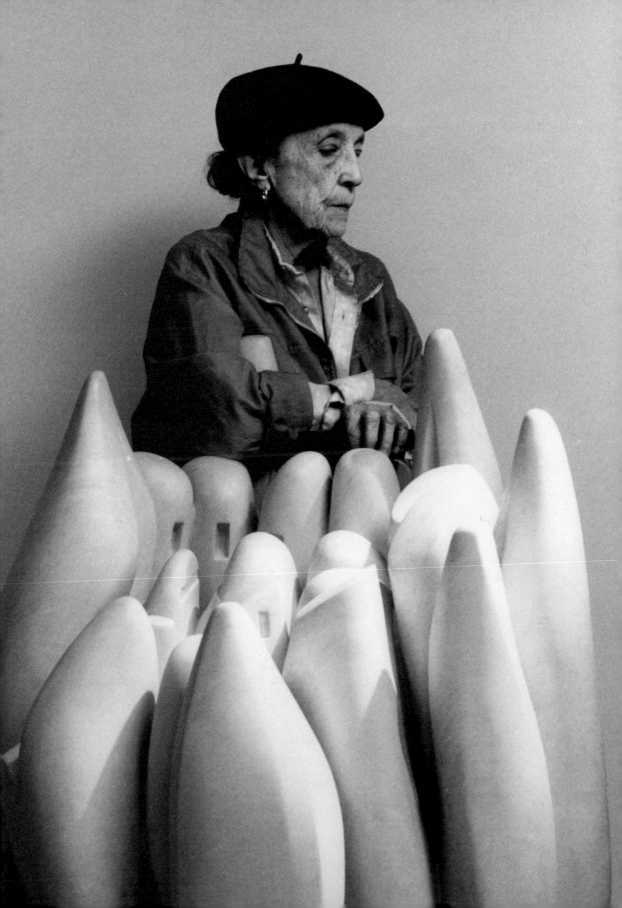

clothes, image, and fashion revealed as much as the art she made about this truth-telling woman. In a 2008 documentary about her, *The Spider, The Mistress, and The Tangerine*, she chooses to wear an oversized hot pink fun-fur coat topped with a sequined peaked cap and later a Huggy Bear pimp number. The clothes she chose accentuated Bourgeois's exuberance and engagement with the camera.

Born in Paris on Christmas Day 1911, Bourgeois even as a young girl was dressed by her parents in Parisian designer garb. The fights they had about her clothes became fuel for artistic inspiration, she said in a 1997 *New York Times* interview. She explained that her 1996 work *Blue Days* (a collection of hanging dresses) and a similar piece from 1997, *Pink Days and Blue Days* (which displayed her own and her family's clothes stuffed and hung on a wardrobe organizer), "refer to a period when my mother and father would argue about who would put the best clothes on me. One would say 'I bought her Poiret' and the other would say 'I bought her Chanel.' She is better in Chanel and my Chanel is better than your Poiret."

After her father died in 1951, Bourgeois suffered from depression and was in therapy for the next thirty years, stopping only when her doctor died in 1982.

Bourgeois held salons in her New York apartment where students could bring their art to be critiqued. She used to call the events "Sunday, Bloody Sunday."

It's unsurprising that the connection between Bourgeois and the fashion world is passionate. In a 2015 interview with *Dazed and Confused*, her assistant, Jerry Gorovey, noted, "You could see her father was dapper and stylish, so her relationship with clothes and society was very important to her growing up." Her parents restored antique tapestries, and Bourgeois explained in a 2008 *Observer* interview that "from the tapestries, I got this large sense of scale. I learned their stories, the use of symbolism and art history. The restoration of the tapestries functioned on a psychological level as well. By this I mean that things that have broken down or have been ripped apart can be joined and mended. My art is a form of restoration in terms of my feelings to myself and to others."

In a 2008 *New York Times* article discussing fashion's place in the artist's work, Bourgeois is quoted as saying, "You can retell your life and remember your life by the shape, weight, color and smell of those clothes in your closet," a sentiment made three-dimensional by her installations. Clothes were vital both to her art and her psyche. In 1978, Bourgeois exhibited her breakthrough performance piece *A Banquet/ A Fashion Show of Body Parts*. At sixty-seven—buoyed by the strengthening of global feminism and the art world's newfound embrace of diversity—she was hitting her stride and embarking on an inspired path.

Among the other works she showed at this exhibition was a bulbous rubber costume that distorted the wearer's body. One can read a similar message in Rei Kawakubo's Lumps and Bumps collection of 1997. Since then, and culminating in the 2017 Comme des Garçons exhibition at the Met, many have observed distinct connections between Bourgeois and Kawakubo, among the most imaginative of designers. That same year, Barneys curated its windows in homage to both creatives, Barneys curator Dennis Freedman explaining that he found "strong similarities in the forms they make, and a lot of it deals with the body and women's bodies in particular—exaggeration, deconstruction."

Kawakubo is far from the only designer to click conceptually with Bourgeois. The artist was great friends with the Austrian designer Helmut Lang, who admitted to feeling a "strong emotional and

I only work when I feel the need to express something. I may not be sure of exactly what it is, but I know that something is cooking and when I am on the right track. The need is very strong. To express your emotions, you have to be very loose and receptive. The unconscious will come to you, if you have that gift that artists have. I only know if I'm inspired by the results.

—Louise Bourgeois, the *Observer* (UK), 2009

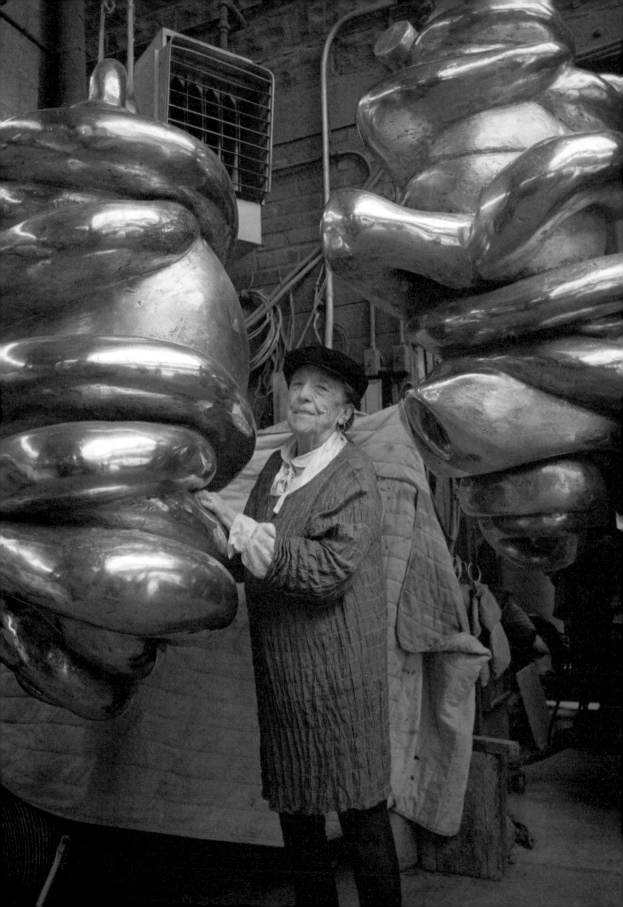

unconditional bond" with Bourgeois. They collaborated on a 2003 limited edition T-shirt called What Is the Shape of This Song? Lang also used a remade version of her 1940s *Shackle Necklace* in one of his catwalk shows as well as images of the artist in his advertising campaigns. In 1998, the two worked with Jenny Holzer on an exhibition for the Vienna Kunsthalle. Lang said in 2007 that "when I met her she didn't leave her house anymore, so she had comfortable clothes she would wear every day, such as a long-sleeved T-shirt with six pocket eyes. She likes to keep the extravagant pieces for special occasions such as photo shoots or when she has company she cares about." This echoes Jerry Gorovey's observation in the *Guardian*: "At a certain point in the 1990s she basically started wearing the same outfit. It was always black: a uniform. When I look back at these photographs, she dressed in a very different way to when I first met her in 1980, when she had certain colors she liked: blue, white, pink."

If Louise Bourgeois didn't like the color
of someone's shirt, she would let them know.

—Jerry Gorovoy, the *Guardian*, 2016

When designer Simone Rocha opened a New York City shop in 2017, hanging in pride of place was a Bourgeois painting. Rocha drew inspiration for her autumn/winter 2015 collection from the artist. She explained, "I just absolutely love her work and the fact that it's so personal. Also a lot of it is very textile based, but I love all of her materials—marble, wood, glass, and the contrast of it." Beyond her textile installations, Bourgeois's delight with the medium of fashion was also manifested in jewelry designs. Her celebrated spider motif was adapted in brooch form for the *Portable Art Project* (2008) at the Hauser & Wirth Gallery in London; curated by Celia Forner, the exhibit also featured silver and gold spiraling cuffs created by the artist. In 2018 the exhibition was re-visited by Forner at Hauser & Wirth in New York City showcasing fifteen new artists.

Opposite:
Louise Bourgeois,
New York City,
March 1996.

VANESSA BEECROFT

Fashion is important in her performances because she subdues it to her will. It's not important as a logo, trend or status symbol: fashion items are used to underline the woman's body and to express the concept behind her performances.

—Franca Sozzani, the *Observer* (UK), March 2005

Despite having disavowed popular culture and claiming that she "doesn't know fashion," Italian performance artist Vanessa Beecroft is probably one of the most style-savvy artists of the twenty-first century. She has collaborated with some of the biggest names in the business, including Prada, Dolce & Gabbana, and Manolo Blahnik, and clearly has a sophisticated understanding of what makes a good label tick. In September 2016, Beecroft worked with the Italian couture house Valentino on its Rockstud shoe line and has said, "I love the purity of the current designs of Valentino, the consolidation of past techniques with a vision of the present and future." She chooses her art-made-to-wear statements carefully, and fashion is integral to her art form. *VB45*, a February 2001 performance for the Vienna Kunsthalle, showed an army of Amazonian women wearing nothing but thigh-high leather boots from Helmut Lang.

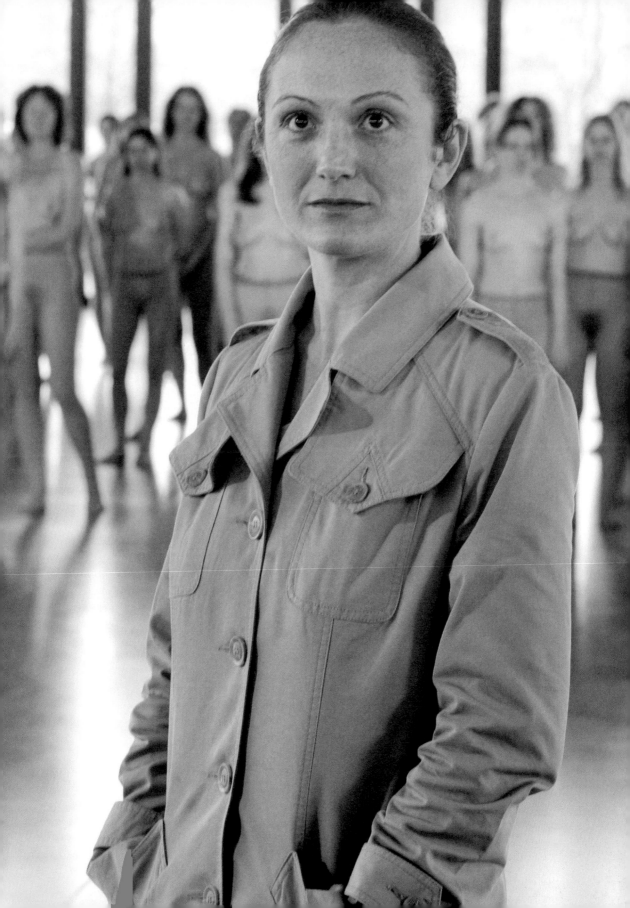

My work created a way of
visually organizing subjects,
mostly women, in a formation
with a certain color uniformity,
and fashion picked up on it
and assimilated it. The fashion
world imitated the art world
and vice-versa.

—Vanessa Beecroft, *Kaleidoscope*, 2016

Born in Genoa in 1969, Beecroft has a European, 1990s-austere aesthetic that echoes the catwalk images of Margiela and Lang in that decade, and her normal working method of assembling and posing a crowd of living figures brings art very close to the performance of the catwalk. Her piece *VB16 Piano Americano–Beige*—displaying women in nude underwear—resonated with the deconstructivist heyday of the Antwerp 6 and the elegance of twenty-first-century minimalism. The show, which opened Jeremy Deitch's gallery in 1996, evoked that exact moment in fashion time. As Beecroft explains, "My reference for the wardrobe was a Juergen Teller photograph of a model wearing sheer Agent Provocateur underwear, Chanel slippers, and a green dress like a lettuce."

Her own pencil-thin eyebrows and easy monochrome elegance taps directly into end-of-the-twentieth-century cool. Along with Céline sunglasses and Yves Saint Laurent dresses, she wears a lot of black and from time to time a whitelab coat—similar to the atelier wear of the designers at Margiela and a nod to the solemn work of being sophisticated. Her hair is long and parted in the middle, sometimes chestnut and sometimes more Arts-and-Crafts reddish. Beecroft's look has a stealthy simplicity that shouts chic. For her event *Show* at the Guggenheim in 1998, she dressed her "army" in Tom Ford for Gucci bikinis and stilettos, focusing on the "it" designer of the last century and taking part in the installation herself. The *New York Times* reported that "everything going on around the piece was part of the performance, the artist herself, prowling among the onlookers in body-hugging black shirt and leggings and Gucci spikes." Beecroft uses heels a lot in her work; she calls them "pedestals," thus elevating the fashion essential to even loftier heights.

In a 2008 interview with *Museo*, she said, "I am not able to rationalize my interest in extremes, but my favorite colors are black and white." Beecroft lives and breathes the life she imagines and

Beecroft is named after the English actress Vanessa Redgrave.

When Beecroft was a child, her mother took her to the opera at the Arena di Verona on Sundays.

Growing up, Beecroft never watched television and ate a macrobiotic vegan diet. She called her neighbors "cage people" because they ate meat.

operates exclusively on her own terms. Amy Larocca described her in *The Cut* online as "beautiful like a painting: a Botticelli, maybe, and her affect is childlike: wide eyes, eyelashes batting, a posture of innocence." She makes the most of her good looks—for a 2006 photographic piece, *White Madonna with Twins*, Beecroft wears a made-to-measure, pale Martin Margiela dress with a scorched hem that features breast cutouts. In the shot, which tells the story of her quest to adopt babies while in Sudan, she breastfeeds two starving orphans. She commented in 2006 that it was an "ambivalent image that should make everyone happy or everyone mad."

I realize I am a bit floating around in the sky.

—Vanessa Beecroft, *The Cut*, 2016

Her collaborations with rap superstar Kanye West's fashion label Yeezy have likewise elicited extreme reactions from critics. Beecroft has worked with West on videos and short films and art-directed his wedding to Kim Kardashian in 2014. She advised him when he launched his first collection with Adidas in February 2015; a few seasons later, the pair had an audience of millions around the world when the Yeezy 3 drop was shown in Madison Square Garden and streamed live on Tidal. Beecroft caused a storm by declaring in 2016, "I have divided my personality. There is Vanessa Beecroft as a European white female, and then there is Vanessa Beecroft as Kanye, an African-American male. I even did a DNA test thinking maybe I am black. I actually wasn't but I want to do it again." Despite the furor, she ignores judgment and powers ahead, both in fashion and out.

Opposite: *VB60*, Vanessa Beecroft, Seoul, February 2007.

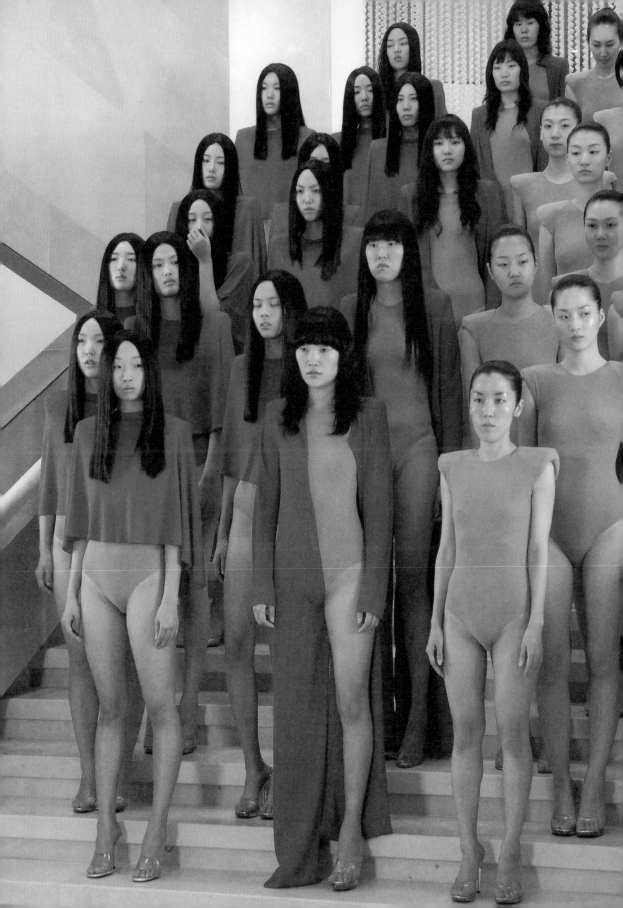

LEIGH BOWERY

Art can be anything that moves us, or, in
the case of the late performance artist,
fashion designer, musician and grand Houdini
of visual and physical logic, Leigh Bowery,
it can also be anything that moves.

—Boy George, *Paper*, January 2005

A thrilling confluence of fashion and creativity occurred in the form of Leigh Bowery, a performance artist who was also a designer, nightclub host, and band front man. Born in 1961 in Sunshine, Australia, he loved fashion from the age of fourteen, when his mother taught him to knit and crochet while he convalesced after an operation. He studied design at the Melbourne Institute of Technology before heading for London in 1980 at nineteen. There he would fulfill some of his unique dreams and along the way inspire others to live theirs, too.

Bowery started making clothes to go out and get noticed in, and he soon became part of the New Romantic underground nightlife of the time. Even in a milieu where dressing up as a nun or a pirate, an eighteenth-century courtesan, or wild-west cowboy was commonplace, he

Opposite:
Leigh Bowery
wears a one-off
ensemble of his
own creation,
London, c. 1980.

was determined to stand out. In 1985, Bowery launched his own club, Taboo, where patrons were encouraged to dress up with abandon; his outfits were always the most avant-garde. When he traveled he wore equally outrageous outfits. The filmmaker Charles Atlas, who produced a film called *The Legend of Leigh Bowery*, said on NPR in November 2003, "I went out with him many times at night in New York in winter, and he would have on a big padded bra covered with hairpins. And then on his head he wore this beautiful beaded bug mask with fringe coming down from the eyes so you couldn't really see his face. And then he wore matching boots and what he called a merkin, a pubic wig. And he, of course, stopped people on the street dead in their tracks."

Bowery was one of artist Lucian Freud's most famous sitters. When he was asked to dress the ballet dancer Michael Clarke and his company for a show, Bowery wanted to clothe them in costumes made from Freud's paint rags.

Bowery loved to experiment with makeup, beginning with polka dots in his early career (see page 73) to increasingly extreme methods of altering his appearance later on.

Art was the natural step forward for Bowery's artistic vision which disrupted, refracted, and melded concepts of gender and sexuality: he blurred and recalibrated his own identity in an era when this was out of step with the norm. Among his most startling and influential performances was one in 1992 at the in London nightclub Kinky Gerlinky, where he gave his first "birth scene" enactment, "delivering" his future wife, Nicola Bateman, who was covered in red paint and KY jelly. The couple would perform the same enactment the next year at Wigstock, which took place in Tompkins Square Park in the East Village, and elsewhere. Way back in 1981, Bowery had worked out his art-life philosophy: the exchange of ideas must happen by any means necessary. "I think that firstly, individuality is important, and there should be no main rules for behaviour and appearance," he wrote in his diary.

Bowery considered his art-looks—"both serious and very funny," according to the journalist Ian Parker, who interviewed him for the *Independent* in 1995. "It's decorative, but there's something underlying

that's maybe tragic and disturbing. There's a tension between the two." Bowery's heart was not in mainstream fashion, although by 1982 his clothes were being stocked in Susanne Bartsch's eponymous boutique on Thompson Street in New York and the next year were part of her *New London–New York* fashion show. The designer Michael Costiff says in Atlas's film: "Leigh didn't really want anyone else wearing his clothes; he was his own best creation." In a 1986 interview with *The Cut*, Bowery said: "Fashion's a little bit of a problem for me, because you have to appeal to so many people, and I like appealing to maybe one or two. . . . I'm only interested in maybe twenty people's opinion of me." On the *Joan Rivers Show* in 1993, he reiterated his stance, saying, "I don't think it's so much about fashion, it's more about expressing ideas and having fantasies and making them all happen. It's about looking different and being subversive."

In October 1988 Bowery was given his own installation show at the Anthony d'Offay Gallery in London, where he sat on a chaise longue behind a one-way mirror—he was not able to see out, but visitors could watch him. He lay there for a week; passing traffic was the soundtrack. According to *Artscribe International*, as quoted in Sue Tilley's book, *Leigh Bowery: The Life and Times of an Icon*, "It was fashion slowed down, collapsed into performance. The designer making clothes for himself that became more and more obsessive."

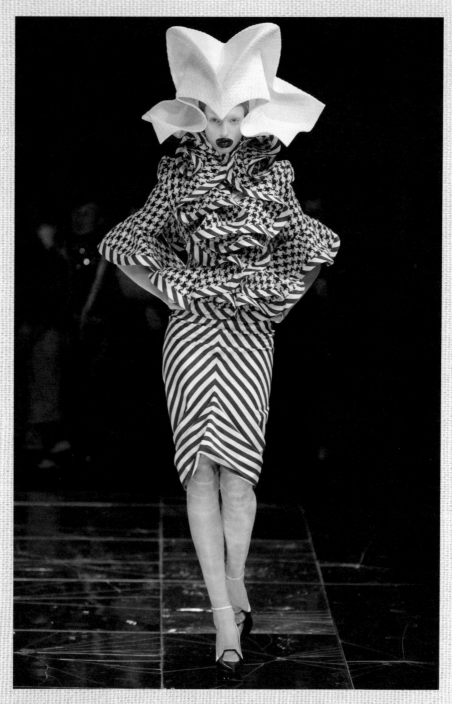

Alexander McQueen's *Horn of Plenty* collection for Fall 2009 featured models with oversized lips and makeup suggestive of Leigh Bowery's in the 1980s.

Tilley, who was Bowery's best friend, said, "He would make what he wanted to make and whether people liked it or not was their business. It didn't matter to him as he wasn't trying to sell the clothes anyway."

Bowery was big news in the fashion world, however, and is still revered by the edgiest talents. The blue faces and exotic Indian jewelry worn by models in John Galliano's spring 2003 show were directly inspired by one of Bowery's famous looks, and Alexander McQueen's 2009 *Horn of Plenty* collection featured exaggerated silhouettes and oversized red lips that evoked Bowery at his finest. Also in that year, Maison Margiela featured pom-pom heads and balding head masks that dripped with paint, another Bowery signature. In 1993, just before Bowery died of an AIDS-related illness, Annie Leibovitz photographed him encased in his fabulous club-footed S&M catsuit—a moment to which Gareth Pugh's black latex head-to-toe bodies from his 2007 collection pay homage.

Bowery's first job when he came to England was at a Burger King in London's West End. The cash-poor aspiring artist said his dream was to work at the branch on Paris's Champs-Elysées.

And there are more recent tributes. A video portrait of Bowery was displayed at the Fondazione Prada's permanent exhibition space's Nord Gallery in Milan, during the *In Part* show of May 2015. And Rick Owens caused a sensation in 2016 with his "human backpacks" on the catwalk that summer—they were based on Bowery's "birth" installation, and the slings worn by the models exactly replicated the ones Bateman had been tethered with. As Owens remarked in a *Dazed Digital* interview, the concept "was transgressive and sweet at the same time."

KEITH HARING

If commercialization is putting my art
on a shirt so that a kid who can't afford
a $30,000 painting can buy one, then I'm
all for it.

—Keith Haring, the *Los Angeles Times*, February 1990

Keith Haring's artistic legacy to the world is one of love and compassion: he proved that it's possible to be both cool and kind. The renowned record producer Junior Vasquez said, "Keith was a product of the whole street vibe. He was about what the street was." Part of the legendary early-1980s New York nightclub scene, Haring was also best friends with Andy Warhol and Jean-Michel Basquiat and an activist who fought for gay rights, helped people with AIDS, campaigned against crack, supported Nelson Mandela, and worked with children around the globe. He was invited to paint the Berlin Wall in 1986. To this day, the Keith Haring Foundation licenses artworks and gives money to the causes he cared about.

Although the distinctive qualities of his art were recognized early, his wardrobe caused him trouble. The Paris Ritz had a problem with his clothes and footwear. When he stayed there in 1989 — having flown in from Italy, where he was commissioned to create a mural

Opposite:
Keith Haring at
the opening of
Pop Shop, New
York City, 1986.

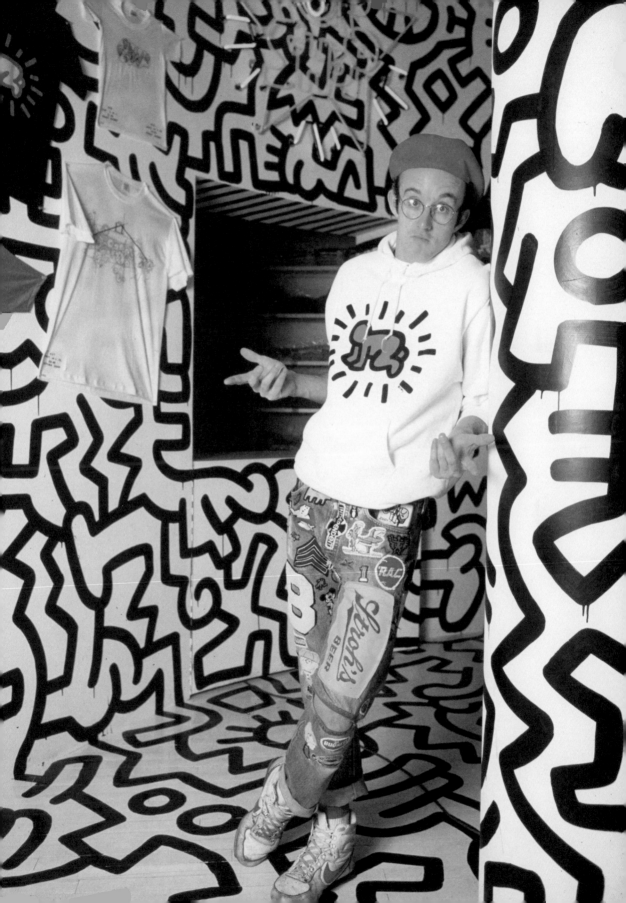

for the city of Pisa—they wouldn't let him in the hotel restaurants because he "didn't have a pair of proper shoes" and only wore high-top sneakers, and they were "constantly reprimanding" him for wearing shorts in the lobby. Today Haring's street style has prevailed: sneakers are on par with designer wear for those in the know, and his favorite black-and-red Air Jordan 1s or Nike Delta Force high-tops (in original boxes) could be lovingly displayed under glass like artwork. In 1982, the art dealer Tony Shafrazi gave Haring his first one-man show at his Mercer Street gallery in New York and noticed his sartorial spirit immediately: "From day one, Keith had a very distinct look about him. . . . At the young age of twenty he was twenty years ahead of his time, a real trend-setter."

Haring, a Pennsylvania native born in 1958, lived for "Saturday night mass" at the Paradise Garage, the groundbreaking West Village discotheque of the 1980s. In a 1997 *Vanity Fair* feature, nightclub legend Johnny Dynell explained how Haring "became the official artist of the Garage. He designed T-shirts, did parties, and created invitations that we always saved. The inclusive energy of the Garage fed Haring's creativity." Haring's look was always unique, starting with his signature geek-chic glasses, usually customized by his friend the artist Kenny Scharf. At first glance they seem at odds with the let-yourself-go hedonism of Haring's party life, but his fashion statements

When Haring was a teenager, his favorite band was the Grateful Dead, and he wrote in a journal all about them. He was also a big fan of the Monkees' Davy Jones and made collages with cutouts of the singer's face.

were intuitive and self-reflective, often inspired by the hip-hop tunes he listened to while painting. He loved music and designed cover art for his friends' recordings, including Run-D.M.C.'s track "Christmas in Hollis"—this artwork later appeared on a limited-edition Adidas Superstar 1980s sneaker from 2013, on the tongue of the shoe.

Although he wore streetwear, his outfits were never a cliché, and his glasses sat just right. Along with baseball caps, sneakers, and graffiti-scribbled jeans, Haring wore, according to his mood, varsity jackets covered in patches, brightly colored satin bomber jackets with sleeves pushed high up the arm, cycle caps, Disney T-shirts, vests, and beaded

Most people want to be cool and think that as soon as something is popular that means that it's "sold out" or it's dangerous. So they have to move on to the next thing that's unpopular and still cool. I don't find any conflict between the two things.

—Keith Haring, *Interview*, December 1984

necklaces. When he visited Princess Caroline of Monaco, after she commissioned a mural for the Princess Grace Maternity Hospital in 1989, he wore a blue pinstriped Armani suit and tie—although in customary fashion, he accessorized the suit with sparkling white high-top Nike sneakers.

Haring's hipness attracted the designers Malcolm McClaren and Vivienne Westwood; in 1983 they approached him to collaborate on their autumn collection, which he decorated with fluorescent shapes of men, dogs, and babies. These clothes are also infused with the spirit of Haring's hip-hop world: tracksuit jersey fabric was made into skirts and jackets as well as sweatpants; three-tongue sneakers and Chico hats further shaped a street-wear-deluxe style. Westwood reportedly thought Haring's art looked like magic signs and hieroglyphs, and she christened the collection Witches; the catwalk show in Paris was soundtracked with rap music.

It wouldn't be the last time fashion designers appropriated Haring's style—the fashion world regularly pays tribute to the artist's work and styling. In autumn 1988, he patterned his friend Stephen Sprouse's Signature collection with Haring squiggles. Comme des Garçons has made cashmere sweaters with Haring figures on them. Tommy Hilfiger collaborated with the artist to make sneakers and wellington boots for the uber-trendy French boutique Colette. Both Reebok and Jeremy Scott have created Haring sneakers, and the Coach spring/summer 2018 collection was a full-fledged Haring homage, with sweaters, dresses, jackets, and bags adorned with his signature artwork.

In 1986, Haring opened his own boutique, Pop Shop, as a way to make his art accessible to as many people as possible. Pins, graphic T-shirts, hoodies, and decals were all big sellers. Although it closed in 2005, the shop's populist fashion ideal has not diminished, and Haring's creative message continues to resonate. His unmistakable doodles and drawings are pervasive: on catwalks, at shops such as those of the Japanese brand Uniqlo, and on streetwear labels such as Joyrich and Obey, which have worked with the Haring Foundation to find creative ways to use his work on their products. And that's the way Haring would have wanted it. He would always sign clothing for anyone who asked; he painted vases for the designer Jean-Charles de Castelbajac and caps for children; he gave away "Radiant Baby" badges for free. His friend Madonna said in a 2009 *Rolling Stone* interview that she had a "leather jacket Keith Haring painted I would never give up." She can be seen wearing it in footage shot at Paradise Garage in 1984.

I had a call from a firm that represents the polyester industry. It had to do with a big media event to try to get polyester back on the map.

—Keith Haring, *Interview*, December 1984

Haring's most exclusive fashion collaboration was with the singer Grace Jones, whose music he adored. He said, "When I look at her I feel her body to be the ultimate body to paint," and so he did. Andy Warhol introduced the two and in 1984 asked Robert Mapplethorpe to photograph the spectacular results. Haring went on to work with Jones in the video for her song "I'm Not Perfect, But I'm Perfect for You" in 1986. In the video, a speeded-up Haring fills a sixty-foot circle of white cloth with his signature drawings, which then becomes a vast, billowing skirt worn by Jones. It's a perfect moment merging art, fashion, fabulousness, music, and fun—all the things Haring himself embodied.

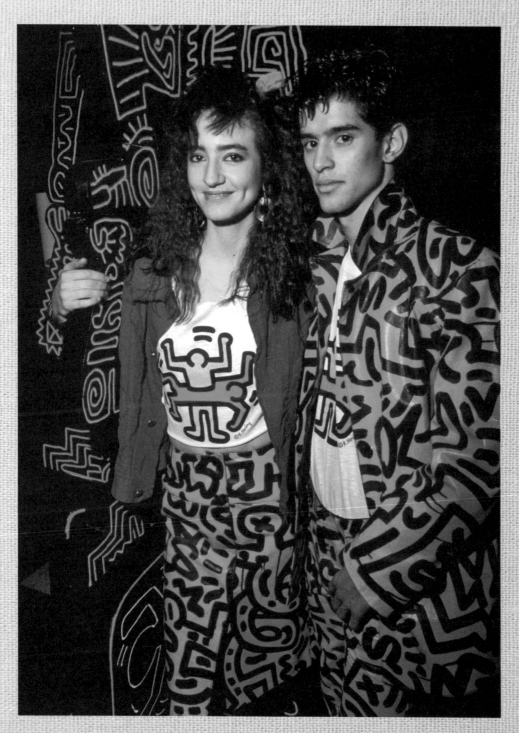

Keith Haring fashion, New York City, mid-1980s.

SIGNATURE LOOKS **GLASSES**

For these artists, their eyeglasses are not a rotational wardrobe item, but a representation of what they do well. The considered gravity of McQueen's plain-speaking frames reveals a dash of the intellectual who has focused his vision on serious issues like slavery and migrant laborers. Fashion evolved under Avedon's gaze in the 1960s—and the impeccable panache of his eyewear matches the perfection of his artful compositions featuring more unusual models like China Machado and Veruschka. Both the cultural connection of Ono's avant-garde offerings and the playful quality of Murakami's collaborations with fashion designers are reflected in the sleek contemporary spectacles they wear.

STEVE McQUEEN

The British artist and film director used to work part-time at fashion and food store Marks & Spencer, leaving only in 1995 when someone paid him "loads of money for a film." It was cash well spent. In 1999, he won the Tate's Turner Prize for his film *Deadpan*—a tribute to the silent movie star Buster Keaton—and later an Academy Award and a BAFTA for his 2013 movie *12 Years a Slave*. As a young man at school in London, he wore an eyepatch, but today he is known for his geek-chic black-framed glasses and casual panache. In 2017, Edward Enninful made him a contributing editor at British *Vogue*, and his appointment lends gravitas and intelligence to the magazine's style-pages—not that McQueen's directing and artwork leave him much time to think about fashion, despite looking debonair on the red carpet. "To me it's about the work; it's the only thing one can do," he explained in a *Guardian* interview in 2014. His work since *12 Years a Slave* includes *Ashes*, a 2014 film about a young boy murdered in Grenada, and the installation *Weight*, a prison bunk bed draped in a 24-carat-gold-plated mosquito net, which was part of the exhibition *Inside: Artists and Writers in Reading Prison* (2016)—an homage to Oscar Wilde, who spent two years incarcerated.

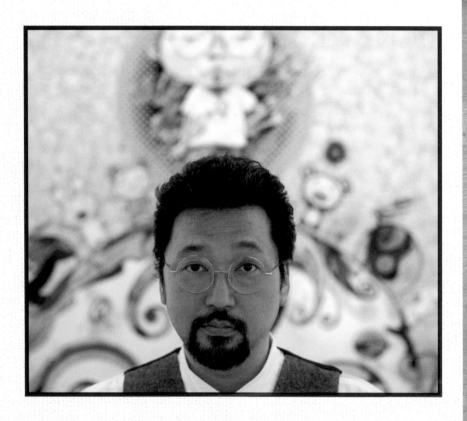

TAKASHI MURAKAMI

Takashi Murakami is celebrated for founding the Superflat conceptual approach in contemporary art. His memorable style bonds the worlds of high and low culture: cartoonish anime figures and brightly colored flowers mashed up with two-dimensional methodologies of more traditional Japanese art. His self-portraits may feature him wearing skater shorts, baggy T-shirts, and sandals, his hair tied in a ponytail. And invariably his distinctive glasses: thin wire-frame circles, elegant and exactly right for the larger-than-life, otherworldly, contemporary character he is. In Murakami's first clothing project, he worked with Naoki Takizawa at Issey Miyake, using his striking imagery of jellyfish eyes on hooded parka coats and men's trousers in the spring/summer 2000 collection. Later, in 2003, Murakami embarked on a collaboration with Marc Jacobs at Louis Vuitton that lasted thirteen years and included a range of leather goods embellished with the famous LV logo in shades like baby pink and sky blue. His Multicolore, Monogramouflage, Cherry Blossom, and Character handbags were well received, opening the door for subsequent fashion partnerships—including a skateboard with Supreme and, in 2017, a hand-printed T-shirt with Virgil Abloh's Off-White label.

Opposite: Steve McQueen at the Toronto International Film Festival, September 2011.
Above: Takashi Murakami at Galerie Perrotin-Hong Kong, May 2013.

YOKO ONO

Yoko Ono has lived her life in glasses. Bug-eyed sunglasses, 1980s futuristic oversized wraparounds, Wayfarers, and round frames to match those of her husband, John Lennon. Ono's intrepid artwork and fearless fashion sense speak volumes about the inimitable spirit she is. At her 1966 show at London's Indica Gallery, she captivated Lennon by inviting him to climb up a ladder and look though a spyglass at the word *yes*. Three years later, in Gibraltar, she married him wearing a white miniskirt, knee-high socks, a flappy white hat, canvas sneakers, and big round shades that almost eclipsed her tiny face. Clothes are part of Ono's DNA. When one of her earliest performance works, *Cut Piece*, was presented at the Sogetsu Art Center in Tokyo in 1964, she wore her smartest suit and summoned the audience to snip it off her body. In her eighties, Ono dresses with a loose androgyny: she wears simple men's tailoring paired with a derby hat and sunglasses, or a leather biker jacket with sheer shirts—all accessorized with a timeless frame. Her art is multifaceted and abstract at its heart; music is also part of her creative oeuvre. The Plastic Ono Band was a collaboration with Lennon—and his first solo project—in 1969. In 1981, she released her first solo album, *Season of Glass*; the cover art depicted Lennon's blood-spattered glasses, found after his murder in New York in 1980.

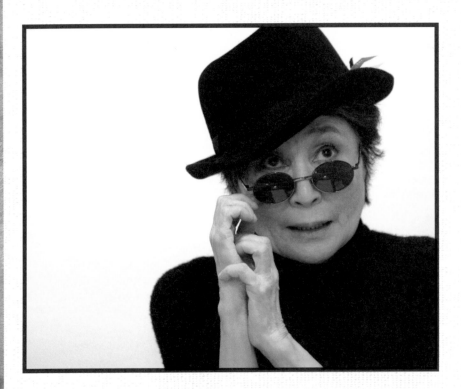

Above: Yoko Ono, Berlin, February 2006. Opposite: Richard Avedon in his New York City studio, 1985. He is standing in front of his photograph *Clifford Feldner, Unemployed Ranch Hand*.

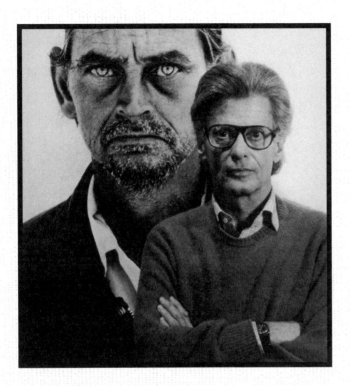

RICHARD AVEDON

At Truman Capote's Black and White Ball, the famous 1966 masquerade dance held in Kay Graham's honor at the Plaza Hotel, Richard Avedon solved the problem of how to see and enjoy the splendid party by wearing a "wrap-around mask that covered his glasses," according to *Life*'s December issue, published shortly thereafter. Avedon and his spectacles were equal entities; images of the photographer show him with glasses pushed up to the forehead, ready to flip down when needed. His look was unchanging: a pair of stylish mobster aviators that were just on the casual side of hip-hop and undeniably cool. His eyewear inspired Garrett Leight—the son of Oliver Peoples founder Larry Leight—to design an Avedon frame in 2015. Avedon's fashion light shines bright in his work as well. His photographic aesthetic was about immersion: for him, couture—however fancy—was about interaction, with models moving, dynamic and in the moment. His methods brought life and character to the clothes he shot. His images are iconic: the model Dovima wearing Christian Dior and posing with elephants at the Cirque d'hiver in 1955 or his 1957 homage to Martin Munkacsi of Carmen Dell'Orefice wearing Pierre Cardin, carrying an umbrella, and jumping off a curb into a Paris street. Just as his commercial work took fashion to new places, his portraits explored and surveyed their subjects with rare intuition, always discovering something new to share about the sitter—whether famous figures like Martin Luther King Jr. or outsiders like *Ronald Fischer, beekeeper, Davis, California, May 9, 1981.*

PABLO PICASSO

Those who try to explain a picture are on
the wrong track most of the time.

—Pablo Picasso, from *Futurism*, edited by Didier Ottinger, 2008

P ablo Picasso didn't keep still: his art advanced from one phase to
the next, as he developed and refined what he wanted to convey
and how he wanted to communicate it to the world. This temperament
was similarly expressed in the restless changing of his personal look.
When he first arrived in Paris from Spain in 1900, at age twenty, he
lived in poverty; over the course of the next few years, he would pay
for dinner at Le Lapin Agile, the Montmartre cabaret, with his work.
He dressed the "artist" part in mended overalls, fisherman sweaters,
and shapeless work jackets: he was intense and serious about making a
name for himself as a laborer in art. In 1919, while working in London
on designs for a Ballets Russes production of *The Three-Cornered Hat*,
he fell in love with the style of an English gentleman. He visited Savile
Row's finest tailors with Virginia Woolf's brother-in-law, the art critic
Clive Bell, and bought three-piece suits, which he wore perfectly with
pocket handkerchiefs, brogues, and a bowler hat. When in Monte Carlo
with Serge Diaghilev in 1925, after collaborating again with Diaghilev's
Ballets Russes, Picasso looked the part in white slacks and navy blazers.

Opposite:
Picasso in
his workshop,
Vallauris, France,
c. 1952.

88

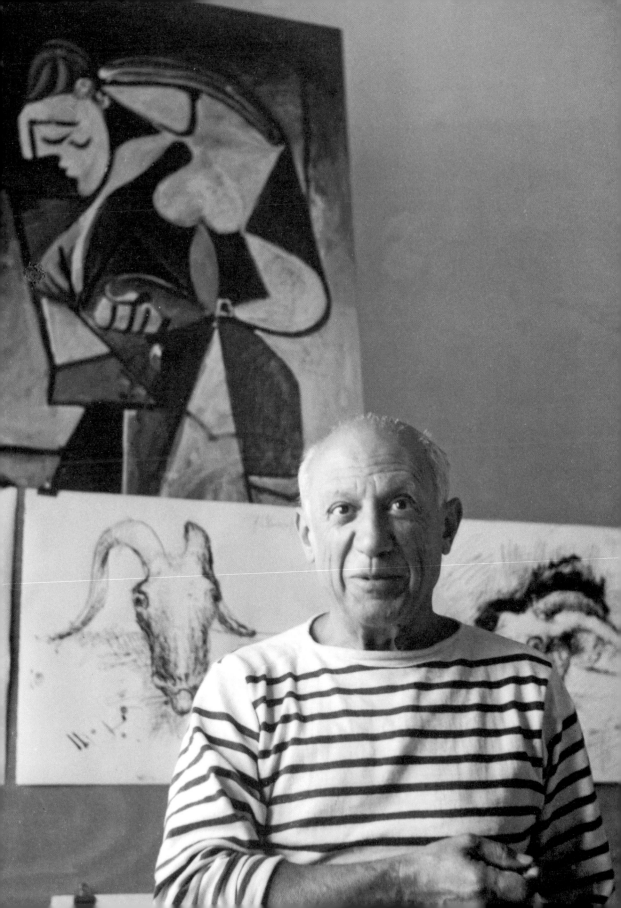

Picasso's looks were numerous: F. Scott Fitzgerald–esque Oxford bags and stylized flat caps, sexy-beast black shirts undone to mid-chest, Breton T-shirts, chino pants, and espadrilles; 1950s toweling polo shirts and shorts, striped shirts clashing with plaid trousers—and sometimes, later in life, striding around shirtless: larger than life and in charge. And he loved hats: Peruvian knitted hats with pom-poms, sun-shielding straw toppers, and stiff, classy homburgs. And more: dress-up matador hats, Vietnamese conical hats, and American Indian feathered headdresses—Picasso wore any and all of these for a laugh, and quite often while smoking a cigar.

The beret, traditionally worn by Basque farmers, would become a Picasso trademark, both in his wardrobe and as a motif he painted time and again. His accessory of choice takes center stage in *Woman with Red Hat* (1934), *Women with Beret and Checked Dress* (1937), *Marie-Therese in Blue Beret* (1937), and *Man in Beret* (1971). Another *Man in Beret* was one of Picasso's first known portraits, made in 1895 when he was fourteen; it shows off his early virtuoso skills. Just how influential Picasso's beret-wearing turned out to be is evident from attendance records at London's Institute of

In 1903 when Picasso was staying in Boulevard Voltaire, he was so poor he shared a bed, notebook, and top hat with his friend the poet and critic Max Jacob.

Contemporary Art, which reveal that after two Picasso exhibitions staged in the 1950s, employees found lost berets more than any other personal items. As the ICA explains, "He wore one and everyone was trying to copy him."

Historically a beret was worn by rebels, radicals, and intellectual bohemians, and Picasso adopted all of these personae in his lifetime. He signed up with the French Communist Party in 1944, and throughout his life he would freely donate money to its causes, along with creating profound imagery that reflected his philosophical concerns. Picasso's most famous public art piece, *Guernica*, was commissioned for the Spanish Pavilion at the Paris World Fair in 1937. One of his most striking statements on war, human suffering, and agony, the painting has become a "symbol of resistance," as the Tate Gallery points out. Over time, Picasso's politics have been explored and evaluated as

One whom some were following was one who was completely charming. One whom some were following was one who was certainly completely charming.

—Gertrude Stein, *Picasso*, 1912

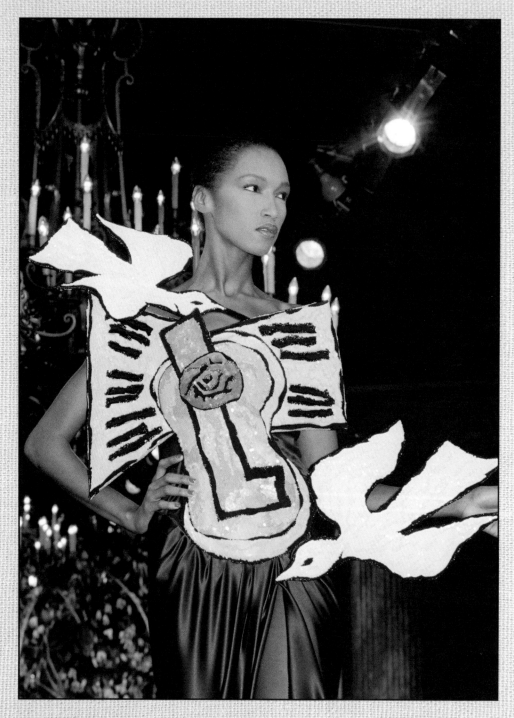

The model Katoucha wearing an evening dress inspired by Picasso for Yves Saint Laurent's 1988 spring/summer haute couture collection, January 1988.

much as his art. A *Spectator* feature in 2018 described him as "rich as Croesus," but he possessed the ideologies of an activist. The beret was a fashion echo of his principles and temperament, part of his brand and sensibilities.

Designers have long been captivated by Picasso and his wide-ranging oeuvre. In 1935, Elsa Schiaparelli was moved by his *Hands Painted in Trompe-L'oeil Imitating Gloves* (Picasso painted real hands and Man Ray photographed them) to create her legendary black gloves with red python nails. In 1940, Bergdorf Goodman's fashion windows displayed seasonal collections together with some of Picasso's paintings as a preview for the exhibition *Picasso: Forty Years of His Art* at the Museum of Modern Art. The works included his Rose Period *Buste de Femme*, matched with a silver fox jacket and a gold lamé dress, and *Nude in Gray* from the Blue Period next to a long cape of baum marten fur. In 1944–45, the great Hollywood costume designer Gilbert Adrian designed an ankle-length dress he called Shades of Picasso, inspired by the artist's blocky color and forms in his cubist work. In July 1979, Yves Saint Laurent's winter couture collection included a tribute to Picasso's alter ego—a Harlequin dress in pale pink satin and black-dot tulle with ruffled collar and cuffs. Prada's geometric-patterned bags of summer 2017, Oscar de la Renta's resort 2012 Picasso newsprint dress, the distorted abstract faces on knitwear at Jil Sander 2012, and the double-faced makeup on the models at Jacquemus in autumn/winter 2015—all have been steered by Picasso's imaginative lead.

Picasso himself was no stranger to the decorative arts. In 1955, he worked with the American company Fuller Fabrics on a Modern Masters collection, producing textiles with names such as Rooster and Fish that were made into daywear; in 1956, he designed a range of furnishing materials, one called Turtle Dove, with the same company. He also collaborated with sportswear brand White Stag in 1962—among the collection were vinyl anoraks printed with bulls and corduroy ponchos made from his Musician Faun pattern. Ads for the line, in keeping with his egalitarian and revolutionary standards, told potential buyers, "Can you afford a Picasso? If you have thirty dollars you can!"

LOUISE NEVELSON

Art and life are the same things to me,
and fashion is part of life. I am happy
in beautiful clothes, wonderful jewelry.
I am constantly creating—why should I stop
with myself?

—Louise Nevelson, *Vogue*, June 1976

The collagelike cacophony of Louise Nevelson's day-to-day wear mirrored the sculptures she created. Odd juxtapositions of dissimilar clothing pieces coalesced in a uniquely compelling way when the artist put them together. Similarly, the flotsam and jetsam of life that she assembled in her sculptures evoke intense feelings but resonate harmoniously. Born in Kiev in 1899, she is best known for *Sky Cathedral*, created in 1958 out of boxed wooden fragments and debris she found in the street and painted matte black. Nevelson's connections and contrasts worked. When couturier Arnold Scaasi first met the sculptor, she was wearing a "man's denim work shirt and a pair of khaki pants. . . . On her head was a pointed wizard's hat made of some kind of terrible reddish-brown fake fur and a sable coat completed her outfit!" He said she looked like "a cross between an eccentric dyke

Opposite:
Louise Nevelson,
June 1980.

94

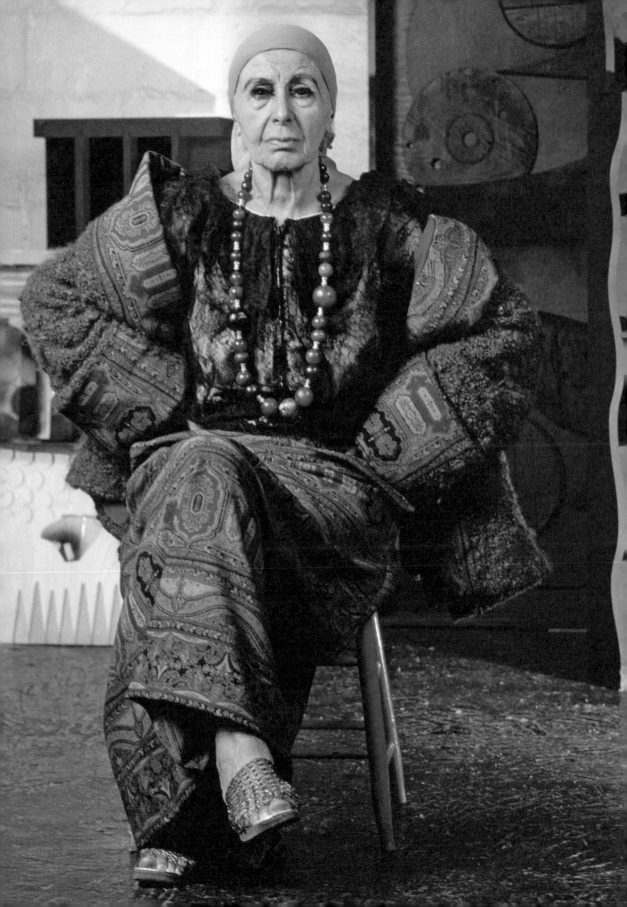

Being "well dressed" is not a question of having expensive clothes or the "right" clothes. I don't care if you're wearing rags but they must suit you. If you think you're not put together well you can't confront the world.

—Louise Nevelson, *The Metropolitan Museum of Art Bulletin*, c. 1965

and an aging, elegant hippie," and was "mesmerized." Scaasi went on to design for Nevelson, but the process was almost always collaborative, and she would call him up to suggest ideas. Velour ponchos in green and plum or Persian-wool, chinchilla-lined jackets to wear in her enormous chilly studio on Spring Street, in New York's Soho, were not unusual commissions. Longtime *Vogue* editor Diana Vreeland contacted Scaasi in 1977 to request one of Nevelson's outfits for an exhibition she was curating at the Metropolitan Museum. She thought the artist's style was "fascinating."

On the opening night of Nevelson's 1967 retrospective at the Whitney Museum, she wore a white embroidered peasant blouse, a long Mexican skirt, and on her head a cerulean damask napkin, draping from her shoulders two purple Japanese tapestries—all accessorized with a boar's teeth necklace and a brooch she crafted from wood and gold. "I look for something that suits me," Nevelson declared in an interview appearing in *The Metropolitan Museum of Art Bulletin*, going on to recount that even as a girl, she felt that fashion was too "temporary." She looked for things to wear that didn't change with the seasons and were more "permanent" than the cyclic designer offerings of Paris. In her mid-sixties, Nevelson shopped for vintage lace frocks and Japanese gowns, and she she was almost seventy when she began wearing her trademark false eyelashes. She thought that two or three pairs at a time looked best, although she was known to wear up to five sets—sometimes ones made from mink—on special occasions. The *New York Times* wrote in 2007 that "Nevelson made old age the stage for a fashion revolution."

When Nevelson was nine years old, she saw a statue of Joan of Arc at the Rockland (New York) Public Library and decided to become a sculptor.

In 1933, Nevelson worked as Diego Rivera's assistant when he was making his series of murals, Portrait of America, for the New York Workers School and had an affair with him, much to the annoyance of Frida Kahlo.

Although she knew as a child that she wanted to be an artist, she only began studying art full time when she was twenty-nine. In her book *Louise Nevelson: A Passionate Life*, Laurie Lisle describes how

the artist personalized her style as teenager: "When she was about fourteen, she bought a piece of linen and a brimmed hat frame at Woolworth's and attached the linen in pleats to the frame. She then stenciled and painted butterflies, sewed them onto the hat, and wore her handmade creation to school until she tired of it." Hats and headscarves were to become a Nevelson specialty. Plush jockey caps, ten-gallon Stetsons, silk bandanas, and furry babushkas were frequent accessories. One of her favorite milliners was Mr. John, whose dramatic creations were worn by the highest society ladies and film stars alike, including Marilyn Monroe. It's said that Nevelson paid for his luxury pieces with art, as they were so costly. Hats were a must-have by any means necessary. In her biography, *Light and Shade*, Laurie Wilson revealed that during the 1930s and 1940s Nevelson "became known as 'The Hat' because she wore gorgeous chapeaux—sometimes stolen and sometimes purchased by lovers for her favors."

Every time I put on clothes, I'm creating a picture.

—Louise Nevelson, from *Dawns and Dusks*, 1976

Nevelson's radical chic was a style that she grew into over time. It was ignited only when she was in her early thirties, after she left her conservative husband, who had expected her to be his stay-at-home wife. After leaving him, she lived the life of a starving artist but managed to dress with a tidy sense of chic that was light years away from the wild, out-of-time styling of her later years. When Nevelson had her first solo exhibition in 1941 at the Nierendorf Gallery in Berlin and started selling her work in the early 1950s, she also began to morph into the Nevelson of her sartorial legacy; she decided that if people were going to pay attention to her art, they needed to pay attention to her. Her wardrobe did the job.

Opposite:
Louise Nevelson,
c. 1970.

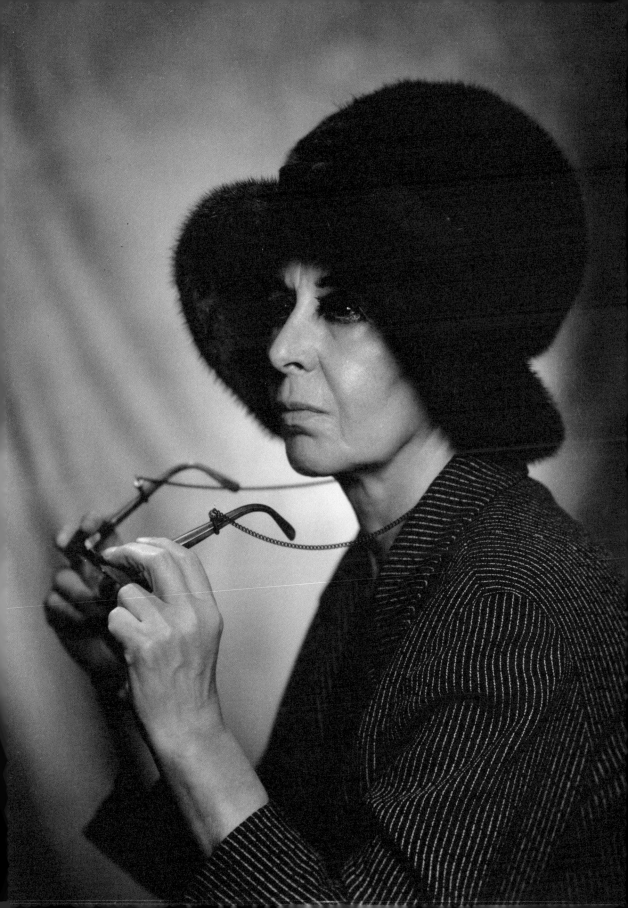

JULIAN SCHNABEL

I refuse to have a signature style. I think
Michael Stipe of REM said to someone the
other day that I "owned white." I don't
know what that means exactly but I thought
it was very nice of him.

—Julian Schnabel, the *Evening Standard*, May 2014

Julian Schnabel is a pajama-wearing artist—a filmmaker, interior designer, and painter who has brought nightwear into the light of day. And he has glamorous allies in important places: his movie debut in 1996 was a biopic of his old friend Jean-Michel Basquiat. His friends feel relaxed enough around him to occasionally request his creative services—something which he has happily provided that has resulted in a multifarious work-load. Donatella Versace knew him because he had done portraits of her children and her brother, Gianni; she partnered with him to design a necklace for an auction to benefit the Whitney Museum of American Art. In 2006, he revamped the interior of Ian Schrager's Gramercy Park Hotel—both men attended the same Catskills summer camp as children and later went on to hit the same party circuit in New York. Schnabel, slightly casual about the

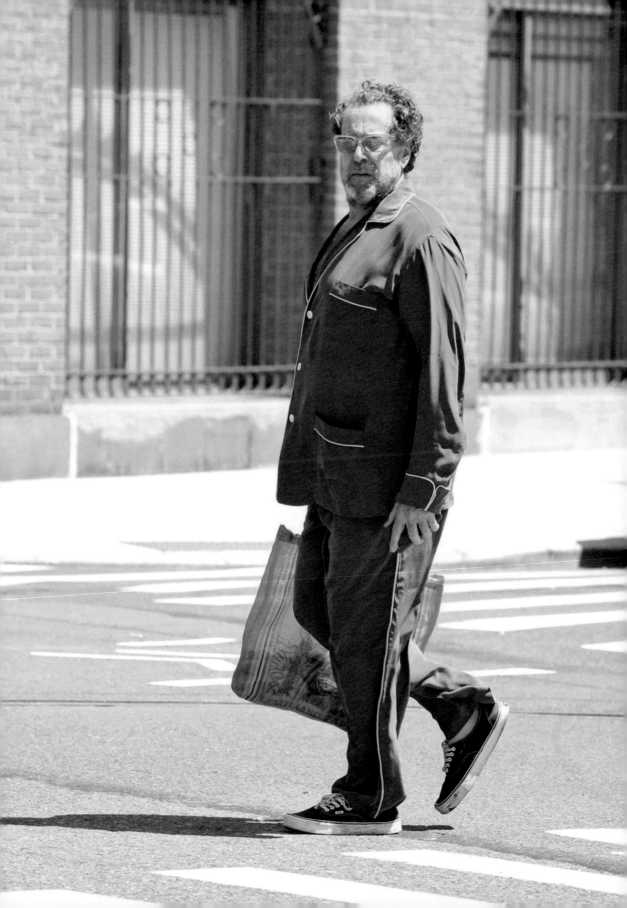

multimillion-dollar project, explained to the *New York Times*, "I'm not a designer, but I've always built things. Basically, I'm a painter and this is something that's not very hard to do." He went on to fill the place with his own work as well as with a canvas by Andy Warhol—another close friend whose portrait he painted in 1982. The taciturn pop artist felt so comfortable sitting for Schnabel that he took his shirt off when asked to reveal a pink corset, as seen in the painting.

Schnabel is best known as the artist who most vivaciously embodies the larger-than-life, go-getting, publicity-hungry, and money-making spirit of the 1980s art world. This wellspring has fostered a global network of dazzling connections that has helped keep his creative legend vibrant. However, whatever he does and whoever he does it with, it's done with a whole heart. One of his most famous paintings, made early in his career, is called *The Death of Fashion* after a newspaper headline he saw about a model who killed herself. It's a crashing statement constructed out of broken crockery—an ardent, enthusiastic art piece that personifies Schnabel.

In the 2017 documentary *Private Portrait*, Schnabel declares, "When you're young you have a desire to do something and you don't know what it is, but you're propelled to do it. You have to have an infinite belief in what you are doing that is not rational; it's blind faith." In the 1980s, his self-assurance and business sense made him loved and loathed in almost equal measure. A 2003 *Guardian* interview described him as "an arrogant dandy who often conducted interviews lounging on the sofa of his palatial Manhattan apartment in silk pajamas and monogrammed slippers." Hundreds of column inches have been devoted to his habits: swanning around New York by day, treading the red carpet by night, and wearing

Schnabel released an album on Island Records in 1993, *Every Cloud Has a Silver Lining*. He sings and plays the piano and organ, and he wrote most of the music.

Schnabel is the father of six children. His eldest son, Vito, an art dealer, is named after the character Vito Corleone in Mario Puzo's *The Godfather*. Schnabel also has twin sons, Cy, named after painter Cy Twombly, and Olmo, named after the character Olmo Dalcò played by Gérard Depardieu in Bernardo Bertolucci's *1900*.

deluxe night-clothes to paint at his fifty-thousand-square-foot Palazzo Chupi in the West Village. *Vogue* and other popular publications have run lengthy features on Schnabel and his twelve-story Italianate mansion, designed by the artist after a Venetian palazzo and situated atop old stables.

"When I wear pajamas, it looks like a tuxedo," Schnabel once remarked, and no one has done more for the garment. Olatz López Garmendia, a Spanish model and his wife for seventeen years, was inspired by her ex-husband's casual wardrobe to launch an eponymous fine-designer pajamas label. And she's not the only designer stirred to create pajamas for the catwalk. Marc Jacobs wore gorgeous jammies while taking his end-of-show bows at the houses of Marc, Marc Jacobs, and Louis Vuitton in 2013. Silk bedtime two-pieces have become virtually a seasonal staple in the current century, regularly featured on the international catwalks of Thakoon, Céline, Dolce & Gabbana, Dries van Noten, and Gucci; Schnabel paved the way for their mainstream embrace as a daywear option. In a CBS interview, he recounted, "When you see somebody walking down the street in pajamas, they think that you just got out of a mental hospital. And when my boys were born, I was in the maternity ward, and I was walking around in my pajamas. And a lady said to me, 'You're on the wrong floor.' I said, 'No, no, no. I'm not. I have these kids.' She said, 'You can't walk around in your pajamas.' And some woman that was a painter said, 'That's

My paintings take up room, they make a stand. People will always react to that. Some people get inspired . . . others get offended. But, that's good. I like that.

—Julian Schnabel, the *Observer*, October 2003

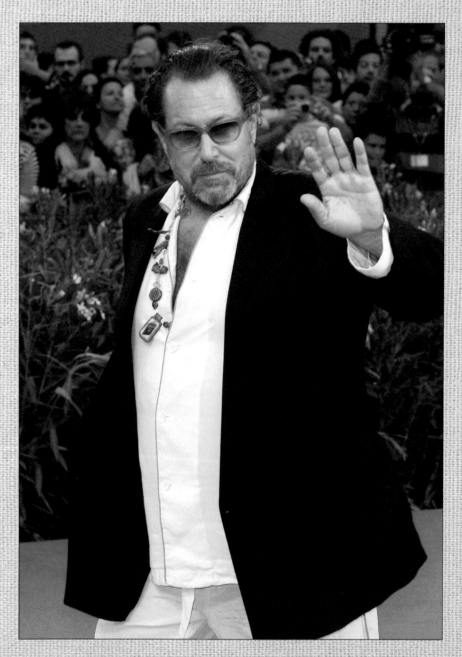

Julian Schnabel at the premiere of his film *Miral* at the 67th Venice International Film Festival, September 2010.

Julian Schnabel. He walks around in his pajamas. It's okay.'" *Vanity Fair* concurred, and in 2008 Schnabel was honored as an "original" on its famed Best Dressed List.

The style world loves Schnabel. He is on the wavelength of an industry that makes the world sit up and take notice on a regular basis. The Tunisian couturier Azzedine Alaïa, known for his body-conscious dresses favored by supermodels and uptown ladies, was a perfect fashion counterpart to Schnabel, so it's no surprise that the two were firm friends and mutual fans. Schnabel talked to Alaïa for *Interview* in 2013, noting that the two had been friends for twenty-five years and describing the designer as: "an artist . . . a sculptor who draws with scissors." In turn, Schnabel's work adorned Alaïa's atelier and boutique in Paris. Another designer who has looked to Schnabel is Victoria Beckham, whose pre-fall 2014 show was inspired in part by a painting of his she owns, which, she said, "particularly inspired me for the color palette of the collection." For Louis Vuitton menswear collection of spring/summer 2018, Kim Jones appropriated a whole raft of 1970s and 1980s artists. His vision could not have been complete without a nod to Schnabel; appropriately enough he sent a pair of divinely voluminous patchworked pajamas down the catwalk. They would look a speck overformal in the bedroom but they are spot-on for the street.

Schnabel is a keen surfer and, along with board legend Herbie Fletcher, started the Blind Girls Surf Club, named after Schnabel's 2001 painting *Large Girl with No Eyes*. The two went on to launch a limited-edition Blind Girls Surf Club collection with the brand RVCA in 2015.

LEE MILLER

I'd rather take a picture than be one.

—Lee Miller, *Lee Miller in Fashion* by Becky E. Conekin, 2013

Lee Miller's career took a sinuous path that she navigated with fluid transitions. Born in Poughkeepsie, New York, in 1907, she worked as a top model in the 1920s, was shot wearing Lanvin by George Hoyningen-Heune for French *Vogue*, and became a muse of and collaborator with Man Ray in Paris. Later she became a war journalist and was the first woman reporter inside the Nazi concentration camps of Dachau and Buchenwald. As a photographer for *Vogue*, she created magazine editorials featuring high fashion and couture gowns by Schiaparelli, Edward Molyneaux, and others.

She learned how to take pictures in 1929, joining forces with her lover, Man Ray, in Paris, where she honed a technique of solarization—a darkroom effect that washed her images with an unreal edge. But it was Miller's graphic eye and composition that made her an impressive surrealist artist. Miller's art—as seen in the abstract detail of a woman's body in *Nude Bent Forward* (1930) or the peculiar juxtaposition of wit and weird in *Fire-Masks* (1940s), a portrayal of women on a bomb site in London—fused great skill and a fresh approach. Her son, Antony Penrose, explained in an April 2013 *Independent* interview that "whether she was photographing fashion or the war, first and foremost she was

Opposite:
Lee Miller,
November 1928.

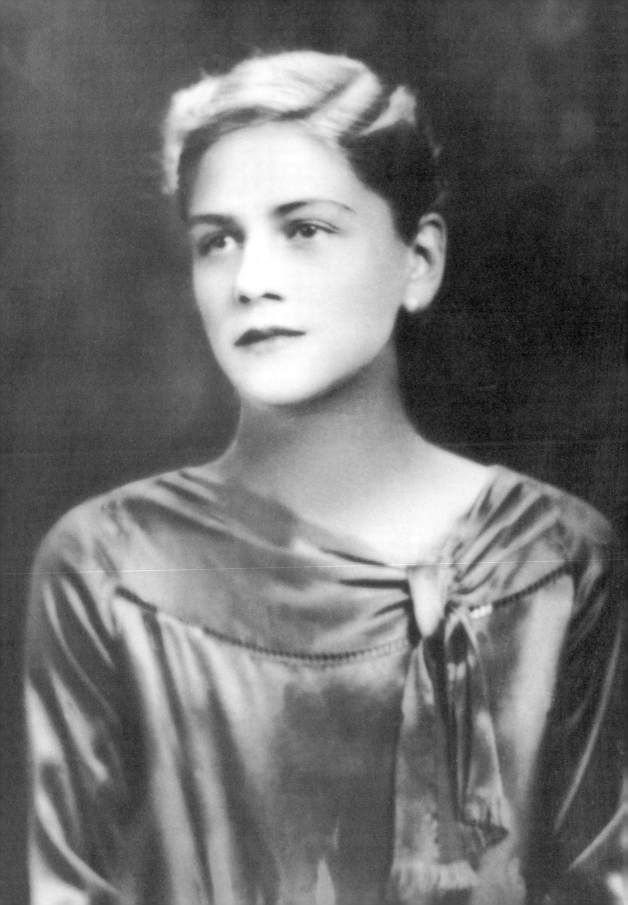

a Surrealist. That quirky way of looking at things, seeing behind the picture, the joke, the pun—it's all part of her lexicon." Miller captured her own kind of reality, one that always veiled a subtext. Her photos—such as the spectral *Floating Head (Mary Taylor)* (1933) or *Untitled (Exploding Hand)* (1930)—broke new ground and articulated an idiosyncratic viewpoint to be reckoned with.

Miller was admired as beautiful and stylish—*Vogue* editor Madge Garland called her a "vision so lovely"—and men fell at her feet, but she disordered the early-twentieth-century feminine stereotype and forged an assertive legacy using her own way of looking at herself and the world.

Miller liked to wear green nail polish on her toes.

Edward Steichen took a photograph of Miller that was used in 1928 for a Kotex tampon advertisement. She was the first person to appear in an ad for women's sanitary products, and although she was horrified at first (and it cost her her modeling career), she later enjoyed the fact she had done something previously unthinkable.

Miller balanced her fine beauty with an uncomplicated, occasionally androgynous wardrobe. Trench coats, wide-leg slacks, shirtdresses, and blouson smocks were Miller staples. These were also featured in Duro Olowu's Miller-inspired catwalk show of summer 2018. Miller looked willowy in her men's-cut trousers, and when she went on assignment for *Vogue* during the war, her military uniform was cut to flatter, manifesting as utility chic. She threw clothes on—calf-length pencil skirts, tweeds, cardigans, Chanel jackets, Caroline Reboux hats—and her nonchalant allure was all the more potent for seeming so gracefully sophisticated. Her hair, cut a shade shorter and in a more boyish style than the prevailing fashion, accentuated Miller's gamine-meets-goddess charisma.

The great and good of the fashion world continue to fixate on her style, reinventing it for a new season. After reading Miller's biography, Frida Giannini was invigorated in designing her autumn 2007 collection for Gucci; stirred by Miller's strength and passion, she respun vintage 1940s silhouettes for Milan Fashion Week. Belgian designer Anne Demeulemeester created "Miller-eye" pendants in 2008. While at Céline, Phoebe Philo often referenced Miller's panache and the

Naturally I took pictures. What's a girl to do when a battle lands in her lap?

—Lee Miller, interview on the *Ona Munson Show*, CBS Radio, 1946

The Céline fall/winter 2014–2015 womenswear show, Paris Fashion Week, March 2014.

look that the artist casually made her own back in the 1930s and 1940s: a red-and-white geometric sweater from a 2012 Céline show is a mirror of one Miller wore eighty years earlier, in 1932. After her autumn 2014 show, Philo told fashion journalist Tim Blanks that "the starting point for the collection was the iconic image of Miller in Hitler's bath, taken in Munich in 1945." Miller is naked in war correspondent David Scherman's shot, but the impact comes from her heavy-duty, muddy boots, sitting outside the tub. Philo points out that the artist was "doing things which were quite radical at the time, like wearing men's clothes, but which today seem quite normal."

Miller's fashion photographs present her own smart sartorial edge. Although her enthusiasm for *Vogue* waned after the war, in 1944 she traveled to Paris and was one of the first outsiders to report back on its liberation. Her eye was at least partly trained on what people were wearing and how couture houses were reviving. She sent home images of milliners waving from the windows of the Paquin Maison de Couture, French women biking around Paris in handmade suits and practical cross-body bags, and Lucien Lelong examining bolts of fabric at his atelier. Her piece in *Vogue* in November 1944 described what she found, portraying real life as she saw it. She discovered that clothes were "plainer and more practical, but rich in ideas. Windbreaker jackets, good for cycling, persist, often fur-lined." Miller's editor, Edna Woolman Chase, responded to her reportage by sending a telegram "urging more elegance." But Miller's unique

According to Judith Newman's 2008 profile of Miller in *The New Yorker*, the artist's modeling career was an accident of sorts: In autumn 1926, "If one is to believe the story, Condé Nast noticed her crossing the street just in time to pull her from the path of an oncoming vehicle, and this fortuitous collision led to an interview with Edna Chase, *Vogue*'s editor-in-chief." In March 1927, Miller had her first *Vogue* cover.

vantage was celebrated by Harry Yoxall, managing director of *Vogue* after the war, when he said, "Who else has written equally well about GIs and Picasso? Who else can get in at the death of St. Malo and the rebirth of the fashion salons? Who else can swing from the Siegfried Line one week to the new hip line the next?"

JACKSON POLLOCK

**Painting is a state of being. . . .
Painting is self-discovery. Every good
artist paints what he is.**

—Jackson Pollock, 1956 interview, from *Conversations with Artists* by Selden Rodman, 1957

Jackson Pollock's outsider attitude and brooding James Dean demeanor translated into his wardrobe—a cool rotation of a white or black T-shirt with blue or black jeans, often worn under paint-flecked overalls and accessorized with a cigarette. What he wore is in direct contrast to the mayhem of his paintings, which brought forth the turmoil of postwar America as well as Pollock's therapy sessions. A 1950 *Time* feature about him was headlined: "Chaos Dammit"; to which he famously responded: "No chaos, dammit; busy painting." Pollock's legacy is disorder revealed as art, and his distinctive and vivid work has not just prevailed in the art world, it has also inspired the style universe. Pollock was painting in a deconstructed fashion before deconstructionist chic existed. And his personal look of grunge-meets-beatnik was set to flourish as the American counterculture took hold.

Opposite: Jackson Pollock working in his Long Island studio, 1949.

Born in Wyoming in 1912, Pollock grew up in Arizona and California and wasn't averse to wearing cowboy boots and neckerchiefs when he began studying at the Art Students League of

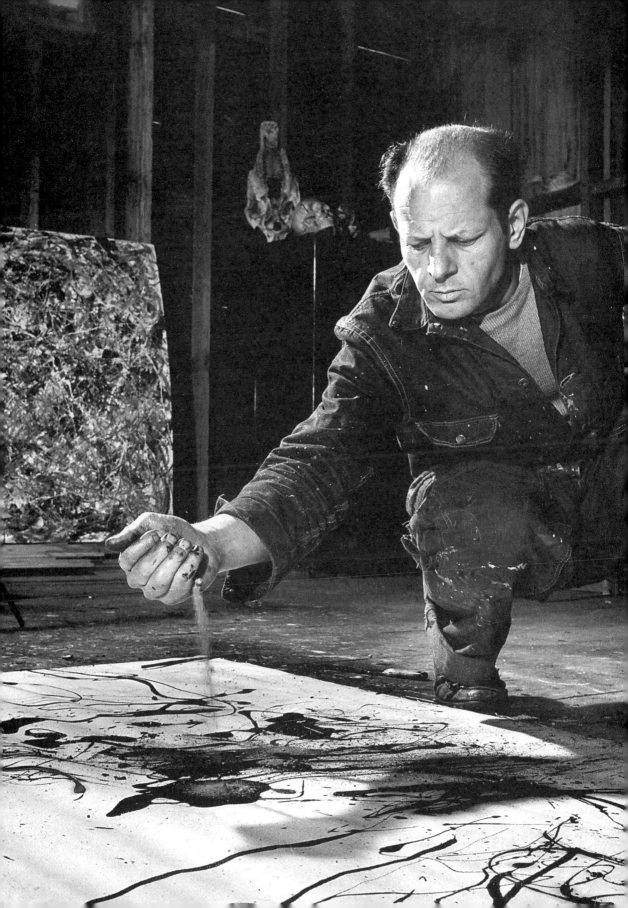

New York in 1930. The look was more daydream than reality, as Pollock was actually scared of horses and had never roped cattle. Nevertheless, rancher denim was his fabric of choice, and he wore Levi's overalls or Lee jeans with a tight-fitting Lee 101 jacket. The way Pollock sported his workwear has inspired labels in the twenty-first century, including M.i.h. and Baldwin, both of which have created lines of jeans named for the artist. Higher in profile were artist Sterling Ruby's designs for the Raf Simons autumn/winter 2014 collection, which showed denim splashed in primary colors.

But Pollock was catnip to the fashion world from the get-go. Cecil Beaton used two of his paintings, including *Lavender Mist* (1950), as backdrops for a 1951 *Vogue* shoot that featured palest blue and coral pink dresses from the labels Sophie and Irene, made with ostrich feathers and silk; a fan and refined strappy sandals and stockings complemented their tranquil elegance. The swanlike models and their outfits contrast with Pollock's feverish canvas in a potent juxtaposition of the before and after of fashion and art. Beaton had a sense of what was to come, though fashion hadn't yet caught up with his intuition or Pollock's artistic manifestations. Pollock exemplified American abstract impressionism and to a large extent the new order of modern America. Although Beaton's models were wearing the very latest in uptown spring fashion, it didn't represent the trickle-up, alternative, streetwear-based fashion that was about to shake up the mainstream. Beaton's fascination with Pollock continued; in a 1968 feature for *Vogue Decorating* he urged readers to "think Jackson" and use paint wildly to create a splatter rug on the floor, or use a tiny watering can to splash bed linens in the artist's "action-painting" style.

Pollock's vision and mindset broke new modern territory, and the fashion world still uses his art as a touchstone. His fourth solo

Pollock would buy remnants of commercial cotton duck canvas—usually used for ships or upholstery—to paint on, using, among other things, basting syringes.

Pollock's mother, Stella, sewed clothes when he was young; she would make tailored outfits with "military epaulettes and fancy buttons" for him and his four brothers. The children were known as the best dressed at their school in Tingley, Iowa.

My opinion is that new needs
need new techniques. And the
modern artists have found new
ways and new means of making
their statements. It seems to me
that the modern painter cannot
express this age, the airplane,
the atom bomb, the radio, in the
old forms of the Renaissance or
of any other past culture. Each
age finds its own technique.

—Jackson Pollock, interview with William Wright, 1950

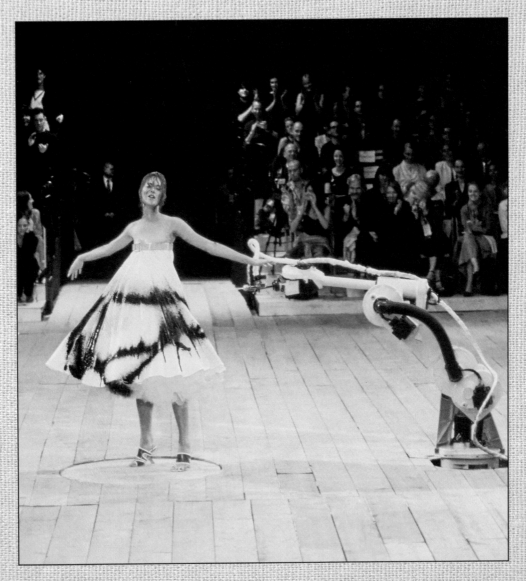

Model Shalom Harlow, wearing a white broderie anglaise dress fastened with a leather belt, was sprayed with paint by robots during the finale of Alexander McQueen's spring 1999 ready-to-wear runway show during London Fashion Week, September 1998. The resulting dress is evocative of a Pollock canvas.

exhibition in 1950, at the Betty Parsons Gallery, was "packed with people from a fashion set . . . eager to catch a view of the notorious painter." In her biography of Pollock, Evelyn Toynton describes him as being "like an exotic animal in the zoo." The painter would continue to stir up the seasonal catwalks, appealing to creatives long after his death in a 1956 automobile crash caused by his drunk driving.

Radical designers gravitate to his nonfigurative style; it works well on a blank silhouette and its message of originality still rings true. Maison Margiela is famous for its seasonless dripped Pollock sneaker, and in his spring 2013 collection Thom Browne showed gray high heels with white paint trickling down their sides. The UK-based Canadian-Turkish designer Erdem Moralioglu said that the swirling beauty of the fabric he used for his fall 2011 collection came from an artistic place, explaining how he was "inspired by the movie *Pollock*. I love the idea of someone tearing a canvas up and wearing it." Moralioglu's

After being declared 4-F—in his case, mentally unfit to serve in the United States Army during World War II—Pollock made a living by painting and printing designs on ties and fabrics. Later he got a job as janitor at the Museum of Non-Objective Art, eventually renamed the Solomon R. Guggenheim Museum for its founder, who was Peggy Guggenheim's uncle.

concept of "the control of the 1950s and the rebellion of the artist going mad" infused his array of delicate, stunning frocks. A few years earlier, in 2006, Belgium's Ann Demeulemeester, one of the original Antwerp 6, showed a refined version of Pollock's painting overalls: flowing white palazzo pants and asymmetrical tied chemise tops in silk finely sprayed with blue dye, echoing Pollock's "action" art. Classic couturiers have also taken to Pollock: while at Dior, Marc Bohan created his own version of a Pollock Dress in 1984—dripping with black jet beading.

SIGNATURE LOOKS **SUITS**

These suit-clad artists demonstrate how self-possessed tailoring doesn't hinder high concepts in the studio. For them, the suit is a uniform. They dress with confidence, a certain imposing strength, and a precise, consistent attention to detail that characterizes their instantly identifiable work, from Piet Mondrian's iconic primary-colored paintings to Jeff Koons's Neo Pop creations—such as his controversial porcelain sculpture of Michael Jackson and his chimpanzee, Bubbles, or his mirror-finished stainless-steel balloon dogs. Creative renaissance man Cecil Beaton was renowned for his photographic portraits of celebrities and the well-to-do; his choice of bespoke suiting was equally top tier.

Cecil Beaton, photographed by Norman Parkinson, 1972.

CECIL BEATON

Cecil Beaton's first visit to the royal tailor Anderson and Sheppard, famed for their loose "American" fit, took place on October 17, 1934. By 1965, at the age of sixty-one, the artful style photographer was still ahead of the curve and impeccably fashionwise, complaining that "Savile Row has got to reorganize itself and, to coin a banal phrase, get with it." Nevertheless, Huntsman, noted for its extremely sharp, stiff tailoring, took an order from Beaton for a three-piece green worsted suit, as detailed in a ledger book from that year. Beaton famously turned his back on English tailoring in the early 1960s but came back to the fold after discovering that the suits he bought in Paris did not compare to the exacting standards found on the "Row." He knew how to shop carefully, noting in his diary: "I spend comparatively little on clothes, an occasional good suit, but most of my suits are made in Hong Kong or Gillingham, Dorset or bought on quaysides during my travels abroad." In 1971, the Victoria and Albert Museum staged an exhibition called *Fashion: An Anthology by Cecil Beaton*, in which he curated a presentation of favorite wardrobe pieces, including a Balmain suit owned by Gertrude Stein and a Courrèges dress belonging to Princess Lee Radziwill.

MAX ERNST

In 1920, Max Ernst created *The Punching Ball or The Immortality of Buonarroti*, a self-portrait montaged with the body of a woman in an off-the-shoulder gown with a head from a medical textbook. In a striped bow tie, suit jacket, and white shirt, he looks like the most suave surrealist and debonair Dadaist you might ever meet. On the outside, he was dashing; on the inside, he suffered from his experiences as a soldier during World War I. Ernst spent his life painting, and cutting, and pasting together the unexpected to expose the illusions of his era. In 1934, he produced a collection of visual novels called *The Week of Kindness*; among the frightening tableaux are a flock of birds wearing suits collaged from Victorian clothes catalogs—a missive to the world about the rise of the Nazi party. His 1922 picture *To the Rendezvous of Friends* includes a self-portrait. As always, he is well dressed in a suit, his white blond hair swept in a boyish crop.

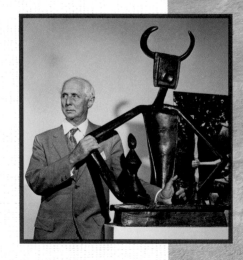

JEFF KOONS

Jeff Koons's uniform of a tailored suit stands in direct contrast to his wavy pop kaleidoscope of artworks. His look is modishly polished, with crisp detailing such as a spruce white shirt or a carefully coordinated color scheme. When he's working a room, he goes for a chic understated minimalism: daywear such as a denim blue linen two-piece suit, matching tie, and navy shirt. His work, on the other hand, spans a showy spectrum, from gilt-edged Michael Jackson statues to Pink Panther sculptures to the forty-three-foot topiary in the form of a West Highland terrier puppy he had installed outside the Guggenheim Museum Bilbao. Koons also explored the fashion-art intersection with Louis Vuitton, appropriating work from old master paintings, including Van Gogh and Rubens, and reimagining them as handbags. Koons has a thing for handbags; he also collaborated on a collection with international fashion chain H&M in 2014. The bags were decorated with images of his celebrated *Balloon Dog*, and at the time of the partnership he was seen wearing indigo suits by the retailer.

Top: Max Ernst at the Museum of Modern Art, New York City, 1961. Bottom: Jeff Koons in front of his *Balloon Dog (Magenta)* at the Palazzo Grassi, Venice, Italy, April 2006.

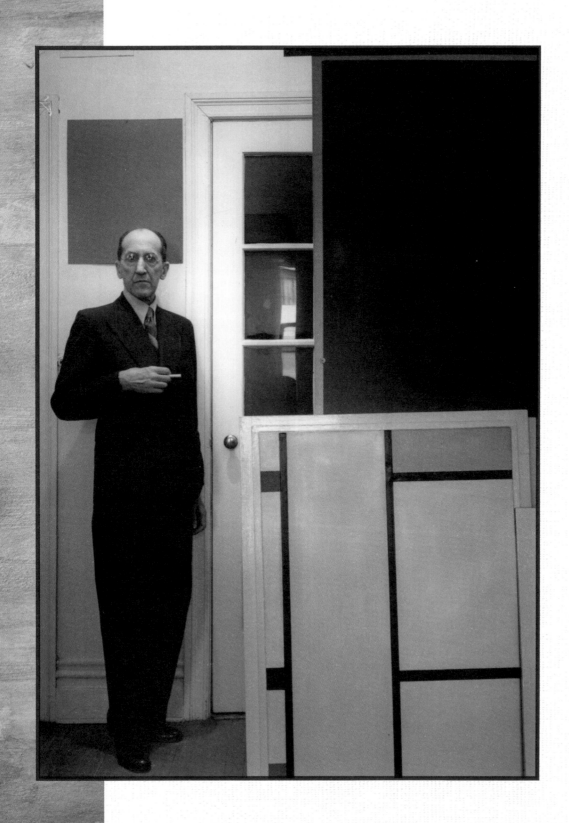

PIET MONDRIAN

From skirts to swimsuits to socks to Yves Saint Laurent's celebrated cocktail dresses from 1965, the Dutch painter Piet Mondrian's pictures from the 1920s and 1930s, with their carefully outlined, primary-colored rectangles and squares, have inspired the fashion world. Mondrian's clearly defined and boldly colored imagery looks good on the blank canvas of a piece of clothing. On his own slim frame, however, Mondrian preferred unadorned suits with single-breasted tailoring and tie. The simplicity of a suit echoes the trim unfussiness of Mondrian's famous *Compositions*, and ultimately it is the artist's clean lines that have captivated elegant designers. Equally minimal were the plain round glasses he wore, and his occasional mustache was trimmed to a modest cube. He may have pared his wardrobe down a little too much now and then. In a 1966 edition of the art journal *Studio International*, the artist Naum Gabo recalls how, after Mondrian moved to London in 1938, Gabo "once called on him in the morning early, and he was wearing an old coat. I found that he didn't have any warm pajamas." As Mondrian had arrived in the country with so few clothes, Gabo's wife, Miriam, took him shopping for "a real smock with gathers at the yoke" to paint in.

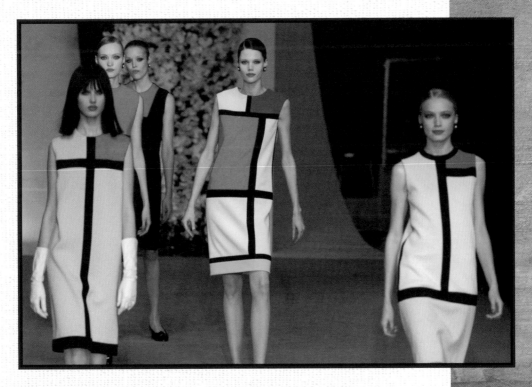

Opposite: Piet Mondrian, New York City, January 1942. Above: Models wearing dresses from Yves Saint Laurent's 1965 Mondrian Collection during the designer's final runway show, Centre Pompidou, Paris, 2002.

HANNAH HÖCH

I should like to help people experience
a richer world so that they may feel more
kindly toward the world we know.

—Hannah Höch, the *New York Times*, 1997

H annah Höch wore her hair in a clipped Louise Brooks bob, and
her wardrobe was a mix of 1920s androgynous "smart-wear":
pinstriped and sailor-collared dresses, woolen skirts, or unisex suiting
worn with floppy bow-ties and simple Peter Pan–collared blouses —
and robust lace-up shoes. In these wardrobe staples she looked
inventive and strong. She kept the same characteristic look until her
death in 1978: a tidy boyish style that expressed a liberated, modern
approach to life but was nonetheless impossibly elegant. Even at the
age of eighty-four, she wore her snow-white hair in a bob with bangs.
There is something reminiscent of Prada about Höch: a sturdy exper-
imentalist who has taken unexpected turns.

Born in 1889 in Gotha, Germany, Höch worked from 1916 to 1926
at the German publisher Ullstein Verlag, where she designed dress
patterns for women's magazines including *Die Dame*. She was fully up
to date with the world of women's media during the Weimar Republic
era. While primarily known for her photomontage work, she wrote

Opposite:
Hannah Höch,
Self Portrait,
1930.

Embroidery is very closely related
to painting. It is constantly
changing with every new style
each epoch brings. It is an art
and ought to be treated like
one. . . . You, craftswomen,
modern women, who feel that your
spirit is in your work, who are
determined to lay claim to your
rights (economic and moral),
who believe your feet are firmly
planted in reality, at least Y-O-U
should know that your embroidery
work is a documentation of your
own era.

—Hannah Höch, *Embroidery and Lace*, 1918

a *Manifesto of Modern Embroidery* in 1918 and saw the unique value of the craft in a creative world dominated at the time by men. Women's creativity need not, she felt, be a reduced or shabbier kind of endeavor. Inspired by an originator of Dadaism, Hugo Ball, Höch later went on to make Dada dolls dressed in Cubist costumes, resembling what Ball might wear to the Cabaret Voltaire nightclub in Zurich, a hotbed of Dada activity. Höch was attracted to the Dadaist manifesto that aimed "to remind the world that there are people of independent minds—beyond war and nationalism—who live for different ideals."

Höch herself lived for different ideals. She was one of the few female artists connected to the Dadaists, but her legacy has been overshadowed by male artists such as George Grosz and John Heartfield. Despite their radical stance, they undermined her and tried to oust her work from the First International Dada Fair, held in Berlin in 1920, simply because she was a woman. Another of their ilk, Hans Richter, said that her contribution to the movement was her ability, despite a lack of funds, to "conjure up beer and coffee" when required. Despite their intentions, Höch's influential photomontage *Cut With the Dada Kitchen Knife Through the Last Weimar Beer-Belly Cultural Epoch of Germany* went on display and became one of the exhibition's standout pieces. Magazine pages and advertisements are artfully collaged on the canvas, in spaces labeled "Dada" and "Anti-Dada." The title of the piece references how Höch navigated gender issues in the years after the World War I—a theme she explored over and over.

Höch deliberately signed her name H.H., which when spoken in German sounds like *ha ha*—a witty nod to her Dada experience.

Höch's art was considered "degenerate" by the Nazis during the Third Reich, and she took refuge in a cottage at Heiligensee, near Berlin. In the garden there she buried the work of her artist friends from the Dada days to protect their legacy.

Höch didn't conform. Her confident and clearly defined style of dress reflects a sure sense of purpose; she was, she admits, "self-certain." Quietly and unflagrantly, she had affairs. For a time she was married to the much younger businessman Kurt Matthies, and she had a nine-year relationship with a woman, the Dutch writer

Mathilda Brugman. Although she was private in her personal life, Höch's work examines how the world defined men and women. She shows a satirical alternate masculinity in the montages *Da Dandy* and *The Strong Men*—images compiled from women's weekly magazines—and she appraised the notion of self in her work *The Gymnastics Teacher*, which depicted a thin, fashionable young woman with modish bobbed hair juxtaposed with a large, apron-clad fräulein. She used familiar images for effect, explaining "that the image impact of an article—for example, a gentleman's collar—could produce a stronger impression if a photograph of one of them were taken, cut out, and ten such cut-out collars were just laid on a table and a photograph made of them."

In 1920, Höch wrote a short story, "The Painter," about a modern, forward-thinking couple whose relationship breaks down when the man is asked to wash the dinner plates four times a year; this, he says, is "an enslavement of his spirit." It's a tale based on her life with an early lover, the artist Raoul Hausmann.

One of Höch's most famous collages, *The Fashion Show* (1925–35), is alive with the possibilities of how we see women in fashion and contemporary culture. The Canadian-born, UK-based designer Edeline Lee was inspired by Höch to create her 2017 catwalk collection. Lee explained the appeal of the artist's era to current fashion, "This was post–World War I—a very nervous period, not so different from today. We have a strong idea of what a 'lady' was supposed to look like in the past, but how should a capable, independent woman dress today, pertaining to her grace and dignity, yet still be comfortable?" Höch was very in tune with such questions.

The bombardment of new media and the expectations of modernism shaped her art and molded her wardrobe, in ways very much like young designers experience today.

MARCEL DUCHAMP

I didn't create Punk alone or out of nothing.
Duchamp chose a urinal. I chose Johnny Rotten.

—Malcolm McClaren, the *Times (London)*, 2009

O f all artists, Marcel Duchamp may have most profoundly inspired fashion. He spent his career analyzing the world around him, constantly expressing himself in varied ways. After his modernist painting *Nude Descending a Staircase, No. 2* (1912) made him famous and caused a sensation, he began experimenting with a new creative approach, the "readymade"—a name Duchamp invented. A method of choosing commonplace objects and turning them into art, this process enabled him to scour for inspiration in every unexpected nook and cranny. Beginning with his famous *Fountain* urinal in 1917, he went on to explore the validity of bottle racks, bird-cages containing marble blocks, a miniature French window, and, of course, a bicycle wheel as expressions of artistic intent. This Dadaist take envisioned the world with satirical irony.

It's hard to avoid seeing parallels in the collections of Georgian designer Demna Gvaslia. In 2017, he declared that his label, Vetements, would only produce clothes "as a surprise" when he felt like it and dipped out of the seasonal catwalk system. Exploiting the appeal of

Opposite:
Marcel Duchamp,
New York City,
February 1927.

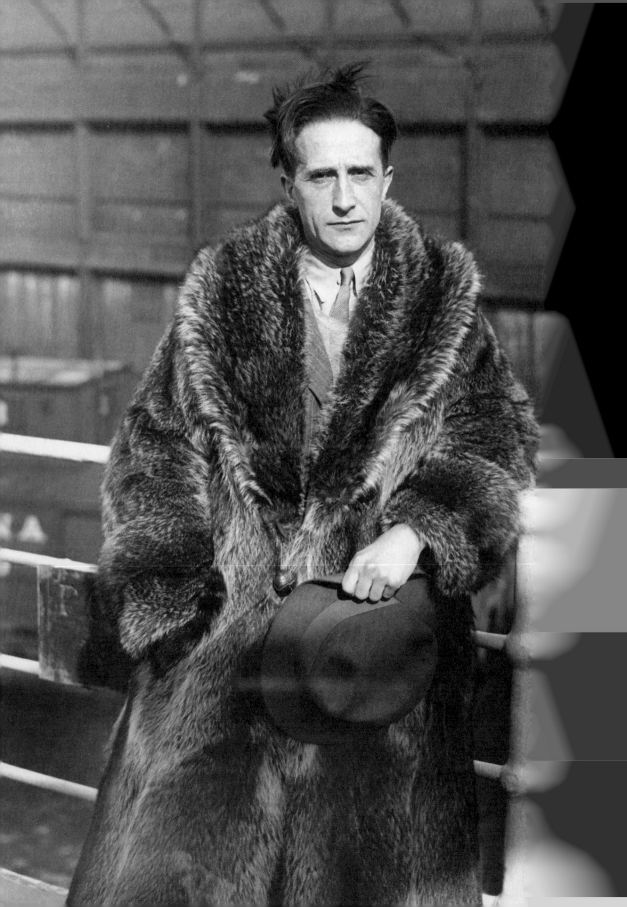

the unexpected, he has shown nonsensically outsized hoodies that look impossible to wear, as well as bright yellow T-shirts branded DHL (the transport company) that cost over $200; all have been instant hits. Jeremy Scott at Moschino has similar affinities, creating clothes with McDonald's fast-food logos and Happy Meal handbags that have the finish of couture.

The unanticipated makes waves in fashion, and Duchamp showed the way. Humor and contemplation are at the heart of what he did: putting facial hair on da Vinci's *Mona Lisa* in 1919 in his *L.H.H.O.Q.* piece is akin to Gvaslia reinterpreting the old masters of fashion as creative director at Balenciaga. Marc Jacobs has said that Duchamp's *Mona Lisa* is his favorite artwork. For a show backdrop in 2014, Karl Lagerfeld took a leaf out of Duchamp's book, decorating a lavatory door with a cartoon of Coco Chanel and calling it *Door II*.

Duchamp's own look was that of a dandy. He wore a raccoon fur coat in 1917, at the time the very pinnacle of fashion statements for the flamboyant, although on a day-to-day basis he preferred a smart white shirt and tie. He explored contradiction and identity in his art: In 1921, he debuted his female alter ego Rrose Sélavy—a pun that in French sounds like *Eros, c'est la vie*. Man Ray, Duchamp's friend and partner in art-pranking, photographed "Rrose" for a readymade that was based on a perfume bottle created in 1915 by Rigaud for its scent Un Air Embaumé. Duchamp's scent was called Belle Haleine, Eau de Voilette (Beautiful Breath, Veil Water); the label with Man Ray's image showed him dressed in a hat, frock, and sultry eye makeup. (The bottle became part of Yves Saint Laurent and Pierre Bergé's art collection in the 1990s before being sold.) Sélavy made a number of appearances, for example, as a mannequin wearing a man's hat, jacket and tie at the 1938 Surrealism Exhibition in Paris. The piece was titled *Rrose Sélavy in one of her provocative and androgynous moods*, with initials RS doodled on the naked crotch.

Things that are not what they seem is an enduring motif in fashion as it was for Duchamp during his lifetime. Dada confronted society's comfort zones, and we can see designers who challenge stereotypical norms of beauty as following this creative line. Originators such as

I don't care about the
word "art" because it's
been so discredited.
There is an unnecessary
adoration of art today.
But I've been in it and
want to get rid of it.
I can't explain every-
thing that I do.

—Marcel Duchamp, BBC Television interview, 1968

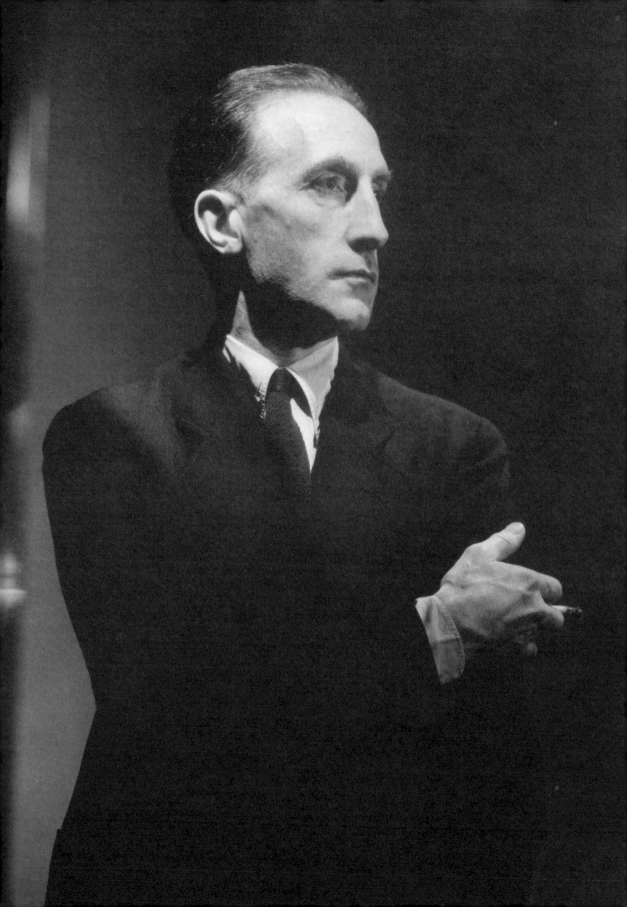

Margiela, Bless, and Comme des Garçons have sought to recalibrate the potential of a clothing label, gently moving the goalposts of consumption. The awkwardness of a white-painted canvas sneaker that cracks with each step makes this Margiela design a classic. The design duo Bless in 1997 created wigs out of old fur coats for the house; it didn't look at all like proper hair. Ann Demeulemeester delivered Duchamp's message unequivocally when she soundtracked the beginning of her 2008 autumn/winter catwalk show with a recording of an interview with the artist in which he "talked about the durability of the nonconformist spirit," wrote Tim Blanks on Vogue.com.

Duchamp himself said in 1957, "The creative act is not performed by the artist alone; the spectator brings the work in contact with the external world by deciphering and interpreting its inner qualifications and thus adds his contribution to the creative act." The act of putting on a piece of designer clothing makes fashion multidimensional, and when the clothing in question is innovative, then predictability in other forms is tested in small ways, too. Duchamp wanted his work to please the brain and not just the eye, explaining, "I was interested in ideas—not merely visual products. I wanted to put painting once again at the service of the mind." The crossover of fashion and art is simply about developing ideas and trying new things.

In 2012, designer Hussein Chalayan and artist Gavin Turk produced "4-minute mile," a musical track inspired by Duchamp's spiraling Rotary sculptures from 1925, on which Turk's conversation about art with Chalayan is recorded. The project defied expectations, and Duchamp would have approved. In 2017, Virgil Abloh commemorated the hundred-year anniversary of *Urinal* with an Off-White hoodie signed R. Mutt, duplicating the inscription on Duchamp's original readymade. At the other end of the spectrum, Philip Colbert of the Rodnik Band made a literal urinal dress—three-dimensional and covered in sequins—for his 2011 collection. Colbert exclaimed, "A model wore that dress on the red carpet. It just created a sense of shock—people were just like 'oh my god, she's wearing a toilet dress.'"

Opposite: Duchamp, photographed by Lusha Nelson for *Vanity Fair*, 1934.

133

NIKI DE SAINT PHALLE

Most people don't see the edginess
in my work. They think it's all
fantasy and whimsy.

—Niki de Saint Phalle, the *Los Angeles Times* online, 1998

Born in Neuilly, France, in 1930, but raised in New York, Niki de Saint Phalle was featured on the cover of *Life* in 1949 and described in its pages as "a blonde young lady that combines American endurance and French chic." The article notes that she is careful with her wardrobe and goes on to report that "to conserve closet space and her allowance, she likes double-purpose clothes" such as the outfit she is wearing—a "white silk taffeta [skirt] whose separate top for full dress evenings costs $19.95." Then a nineteen-year-old post-debutante and model, Saint Phalle would grow up to become a leading feminist artist, described by the *New York Times* after her death in 2002 as "a heroine to feminism before the movement even emerged."

De Saint Phalle was indubitably chic. Her style reportedly inspired Yves Saint Laurent's 1966 Le Smoking tuxedo suit, which caused a stir in Paris—some deemed it inappropriate for ladies to wear trousers to dinner, but evidently Saint Laurent loved the way Saint Phalle wore men's suits with high heels. Possibly he loved her defiant attitude, too; in any case, it all translated into one of his most enduring silhouettes.

Opposite:
De Saint Phalle
among her
Nana sculptures,
photographed
by Bert Stern
for *Vogue*,
April 1968.

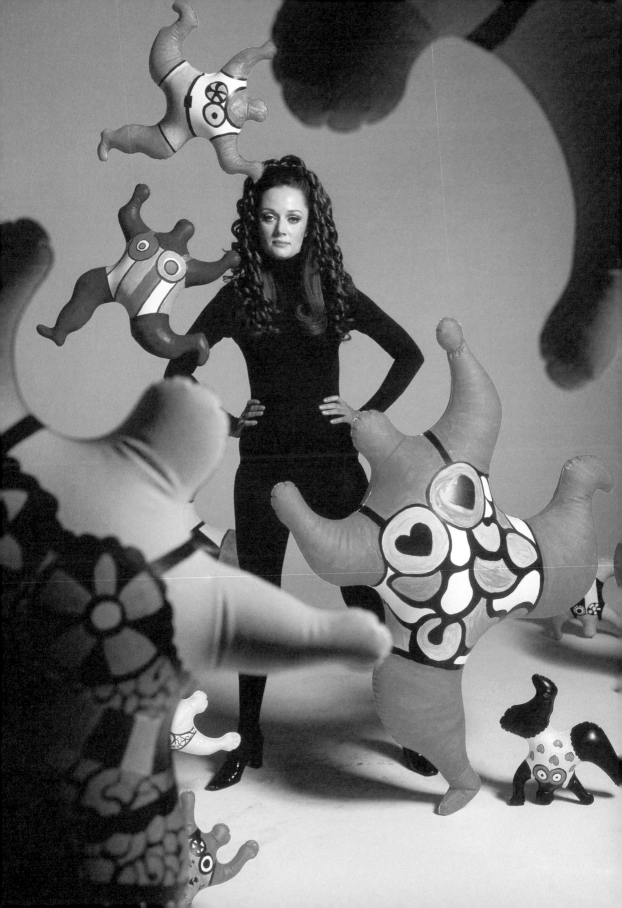

In the February 1950 *Vogue*, Saint Phalle appeared in a beige crepe de chine shirt alongside the announcement of her marriage at age eighteen to the writer Harry Matthews. They lived like bohemians for a while, moving around Europe, then in the mid-1950s they settled in Paris, occupying one of the famed half-derelict studios in Montparnasse's Impasse Ronsin. In 1956, however, she met the Swiss kinetic artist Jean Tinguely, and they began to collaborate on artwork. She left Matthews and moved in with Tinguely in 1960 and continued her avant-garde adventure. She started making her *Tirs* (gunshot) paintings in February 1961, at first shooting an ex-lover's shirt and then moving on to plaster molds embedded with paint and collaged with kitchen utensils, doll's arms, and razors, among other found objects. She would fire a .22-caliber rifle at them, and they would explode with color and ferocity. These performance pieces made Phalle an art-world phenomenon. She wore a white jumpsuit and black boots while taking aim and was often joined by fellow artists, including Jasper Johns and Robert Rauschenberg. She appeared strong, terrifying, and tough, with a panache and intensity few could compete with. In a posthumous 2016 *New Yorker* article, she was quoted: "Performance art did not yet exist, but this was a performance. Here I was, an attractive girl (if I had been ugly, they would have said I had a complex and not paid any attention), screaming against men in my interviews and shooting."

Jane Fonda appeared at one of Saint Phalle's famous *Tirs* shooting performances in Malibu in 1962; Robert Rauschenberg bought one of the paintings.

In 1969 Le Grand Palais filmed an interview with Saint Phalle, in which she said, "Women could administrate this world much better [than men]. Black power and women power: if they get together and take over everything. That's the solution. A new world of joy." This radical spirit attracted designer Maria Grazia Chiuri, the first female artistic director at the legendary fashion house of Dior, who described Saint Phalle after Dior's spring 2018 show, as a "very revolutionary woman, really inspiring, and really strong in herself." Chiuri's collection synchronized Saint Phalle's personal style and her art: the artist's famous veiled berets were reimagined by milliner Stephen Jones and

I never know what is next.
I change things as I go
along. Nothing is really
predictable. There was no
preconceived plan.

—Niki de Saint Phalle, *Vogue*, 1987

Designer Julie de Libran's autumn 2017 ready-to-wear collection for Sonia Rykiel was inspired by Niki de Saint Phalle's *Nana* sculptures. Here is a photograph from the runway presentation during Paris Fashion Week, March 2017.

worn by models in dresses and skirts that were decorated with Saint Phalle's trademark swirling serpents, tarot card characters, cartoonish colors, and swirls. The cover of her autobiography, *Traces*, was emblazoned on luxe T-shirts. The show laid bare Saint Phalle's essence, but it wasn't the first time that the house of Dior had fallen in love with her. A 1971 *Vogue* spread showcases the French country residence of Marc Bohan, near Fontainebleau. Bohan led Dior in 1960, and throughout his home were Saint Phalle works in lithograph, crayon, and watercolor, as well as a gigantic green-and-black *Nana* figure in the dining room. Bohan said, "Niki is a neighbor, a great artist, and a great friend." Chiuri discovered the connection when researching her Saint Phalle–inspired collection, saying, "I found this picture with Niki de Saint Phalle on top of a camel, and also a letter that she wrote to Mr. Marc Bohan, where she said, 'Thank you for the outfit that you did for me.'"

Other designers, too, are drawn to Saint Phalle. David Koma, a graduate of Central Saint Martins whose work has been worn by Lady Gaga, created a collection in 2009 fueled by the curvaceous lines of Saint Phalle's colossal *Nana*s, colorful sculptures of animals and humans she began making in 1964. The most famous was *Hon*, made in 1966 with the help of Tinguely: a temporary installation at the Moderna Museet in Stockholm. The open legs of the massive figure (its full title was *Hon-en-Katedrall*, [She-a-Cathedral in Swedish]) served as a visitors' entrance to the exhibition for which it was created.

The aesthetic of the *Nana*s would influence Saint Phalle's later Tarot Garden in Tuscany, a sculpture park she would call her life's work. She took on commercial ventures to power her art projects, such as a perfume she created in the 1980s—the bottle, a blue cube; the stopper, two entwined serpents—and miniature inflatable *Nana* swimming pool accessories produced in the 1970s and sold at Bloomingdale's in various sizes. She couldn't stop herself from creating by any means necessary, explaining, "I'm not someone who can change society except for showing some kind of vision of these happy, joyous, domineering women. That's all that I can do."

WILLIAM MERRITT CHASE

I think that Chase as a personality
encouraged individuality and gave a sense
of style and freedom to his students.

—Georgia O'Keeffe, in *A Private Friendship Part 1: "Walking to the Sun Prairie Land,"* by Nancy Hopkins Reily, 2014

William Merritt Chase, born in 1849 in Indiana into a "poor but proud" family, went on to become the very model of a suited and booted dandy. As a young man, he sold shoes at his father's shop to Victorian ladies in Indianapolis and was an excellent salesman; later he confessed that he always sold a size too small so customers would come back sooner.

Chase became a celebrated and famous society painter who walked his wolfhound around Greenwich Village. In 1879 he moved to a huge and handsome space in the Tenth Street Studio Building, a designated space for artists in New York, which he filled with intriguing objects that included a stuffed swan and flamingo, African and Japanese masks, tapestries, and Venetian drapes. This splendid space was inspired by his travels to Munich in 1872, where he spent time at the Royal Academy of Fine Arts, honing his skills and picking up the habits of European artists, whose ateliers were creative expressions of themselves. His studio became an extension of all the qualities he embraced and espoused; it was a rich and luxurious environment in which to work.

Opposite:
William Merritt
Chase, 1900.

140

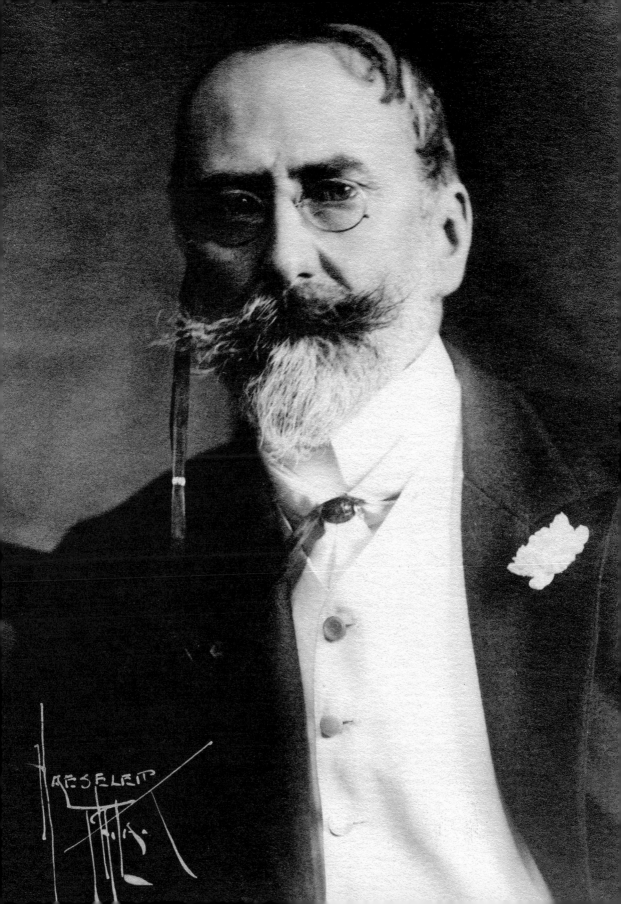

At Tenth Street, Chase would receive guests, hold parties, and perform tableaux vivants, for which he would don fancy dress such as "velvet breeches and frilled collars." While painting he wore a white flannel suit; when he went out on the town, he dressed flawlessly in a top hat and shoes with spats, a pince-nez hung around his neck with a black silk ribbon. John Singer Sargent painted him in 1903 wearing white tie and tails, holding a paintbrush and palette, and flourishing his immaculately groomed handlebar mustache. *Self-Portrait in 4th Avenue Studio* (1915), created just before he died at the age of sixty-seven, shows Chase characteristically elegant in a brown, velvet-collared smoking jacket thrown over a formal black suit, facial hair and monocle in place, his distinctive panache captured in time. Chase fashioned a discerning persona and painted himself the way he wanted the world to remember him.

As far as women's clothes were concerned, Chase had an expert eye, and his portraits of American society women wearing the latest fashions are renowned. Unusual for the time, many of his models

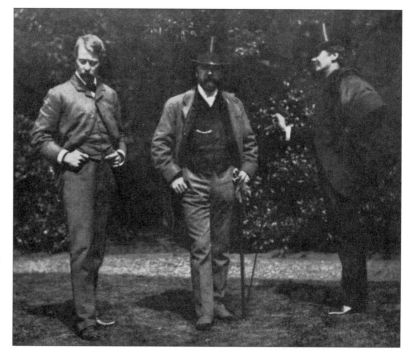

From left: Artists and friends Mortimer Luddington Menpes, William Merritt Chase, and James McNeill Whistler. This image is from Menpes's book, *Whistler As I Knew Him* (1904).

Do not imagine that I would disregard that thing that lies beneath the mask . . . but be sure that when the outside is rightly seen, the thing that lies under the surface will be found upon your canvas.

—William Merritt Chase, from *American Iconology: New Approaches to Nineteenth-Century Art and Literature* by David C. Miller, 1995

William Merritt Chase, *Self-Portrait in 4th Avenue Studio*, 1915.

affected strong, liberated poses in his progressive compositions; the irony was that while holding these poses they routinely wore ornate and severely restricted clothing. Such garb was de rigueur for a rich man's wife, as Edith Wharton documents in her novels of the period. Chase, however, was drawn to assertive women who were beginning to break the traditional feminine mold. *Portrait of Lady in Pink* (1888) is an image of Mariette Leslie Cotton, a pupil of Chase who would become an internationally acclaimed artist herself. She was part of a new wave of American women who were making their lives their own. In Chase's portrait she wears a satin and tulle evening gown adorned with ribbons and bows; the dress is corseted but her posture and expression are not. The painting also reflects the remarkable handiwork of the couture gown.

Chase founded the Chase School of Art in 1896 in New York; it would go on to become the Parsons School of Design, which counts Tom Ford, Marc Jacobs, and Donna Karan among its alumni.

Among Chase's students was Georgia O'Keeffe, who said, "There was something fresh and energetic and fierce and exacting about him that made him fun." He also taught Edward Hopper, who mentioned this fact on his business cards.

Analyzing Chase's work offers insight into the contents of the highest-end wardrobes of the late nineteenth to early twentieth century. His 1879 portrait of Harriet Hubbard Ayer shows her wearing a black dress by Frederick Worth; its lace sleeves and gauzy trumpet cuffs call to mind Karl Lagerfeld's Métiers d'Art collections for Chanel, which showcase the craftsmanship and beauty of specialist textiles and embroidery artisans. A moneyed socialite who didn't need to work, Ayer became a pioneering businesswoman who launched the first cosmetics company in America in 1886, and later a successful journalist. *Ready for the Ride* (1877) is painted in the style of an old master but includes a modern twist; his model is about to go horseback riding and is pulling on a pair of soft yellow leather gloves. Her outfit is elegant but unfussy, designed for a strenuous side-saddle gallop. And although the elaborate formalities of nineteenth-century womenswear are clearly defined, the subject's direct stare is confident and unapologetic, signaling a new era on the horizon.

SIGNATURE LOOKS **HATS**

The signature hats these artists wear are evocative expressions of their approach to their work. Joseph Beuys's art bridged mediums, from installations to sculpture created from everyday items infused with a social message. His felt fedora was part of that unswerving narrative. The formality of Magritte's bowler hat is a nod to the humor and surrealism of his paintings, while Bruce Nauman's cowboy hat is suggestive of the fearlessness with which he approaches his ground-breaking, highly influential work. Grayson Perry, known best for his ceramics and for challenging social and political norms, often dresses for public events as his alter ego, Claire, usually sporting a bonnet to top off his controversial look.

JOSEPH BEUYS

The German artist Joseph Beuys was nick-named "the man with the hat" in his home country because he was never seen without the cherished felt trilby he bought from the world's oldest hatters, Lock & Co., founded in London in 1676. Whenever he was asked for an autograph, he'd invariably scribble his name and a silhouette of the favorite headwear, which he usually wore in gray, khaki, or shades of black. Although he worked in a range of media, he reportedly said that "The hat could do it on its own." Along with the trilby, his wardrobe of long, heavy coats, fur collars, hefty boots, sleeveless utility jackets, and felt suiting were renowned. Throw in his movie-star cheekbones, boyishness, and furrowed intensity, and it's no wonder the fashion world succumbed to Beuys's charm. Rick Owens's autumn 2015 collection evokes the artist's 1974 performance *I Like America and America Likes Me*, in which Beuys was wrapped in felt and then confined for three days in a gallery with a live coyote. Owens freely admits his "fascination" with Beuys, saying, "I've worked so hard on establishing a gray, soft, Joseph Beuys cocoon." The Belgian design team A.F. Vandervorst has used Beuys as a muse from the start: in 2012, they showed him reimagined as a girl on their womenswear catwalk, wearing Stephen Jones trilby hats and rabbit-fur scarves. The show echoed *Beuys's Felt Suit 1970*—an edition of one hundred replicas of his own suits but made from pressed pelts.

BRUCE NAUMAN

Bruce Nauman likes his personal space undisturbed. An artist who works in a broad range of media, he lives with his wife, painter Susan Rothenberg, far away from it all on seven hundred acres in a town near Galisteo, New Mexico, where designer Tom Ford built a huge ranch. It's a world away from the dinner Missoni gave in his honor on the super-deluxe yacht *Timoteo* during the 2009 Venice Biennale, where fashion industry leaders such as Carine Roitfeld and Renzo Rosso partied the night away. They were celebrating Nauman's Golden Lion win for best national pavilion of the Biennale: his *Topological Gardens* assembled a retrospective of the artist's work including the neon sign *Vices and Virtues* (1983) as well as two sound installations, *Days* and *Giorni*. The new and different is Nauman's terrain; his art challenges stylistically. His hats, though, are a constant. He wears an unfussy Stetson bought from Nudie's Rodeo Tailors— outfitters to the stars, including John Wayne and Elvis Presley. In 1990, he made a disquieting video installation called *Shit in Your Hat—Head on a Chair*, in which an androgynous mime calmly repeats a series of orders: "Sit on your hat, your hands on your head. Shit in your hat."

Opposite: Joseph Beuys, June 1982. Above: Bruce Nauman, New Mexico, June 1983. Portrait by François Le Diascorn.

GRAYSON PERRY

Grayson Perry likes a sweet hat, preferably a bonnet made from bows, flowers, lace, satin, and ribbons. It's something you might wear if you're into the Japanese Lolita subculture—a look that's overly cute and girly, generally made in pastel shades of pink, mauve, and aqua blue with a little Victoriana detailing thrown into the mix. Perry wears such hats when dressed as his alter ego, Claire. In this incarnation, Perry has been honing his sartorial skills for years; he borrowed a dress from his sister when he was ten and went out in public at fifteen wearing a wig and tennis shoes. Today, his fetish is out and loud; in 2005, he even reported on the Chanel couture fashion show for *Spoon* magazine dressed as Claire. In 2017, the Walker Gallery in Liverpool staged an exhibition called *Making Himself Claire: Grayson Perry's Dresses*, which displayed twelve of his favorite outfits and bonnets—some designed by himself and others by students at Central Saint Martins in London. His headwear is not just decorative or crowd-pleasing, though. He revealed in an interview in 2005 that he is becoming slightly deaf, and "there's nothing I can really do about it except continue wearing bonnets and hearing aids. At least the bonnets are pretty!" In 2014, when he was awarded the MBE and presented to Queen Elizabeth at Buckingham Palace, he opted for a more conservative wide-brimmed and ostrich-trimmed "mother of the bride" hat instead of the usual Bo-Peep style.

Above: Grayson Perry at the annual Serpentine Summer Party, Serpentine Gallery, London, June 2011. Opposite: René Magritte with his painting *Le Barbare (The Barbarian)*, 1938.

RENÉ MAGRITTE

René Magritte's *Son of Man* (1964) is one of the most famous and widely recognized paintings the surrealist artist ever made. The man wearing a bowler hat, red tie, and overcoat, his face hidden by a green apple, is, of course, Magritte himself. There was no mistaking his silhouette: the artist forever wore a bowler hat and used it as a motif in many paintings. In *Man in Bowler Hat* from that same year, the face is obscured by a white bird; in a 1955 image, *The Mysteries of the Horizon*, three men in bowlers stand beneath three crescent moons. The bourgeois headwear and the artist's grasp of the absurd seemed to go together perfectly. Magritte's metaphors are often honed through clothing: *The Red Model* (1934) shows a pair of boots that morph into bare feet—cleverly reimagined in Comme des Garçons's 2009 collection, which included shoes with trompe l'oeil feet. Opening Ceremony's 2014 *Ceci ne-pas un Shirt* collection featured his visuals on skirts, dresses, bomber jackets, T-shirts, and sweaters. In 2016, accessory designer Olympia Le-Tan made silk-embroidered handbags depicting famous Magritte works, including the painted woman's eye in *Objet Peint: Oeil*. Magritte himself was a fastidious dresser, always dapper in suiting, shirt, tie, and scarf. He was involved in the fashion world, too; while working as a commercial artist, he produced imagery for Brussels-based couture house Norine as well as a catalogue in collaboration with poet Paul Nougé for Maison Samuel's 1928 fur collection. The latter is regarded as a classic example of an innovative fusion of graphic art and high style.

CINDY SHERMAN

I think my work has often been about how
women are portrayed in the media, and of
course you don't actually see that many
portraits of older women or old women in
fashion and film. So that's part of it.

—Cindy Sherman, the *Guardian*, July 2016

The fashion world adores Cindy Sherman. Designer stores call
her when they get something in that might cater to her "extrava-
gant tastes." Raf Simons says she is an influence and hung a large work
by her on the wall of his New York office. The artist sat front row at
Simons's debut Calvin Klein catwalk show in 2017, and he repaid the
favor by dressing her in his exclusive Calvin Klein By Appointment
collection for the annual benefit gala at the Metropolitan Museum of
Art a few months later. At the fashion world's most exclusive party, she
was the epitome of uptown edgy chic in a floral two-piece trouser suit
and heels. Sherman attended in company with Simons's clique of sup-
porters, including rapper ASAP Rocky and actress Gwyneth Paltrow.
A member of fashion-and-art's royal family, she designed a bag for Louis
Vuitton in 2008 that sold quickly and is now a collector's item. In 2011,
she collaborated with MAC Cosmetics to create a selection of makeup
including lipsticks called "Flesh-Pot Pale" and "Ash Violet."

Opposite:
Cindy Sherman,
Paris Fashion
Week, March
2014.

Sherman, born in New Jersey in 1954, has spent her life as an artist trying on clothes and morphing her looks with outrageous makeup, so it's natural that her universe and fashion's should convene. An artist who explores identity, she believes her compulsion to dress up stems from a childhood where she needed to remind her parents she was there—she was the youngest of five children. Yet there is no nervous ambiguity about Sherman's personal style. She has worked and associated with fashion designers for more than thirty years, beginning with a series of images she made for *Interview* in 1983, in which she wore Issey Miyake, Comme des Garçons, and Jean-Paul Gaultier pieces from Dianne Benson's boutique. The idea was to spotlight the expectations of the fashion world. Sherman was captivated by the outfits, saying in a 2016 *Harper's Bazaar* interview: "It was the weirdest stuff, especially the Comme. I was like, 'This looks like bag lady clothes'—holes in it, ripped up, pirate-y. Kind of ugly, *jolie laide*. I was fascinated by that." Ten years later, in spring 1993, she was commissioned by *Harper's Bazaar* to create a selection of self-portraits called "The Cindy Sherman Collection." For this assignment she wore new-season outfits, including a patchwork ensemble by Dolce & Gabbana, and an evening frock by Vivienne Westwood; in one image she sported a pair of underwear on her head.

Molly Ringwald starred in Sherman's 1997 horror film *Office Killer*, about a copyeditor who turns into a mass murderer after accidently killing a colleague.

Sherman maintains that her ideal epitaph would be: "She finally found the perfect outfit."

These days Sherman counts Narciso Rodriguez as a personal friend; in a *Harper's Bazaar* interview with Cathy Horyn, the designer commented that "it's easy to talk to her about fashion, she knows so much." For an artist who is intent on portraying the dilemma of image, confidence in her own look doesn't seem to be a problem. Despite reservations about art being used as a "cool accessory" for the fashion pack, she is able to get right on board with elite labels and pick and choose what works for her. The first Parisian piece she ever bought, back in the 1980s, was a Jean-Paul Gaultier suit. But finding equilibrium in her personal identity has taken time. As Sherman said

When I was a kid—maybe ten years old—
because I had a suitcase of old clothes,
old prom dresses and things like that,
I would play dress-up. Plus, I discovered
some of my grandmother's clothes somewhere
in the basement—she had died years before,
or maybe it was even my great-grandmother
because they were really old clothes, from
the turn of the century. I put them on,
and I turned into this old woman. I have
a photo somewhere. My girlfriend and I
would turn into little old ladies, and
we'd walk around our neighborhood dressed
like this. But then I discovered that
while all my girlfriends were turning
themselves into ballerinas and princesses,
I was more interested in turning into
monsters or witches—ugly things.

—Cindy Sherman, *System*, 2014

Cindy Sherman with designers Azzedine Alaïa (center) and Nicolas Ghesquière of Louis Vuitton,
Paris Fashion Week, March 2014.

I don't think I can see the world through
other people's eyes, but I can capture
an attitude or a look that makes others
think I can. I have an appreciation for
why people choose to look the way they do.
But I can't know what they experience.

—Cindy Sherman, *Interview*, November 2008

in a 2016 interview with the *Observer* (UK), "I think it took me a very long time to figure out who I am, what my needs were, and for a long time my characters were to ask those same questions: maybe this is who I want to be?"

Sherman understands the complexities of innovative style. She was a fan of the amazing—but slightly awkward and tricky to wear— label Marni, when it was helmed by its founder, Consuela Castiglioni. You had to be confident to wear the collections Castiglioni designed before she left in 2016, which featured geometric shapes and prints, dusty colors, and difficult silhouettes. The intelligentsia loved them. Sherman's idea of fun is "going to Marni and having four big shopping bags delivered the next day." Labels of choice also include Prada, Stella McCartney, and Jil Sander—clothes for the thinking woman.

And Sherman most definitely thinks about fashion. In a 1994 *New York Times* interview, she said, "The way that fashion imagery in the industry has already directed our way of thinking so that we assume anyone who wears those clothes has to be thin or beautiful isn't anything like reality anyway." Her editorial work for *Harper's Bazaar* in the current century includes "Project Twirl," for which Sherman dressed up as a street-stylish blogger and wore clothes by Chanel and Miu Miu. She satirized the social media catwalk of Instagram but also revealed how much she enjoyed the clothes. Marc Jacobs's boots were "amazing," and she loved the green Gucci suit from the shoot, which was "so out there that it's something I'd consider wearing. . . . There was a snake on the back that was really cool."

ROBERT RAUSCHENBERG

Screwing things up is a virtue . . .
being correct is never the point.

—Robert Rauschenberg, in the "Secret of My Excess" by Michael Kimmelman, the *Guardian*, 2000

Robert Rauschenberg came from a humble home in Port Arthur, Texas, born in 1925 to fundamentalist Christians who went to church twice on Sundays. His mother, Dora, used to make clothes for Milton, as he was then known (he changed his name to Bob in 1947 and then Robert later), out of odd bits of cloth. He had no encouragement to become an artist, yet upon his death in 2008 he was described as "the grandfather of modern art." He documented the American cultural landscape, showing how media and consumption were changing life. Fast-paced information exchange due to technological advances, along with cheaper imported goods, fed into globalization and shifted sensibilities, and Rauschenberg altered his art techniques—painting, collaging, silk-screening, and sculpting—to describe the panorama of what he saw. His life and work both mirrored the world around him. His famous series of "combines" featured old socks, sneakers, ties, and worn-out clothes strewn alongside comic strips, advertising, and even a stuffed goat—anything he could forage, it seemed. He considered himself a reporter.

Opposite:
Robert
Rauschenberg,
1975.

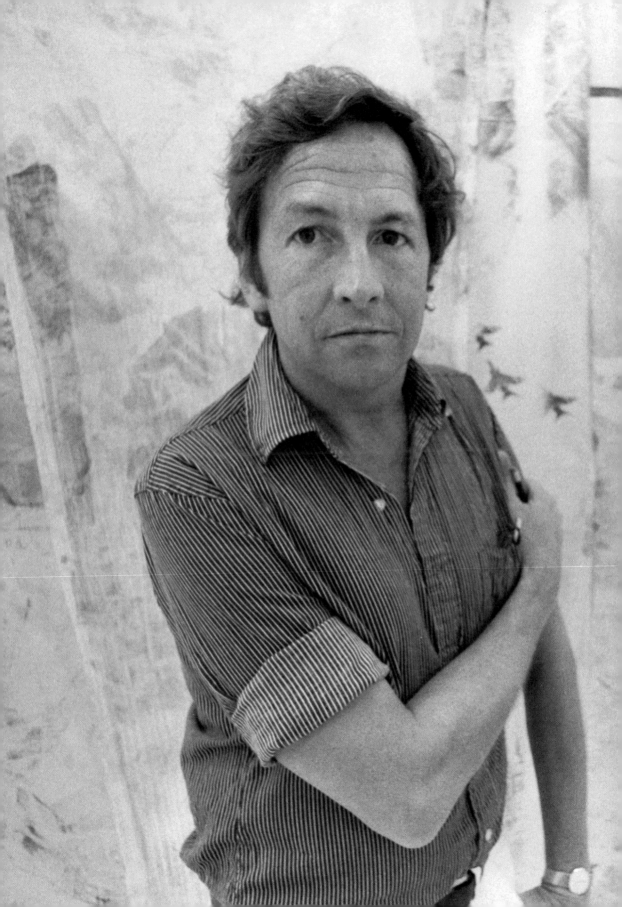

Rauschenberg's own clothes spoke the language of American fashion. In an October 1965 *Vogue* interview, Lawrence Alloway observed, "Rauschenberg seems most at ease in casuals of the classic American vernacular, which have influenced the world (through Western movies and the US Army): pants—often chinos on the hip, T-shirt or workshirt, wristwatch, sneakers. When he puts on a suit, its reserve is a kind of personal statement in homeliness, and not, as with Ivy League clothes, a uniform professing restraint." He also looked good in and wore denim in a variety of ways, most charmingly as cutoff shorts; snakeskin cowboy boots and polo-neck sweaters paired with casual blazers ramped up his style quotient a notch in the 1970s. But Rauschenberg's emblematic clothing detail was wearing his shirt sleeves rolled up neatly. He was his own facilitator, creating and innovating until his death. With every hard-earned step, he did, as *Vogue* noted in 1977, "bear witness to his times."

In 1946, Rauschenberg worked in Los Angeles as a packing clerk at a bathing suit factory. While he was there, the assistant designer, Pat Pearman, convinced Rauschenberg he had the talent to make it as an artist.

At the beginning of his career in the 1950s, before he earned any success or much money, Rauschenberg worked as a window designer with Jasper Johns—his partner at the time—at the department store Bonwit Teller, creating dramatic art-infused backdrops for fashion displays. They also worked for Tiffany; the store's celebrated artistic director, Gene Moore, loved the duo's work, remarking before his death in 1998: "One of my personal favorites is the window design that depicts one of the road scenes. . . . It speaks to the idea of adventure and exploration."

An artistic chameleon, Rauschenberg was also a fine dancer and choreographer. He was resident set and costume designer at the Merce Cunningham Dance Company, and when he won the Grand Prize at the 1964 Venice Biennale, said that the company's dances were his "biggest canvases." For *Antic Meet* (1958), he dressed Cunningham in a black costume embellished with a chair fixed to his body. A 2008 *New York Times* article compared the outfit with Rei Kawakubo's famous Lumps and Bumps collection of 1997—the year that she too dressed the Cunningham dancers—and the silhouettes are related.

For the first time, I wasn't
embarrassed by the look of beauty,
of elegance, because when you
see someone who has only one
rag as their property, but it
happens to be beautiful and pink
and silk, beauty doesn't have
to be separated. . . . I have
always said that you shouldn't
have biases, you shouldn't have
prejudices. But before . . . I'd
never been able to use purple,
because it was too beautiful.

—Robert Rauschenberg, after a trip to India in 1975, from *Rauschenberg: Art and Life*,
by Mary Lynn Kotz, 1990

The patchwork detailing on this dress by Erdem Moralioglu echoes Rauschenberg's cut-and-paste aesthetic—the way he reconfigured found material into new and relevant art. From the fall/winter 2017–2018 runway presentation of ERDEM (the designer's ready-to-wear label) at London Fashion Week, February 2017.

Rauschenberg's connection with Comme goes further; in 1993 he walked the catwalk in Paris for the autumn menswear collection, wearing a black mohair round-neck cardigan and silvery paneled trousers. Moreover, the fusion and juxtaposition themes and the layered imagery in many Rauschenberg artworks, such as *Windward* (1963) and *The Seat of Authority* (1979), are seen in the designs of Kawakubo's protégé Junya Watanabe and the patchwork motif he is known for.

Rauschenberg's philanthropic eco-initiatives were ahead of their time. Dating to the 1990s, when he started his foundation, they promoted ideas that today's style industry leaders are addressing, such as waste and pollution created in the manufacture of textiles. The foundation has a legacy of good causes worldwide. Its message—"to promote a sustainable world through the power of creative problem solving"—has had impact on both small and large scales, especially on young leaders. The New York–based creative Michael Laed, who has fashioned clothes from scraps he finds, explains the appeal: "It isn't that hard to make something that looks unique and cool out of materials at hand." International labels, including Timberland, have begun their own way forward: for example, reclaiming and reusing old tires in shoe production. Tom Ford also has sought for a decade or more to establish his brand as environmentally friendly, designing "eco-tuxedos" made from ethically sourced wool for celebrity friends like Michael Fassbender and Bradley Cooper. Warby Parker, working directly with Rauschenberg's foundation, created ROCI sunglass frames, named for the Rauschenberg Overseas Cultural Interchange, an endeavor begun in the 1980s. The sunglass collection, created in 2017, subtly echoes Rauschenberg's color palette. For every pair sold, another is given to a person in need; a portion of the proceeds also goes to the Rauschenberg Foundation.

Rauschenberg surely didn't envision all this back when he was scavenging for materials to make good art with, but his career-long penchant for upcycling has huge value for consumer culture today.

When Rauschenberg married Susanne Weil in June 1950, he wore a white suit, white bow tie, and white shoes to match the bride's all-white outfit.

ALEXANDER RODCHENKO

I have to buy myself a damned hat, I
can't walk around in my cap because
not a single Frenchman wears one, and
everyone looks at me disapprovingly,
thinking that I'm German.

—Alexander Rodchenko, letter to Varvara Stepanova, April 1, 1925

Shapes and styles of clothes we wear are constantly recycled and revamped in quirky, impulsive ways; however, little on the catwalks is completely new. Retro tends to rule in one way or another—instead, fabric innovation and technology are where progress lies. Not so in Russia after the 1917 Bolshevik Revolution. Alexander Rodchenko and his constructivist associates were on a mission to bulldoze the bourgeois past of Tsarist Russia and start from a completely new place, shaping a future different in every area of life—including fashion. Utility was his purpose, embodied in his art, sculpture, photography, and graphic design. Likewise, the clothes Rodchenko designed to express the new Russia's utopian ideals were simple, geometric in form, and ultrafunctional. Made of heavy denim, trimmed with leather, and adorned with four large pockets, the prototypical overalls he created were a workwear uniform, practical with a flash of modernism. Both

Opposite:
Alexander
Rodchenko,
1924.

he and his wife, Varvara Stepanova, along with other party faithful, designed outfits on paper that couldn't be manufactured: fabrics and machinery were in short supply, and the constructivists' brave new wardrobe was never made for general use. Instead, Rodchenko created sets for theatrical productions such as Vladimir Mayakovsky's *The Bedbug*, which became the testing ground for his designs. His personal jumpsuits were sewn by Stepanova, who had a much-prized Singer sewing machine.

Rodchenko's clothes and his art shared the same graphic sensibilities; clear-cut lines and boxy, arithmetic approaches underpinned his striking work. His bold and optimistic doctrine translated to his wardrobe, in strong silhouettes that were largely gender-neutral. Strength was an aspirational characteristic for both men and women during this time, and, on the whole, the constructivist ideal made no room for sexy or fussy womenswear. Red and black color-blocking fueled Rodchenko's workwear designs and later the graphic art he produced for films, including *Battleship Potemkin* in 1925, as well as his influential "Books!" advertising poster for the Lengiz Publishing House a year earlier. All the propaganda he was commissioned to generate married form and function and focused on optimism about the future. He was pragmatic in approach, diverse in creative output, and uncompromising in his support of communism. In his work under the volatile direction of first Lenin, then Stalin, Rodchenko toed the party line enthusiastically: he did what he was asked and promoted his country in every way he could.

Rodchenko's principles deeply connected with everything he did. His sculptures, such as *Spatial Constructions no. 12* (1920), used widely available materials, such as plywood cut into a sequence of rings that could be unfolded and refolded from two to three dimensions and back again. His painting *Pure Red Color, Pure Blue Color, Pure Yellow Color* (1921) was his declaration that art was "over." His compelling photography, including *Stairs* (1930) and the Young Pioneers

Rodchenko met Picasso only once, when he visited Paris in 1925 for a Russian constructivist exhibition. However, neither artist could speak the other's language, so they couldn't talk to each other.

I want to take some quite incredible
photographs that have never been
taken before . . . pictures which
are simple and complex at the same
time, which will amaze and overwhelm
people. . . . I must achieve this
so that photography can begin to be
considered a form of art.

—Alexander Rodchenko, diary entry, March 14, 1934

series (1932), have a simple elegance and modernity, prefiguring the high-voltage black-and-white editorial work of 1970s image makers such as Helmut Newton. In the 1980s, his graphic design—with its recipe of unusual angles, closeups, full-page face shots, and radical typography—influenced the art direction of many magazines, including *The Face*. Neville Brody, the magazine's art director at the time, reworked Rodchenko's vision and celebrated his graphic design skills in its typography. *The Face*'s 1985 "Killer" shoot featuring a thirteen-year-old model, Felix Howard, is still seen as the epitome of style-magazine covers.

Rodchenko is among the least, and most, likely influences on fashion today. His ethics and politics may be out of kilter with the "me generation" of consumption, but the threads of his inspiration are style-forward. In the 1960s, the Italian design house Pucci used sharp color-blocking on shift dresses with boldly simple silhouettes that suggest the power of constructivism as well as the youthquake then waking up the world. Rodchenko is an easy reserve to tap, as the uncomplicated, robust clarity of his work appeals to passionate statement-making. For example, it's hard not to see Rodchenko in the past collections of Russian designer Gosha Rubchinskiy, who has more right than most to connect to constructivism. The hammer-and-sickle motifs he used on red-and-black sportswear and tracksuits—the workwear equivalent

Jerry Hall, photographed by Norman Parkinson on location in Russia in 1975. This shoot for British *Vogue* was styled by Grace Coddington, and the images were inspired by Rodchenko's use of Russian iconography for graphic effect.

of Rodchenko's overalls—are symbols of the proletariat, the history of youth, and, of course, the Soviet Union. The graphic constructivist elements were infused throughout Rubchinskiy's spring/summer 2016 collection. It's not something the designer chooses to hide: that same year, Rubchinskiy was seen taking Kanye West around Moscow's Multimedia Art Museum, where Rodchenko's work was on exhibit.

Issey Miyake's diamond-shaped kimono silhouettes and his early 1976 Cocoon Coat, too, are enigmatically evocative of Rodchenko. Mikaye and other Japanese designers, including Yohji Yamamoto, introduced such authoritative contours to the West in the early 1980s; they were tuned to a way of expressing femininity that had little to do with a traditional Parisian hourglass figure. Ironically, Rodchenko's revolutionary inspiration was most apparent during the money-fueled ostentatious-ness of the 1980s; those large, glossy shoulder pads on the Thierry Mugler catwalk in 1988 reflected a constructivist love of angular structures. Although Rodchenko felt that designer clothes were the epitome of bourgeois susceptibilities and needed rebooting, these two creatives are linked by Mugler's declaration that he wanted his "models to be bigger, stronger and taller than common mortals"—in rather the same way that Rodchenko wanted his designs to empower the masses. The Soviet artist may or may not have approved, but the message and medium are the same.

Rodchenko was a great practical joker, and his favorite trick was the "tearing the thumb apart" prank, where, with sleight of hand, the thumb appears chopped in two.

TAMARA DE LEMPICKA

There are no miracles, there is only
what you make.

—Tamara de Lempicka, from "Artist of the Fascist Superworld" by Fiona McCarthy, the *Guardian* online, 2004

Tamara de Lempicka thoroughly embodied the art deco ideal with her distinctly styled, soft cubist paintings that keenly encapsulate a particular kind of swagger and luxe. They often depict glittery socialites and the many lovers—male and female—she adored and seduced. Born in Warsaw in 1898, she lived for a while in St. Petersburg with her attorney husband; the two fled after he was arrested during the Bolshevik Revolution. After they moved to Paris, she learned how to earn a living with her art. The pictures she created feature women wearing high fashion, including Jean Patou knitwear, and silk bias-cut dresses by Madame Vionnet. In a 1930 painting, de Lempicka's mistress, Ira Perrot, shows off a white satin, body-clinging, asymmetrically ruffled robe—an idealized silver-screen outfit and similar to looks de Lempicka often wore in public. De Lempicka lived a glinting, fashionable life, faithfully channeled in the crisp, graphic images she produced and the clothes she wore. She dressed to impress and kept company with the beautiful and clever. As a regular visitor to the American writer Natalie Barney's tea-and-more salons,

Opposite:
Tamara de
Lempicka,
Paris, 1932.

168

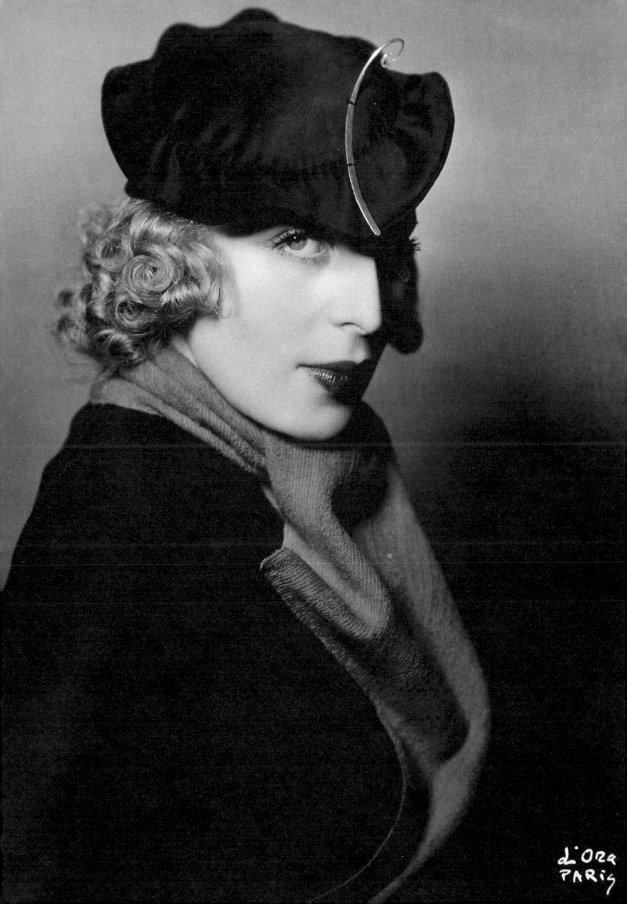

d'Ora
PARIS

she met Jean Cocteau and other contacts, including the Marchesa Luisa Casati, who introduced her to the photographer Baron Adolph de Meyer and the Italian poet Gabriele D'Annunzio.

De Lempicka's elegant wardrobe attained the height of style each season, the finest fashion had to offer. She loved hats; her favorite milliner was Rose Descat, whose on-trend constructions, worn by the elite in Europe and New York, typically had exaggerated silhouettes such as flying saucers and dinner plates. But she also made less fussy cloche or veiled pillbox hats; de Lempicka had cupboards full of them. The artist also favored the Parisian designer Marcel Rochas, who founded his fashion house in 1925. She wore Charles Creed suiting and sable fur coats, and her hair was coiffed into glorious blonde curls.

Some critics feel that de Lempicka's artistic achievement was less lofty; her works are too specific to a moment in time. The *Newsweek* art critic Peter Plagens wrote that she was "the end product, not the producer of art that influences other artists." Fashion, by nature, goes out of fashion, but good art is meant to last. But if de Lempicka's art relies on surface appeal, her legacy as a stylish, independent woman, who burned brightly for a short time, endures. Her work has been showcased around the world—for example, at London's Royal Academy in 2004 and in 2015 at the Piano Nobile di Palazzo Forti in Verona—and is collected by luminaries such as designers Domenico Dolce and Stefano Gabbana, whose autumn/winter 2000 collection was based on a de Lempicka canvas Stefano gave Domenico in 1997. De Lempicka evaluated her own artistic purpose simply enough. In addition to making money to live, she said, "My goal was never to copy, but to create a new style, bright, luminous colors and to scent out elegance in my models."

De Lempicka's modernist drive is illuminated in her famous *Autoportrait (Tamara in a Green Bugatti)* (1929), created for the cover of German fashion magazine *Die Dame*. The image shows the epitome of an unfettered, liberated woman; a little remote, a little aloof, but wealthy and up to the minute. Ironically, de Lempicka never owned

The leather driving cap worn in de Lempicka's famous 1929 *Autoportrait (Tamara in a Green Bugatti)* is based on one by Hermès.

I was the first woman to paint cleanly, and that was the basis of my success. From a hundred pictures, mine will always stand out. And so, the galleries began to hang my work in their best rooms, always in the middle, because my painting was attractive. It was precise. It was "finished."

—Tamara de Lempicka, 1925, artquotes.com

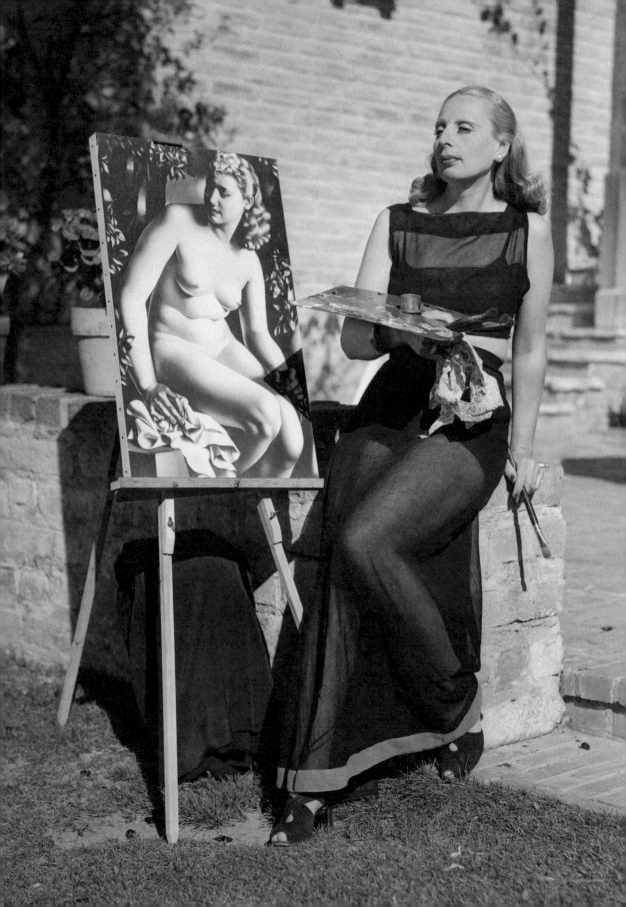

a Bugatti; her car, a yellow Renault, was stolen on a night out. She was the queen of appearance; both her artwork and her personal style were all about putting on a brave and impressive show regardless of reality. The smooth lines and shiny surfaces of art deco reflected an aspirational and eager-to-please aesthetic that isn't complicated to understand. De Lempicka wanted to succeed in life; her art and fashion sense were contemporary and satisfying at a time when the deprivations of revolution and war were still fresh.

Today de Lempicka remains a favorite with fashion designers, who admire the lustrous sheen of her imagery. That's what fashion is for many: a way to put on a brave face—the shinier and more perfect the better. De Lempicka—painting at her easel in a gauzy tulle evening dress, with four rows of pearls and armfuls of diamond bracelets—wove her own fantasy. Her *Girl with Gloves* (1929) is beautifully reproduced in Alber Elbaz's 2014 resort collection for Lanvin: a perfectly modern green dress, dramatic and fabulous; the collection also featured a one-shoulder, ruffled floor-length red-carpet frock that looks made for de Lempicka's model. Peter Copping's autumn/winter 2011 collection for Nina Ricci also channeled de Lempicka and her love of Marcel Rochas's flounced and pleated confections. Madonna—also a de Lempicka collector—was shot by Steven Meisel for Marc Jacobs's Louis Vuitton advertising campaign (autumn/winter 2009); the de Lempicka luster is evident in the sultry, smoky eye, jewel-colored dress with ruffles, and Hollywood-glam waved hair.

De Lempicka knew what looked good; in her heyday she worked as a fashion model, becoming a regular subject for Austrian photographer Madame D'Ora (Dora Kallmus). Before immersing herself in fine art, she had turned her hand to fashion illustration. From portraying women with a more androgynous look, as in the sophisticated simplicity of *Blue Scarf* (1930s), to the amply curved nude of *La Belle Rafaela* (1927), her paintings elucidate ways that still seem modern.

Opposite:
Tamara
de Lempicka
at her easel,
1930s.

MARINA ABRAMOVIĆ

Fashion feeds on art and constantly revisits different periods in history and art history. It is up to the talent of the designer to determine how they can bring historical ideas into contemporary looks.

—Marina Abramović, *AnOther*, December 2010

Performance artist Marina Abramović has been on the cover of more style publications than a lot of top models could hope for, including those of influential fashion tastemakers *V*, *Pop*, and *Elle*. Facing the camera, she looks slick and glossy, with long dark shiny hair, very often with red lips and a matching manicure. Born in Serbia in 1956, she now lives a glittering life with easy access to the creative elite and wears outfits to match her status—often haute couture coordinated with a thousand-dollar-plus bag. Her favorite perfume is Wonderwood by Comme des Garçons.

She has a strong relationship with the music world as well. She has lent her work to Jay-Z, who recreated one of her performances at New York's Pace Gallery when he dropped his single "Picasso Baby," and Lady Gaga supported the Kickstarter campaign for Abramović's traveling educational arts institute, MAI (Marina Abramović Institute for the Preservation of Performance Art).

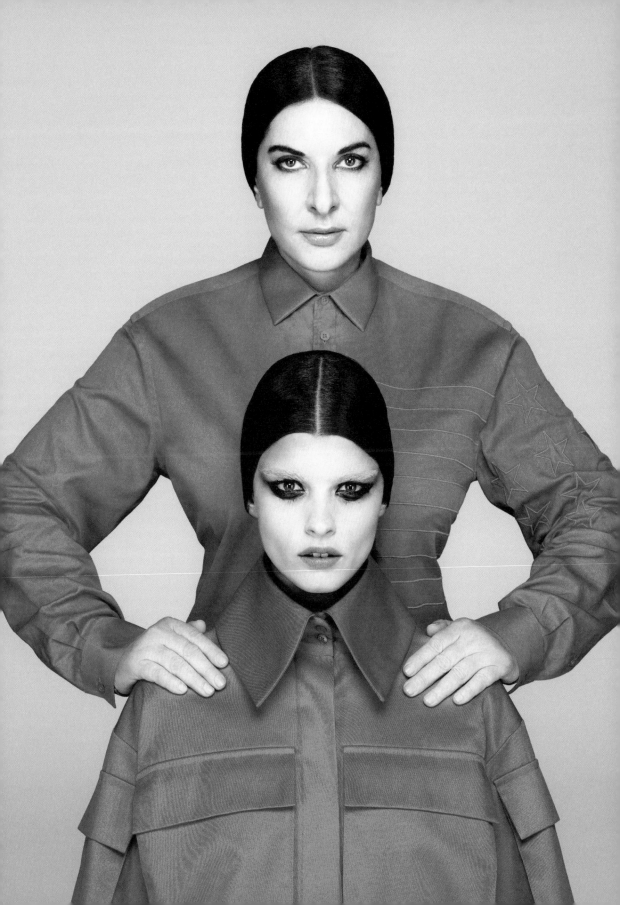

Abramović's attitude toward fashion today represents a complete U-turn from how she felt when she was younger—it's almost as if this trendy phase is another installment in her career as a performance artist. In a 2005 *Vogue* interview, wearing an Alberta Ferretti sweater, she explained, "Until I walked the Great Wall in 1988 I wanted the public to see me in only one way. Very radical, no make-up, tough, spiritual. And after . . . there was a moment when I decided to stage my life, and have fun with it. I just said, why not? Let's have it all." She's never looked back, not just wearing designer clothes but fully immersing herself in the industry. She's worked with labels such as Costume National on high-profile events such as the Art of Elysium's charity ball "Heaven" and made films, including one with sportswear king Adidas in 2014. She also created her own limited-edition clothing as part of the National Arts Club Art Capsule project. According to *Women's Wear Daily* (2013), Abramović designed seven jumpsuits for the project—each in a different vitality-inducing color and containing "seven small magnets held in pockets strategically placed to denote certain energy points on the body."

Abramović is fascinated by Maria Callas, whom she resembles. She owns pictures of the opera singer in which the two look quite similar.

The Lovers, Abramović's performance at the Great Wall in 1988, is just one example of the endurance for which is celebrated. Starting from the eastern end of the wall, she walked fifteen hundred miles to meet her partner, the German performance artist Frank Uwe Laysiepen (Ulay), who was walking from the opposite end. They broke up after meeting on the wall, after twelve years together. Completing this project seems to have broken through any constraints she had felt about expressing herself through fashion. Her confidence in her work meant that she "didn't need to prove anything to anybody anymore." Rationalizing her new assessment of style, she thought, "I am an okay artist. I can do this. It felt liberating to embrace fashion. And I wasn't ashamed of it."

Abramović articulated her initial struggle with fashion in her films for the PBS series *Art:21—Art in the 21st Century*: "In the 1970s, when artists wore red lipstick and nail polish and anything in relation to

fashion there was disgust, like you were being a really bad artist. It was like that was the way you were proving yourself, you couldn't do it with the work. It was a big no-no." Over time her attitude transformed, perhaps subconsciously. In a 2010 interview with *AnOther*, she said, "I had a secret desire to engage with fashion which I never admitted to myself, so the first time that I ever had serious money, I bought a Yamamoto suit. I felt so good in it, and without guilt!"

Today, she admits wearing lovely clothes that cause her no worries—except that "the one problem in my life is that everything is black, and when you open my closet you can't find anything," as she said, to Australian *Harper's Bazaar* in 2017. Her friendship with Riccardo Tisci, the Italian designer who was creative director at Givenchy for twelve years, has been a fruitful and compelling one. She art-directed his 2015 show set on Pier 26, against the backdrop of the Hudson River. Tisci has nothing but praise for the artist, saying in an interview with *Dazed Digital* in 2013, "Marina is, for me, the world. She is black and white; romantic and tough; beautiful and ugly. She is elegant. She has the beauty of Mariacarla [Boscono], the intelligence of Einstein and the softness of my mother. . . . As a person, Marina is funny and brilliant and warm."

In a 2018 interview with the *Art Newspaper*, Abramović says she learned how to swim when her father pushed her overboard from a boat and started to row away.

Tisci celebrated and explained the creative process of their relationship when he guest-edited the summer 2011 issue of *Visionaire*, which featured a black-and-white Mario Testino image of Tisci suckling Abramović's breast—one of the most literal of all testimonies to how creative worlds can intertwine. In the issue, according to Abramović, "I said to him, this is the situation: do you admit that fashion is inspired by art? Well, I am the art, you are the fashion, now suck my tits! He's very shy, so it took him a while to come around. But he did. During the shoot, I wanted to be in a state of mind, as if I were delivering the emotions of the artist whose work is being used as inspiration—luminous yet strong. Art is giving. Art is nourishing. Art is oxygen to society."

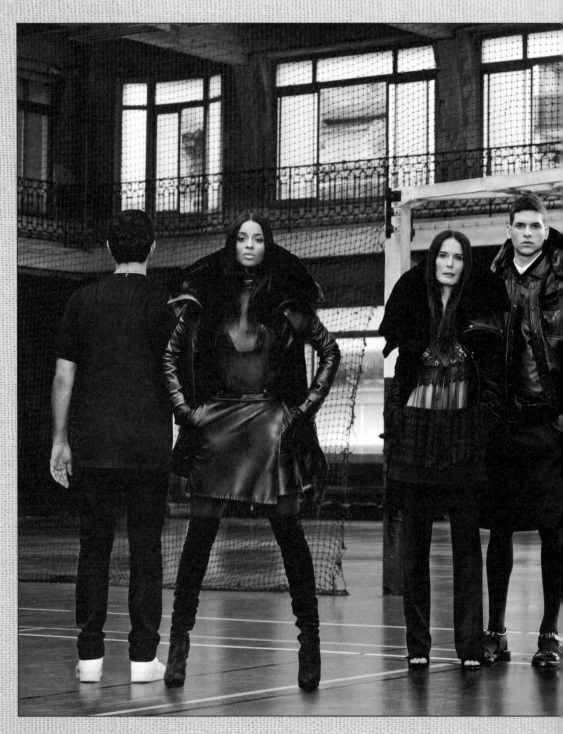

Former Givenchy designer Riccardo Tisci photographed with his muses. From left: Tisci, singer Ciara, actress-singer Bambou (Caroline Von Paulus), model Diego Fragoso Calheiros Lins, actress Liv Tyler, stylist Panos Yiapanis, models Jonathan Marquez and Mariacarla Boscono, and Marina Abramović in *W*, September 2010.

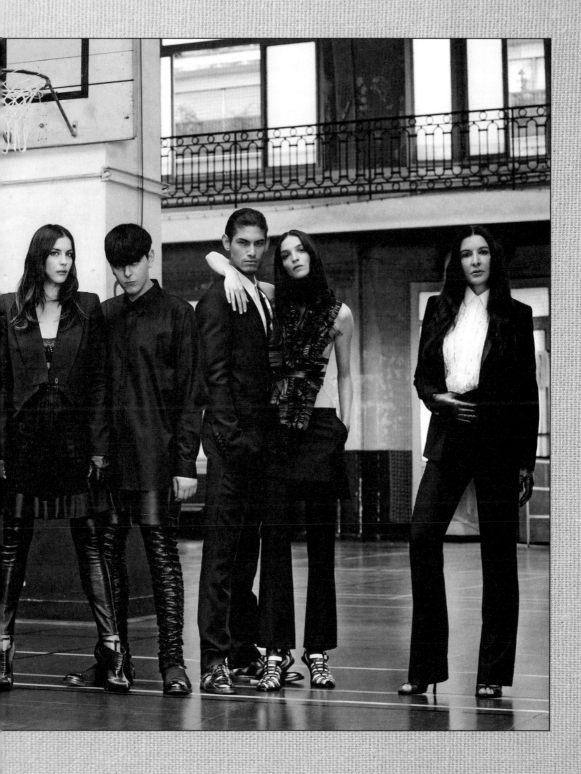

EGON SCHIELE

All his angst made sense, because he didn't
live very long. He died when he was twenty-
eight. Most artists get their MA when they're
twenty-eight now. . . . He was dead, his
wife was dead, most of his friends were
dead. If they didn't get syphilis, they died
of TB, they died of the flu, they died in
the first world war.

—Tracey Emin, the *Guardian* online, June 2017

Austrian-born Egon Schiele was the art world's Rimbaud. He inspired the cover of David Bowie's 1977 album *Heroes*, on which the pop star's gaunt features, hollow cheeks, and angular hand position vividly echo a classic portrait of Schiele from 1904 by photographer Anton Josef Trčka. Created at the beginning of the twentieth century, Schiele's paintings still look modern, and they have informed the work of voguish fashion illustrators including David Downton, Bil Donovan, and Richard Hanes. The English artist Tracey Emin is infatuated with Schiele, whom she discovered at the age of fourteen. She was immediately drawn to the magnetic, romantic reality he presented: "I was so influenced by him it was ridiculous. I was doing

Opposite:
Anton Josef
Trčka's famous
portrait of Egon
Schiele, 1914.

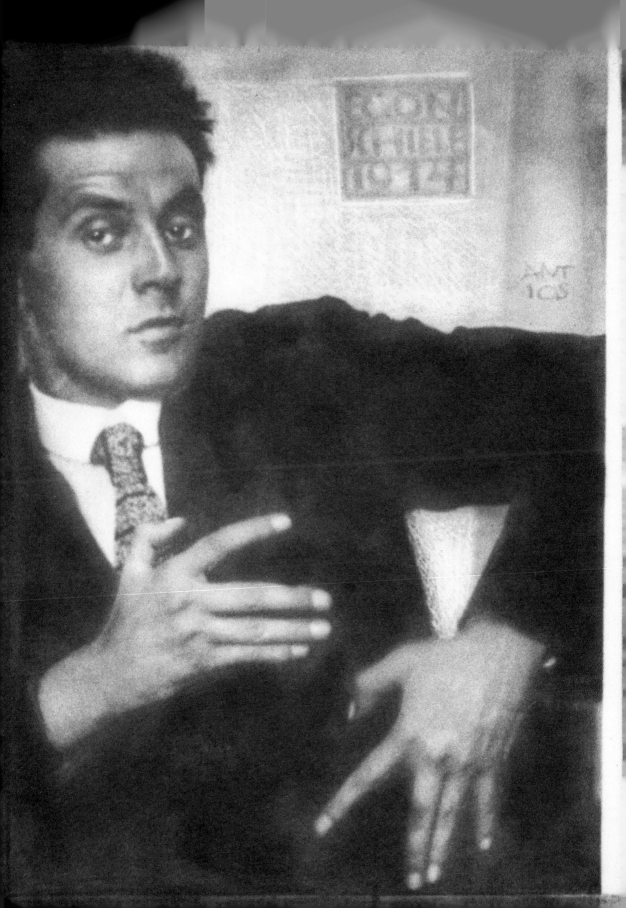

my own little versions . . . and I learned a lot," she said in a 2017 *Guardian* interview. Schiele is also a touchstone for fashion's rock-and-roll youth. During his years at Yves Saint Laurent, Hedi Slimane promoted a skinny silhouette that could have walked off a Schiele canvas. The campaign for Slimane's spring/summer 2013 menswear collection shot model Saskia de Brauw in a black, pipe-cleaner-thin trouser suit, crouched in a corner with a troubled expression, her thin, elongated fingers stylishly posed. Stretched fingers are a Schiele feature typical of the skeletal and bony models he drew. Karl Lagerfeld's slender angularity also suggests paintings by Schiele, and the skinny, spare house styles at Acne and Lanvin have stylishly reworked slim suiting and denim on Schiele lines for a cultivated twenty-first-century customer.

Coming from a poor family, Schiele aspired to wear smart clothes. As a youth, he satisfied his craving by cutting out fancy shirt collars from cardboard, creating a distinctive appearance on a frugal budget. He would often buy stylish outfits instead of everyday rations; his love of fashionable clothes can be seen in the few photographs that exist of him. Invariably he wears a shirt, tie, and suit that contrast charmingly with a swept-back hairstyle that occasionally veered toward the punkish with spikes. Schiele painted himself as he wanted the world to see him. *Self-Portrait with a Peacock Waistcoat* (1910) shows him wearing a waistcoat that "was almost definitely not his, as he was very poor and living in poverty with his lover, Wally Neuzil," explains Klaus Albrecht Schröder. Schröder, who directs the Albertina Museum in Vienna, which exhibited a commemorative selection of Schiele works in 2018, goes on to say, "The picture is no mirror image, but inventions. He slips into the role of an elegant man who brings salvation to the world through his art." *Self-Portrait in a Shirt* is another early selfie that is seminal Schiele. The boy artist depicts himself as a Bambi-eyed, cupid-lipped teen throb, staring out from the picture from under long eyelashes.

In 1906, when Schiele was sixteen, he enrolled at the Academy of Fine Arts in Vienna. He was the youngest student ever to attend but left without graduating, instead forming his own collective called the *Neuekunstgruppe* (New Art Group).

Along with many self-portraits, Schiele painted working-class girls who were gaunt, androgynous, and unafraid of their sexuality—a useful trait, as they often earned their living from sex work. Vienna teemed with prostitutes around the fin de siècle. The fine features that Schiele found so attractive were at odds with the norm for a healthy and wealthy woman: well fed, curvaceous, and shapely. Although Schiele is famous for his erotic nude or nearly nude images, many of his portraits spotlight fascinating elements of a bohemian wardrobe that contrasted with the era's mainstream styles, which still veered toward pastel and froufrou. A Miss Waerndorfer in 1913 wears a loose-fitting red-polka-dot blouse that looks liberatingly modern, with three-quarter sleeves, a slash boatneck, and jaunty buttons on the shoulder. In 1914, Schiele painted Friederike Maria Beer—a socialite ambitious to be celebrated by the best artists of her time—wearing an ankle-length, brightly multicolored Missioni-esque tube dress topped with a turban. Schiele skilfully captured this avant-garde and unconventional outfit. He also did some illustration work: in 1910, the Wiener Werkstätte commissioned him to draw fashion postcards, which portray feminine elegance with a divinely appreciative line and his signature sveltness. These images, however, eschew angst and simply mirror beauty.

The city is black and everything is done by rote. I want to be alone. I want to go to the Bohemian Forest. May, June, July, August, September, October. I must see new things and investigate them. I want to taste dark water and see crackling trees and wild winds. I want to gaze with astonishment at moldy garden fences. I want to experience them all, to hear young birch plantations and trembling leaves, to see light and sun, enjoy wet, green-blue valleys in the evening, sense goldfish glinting, see white clouds building up in the sky, to speak to flowers.

—Egon Schiele, letter to Anton Peschka, 1910

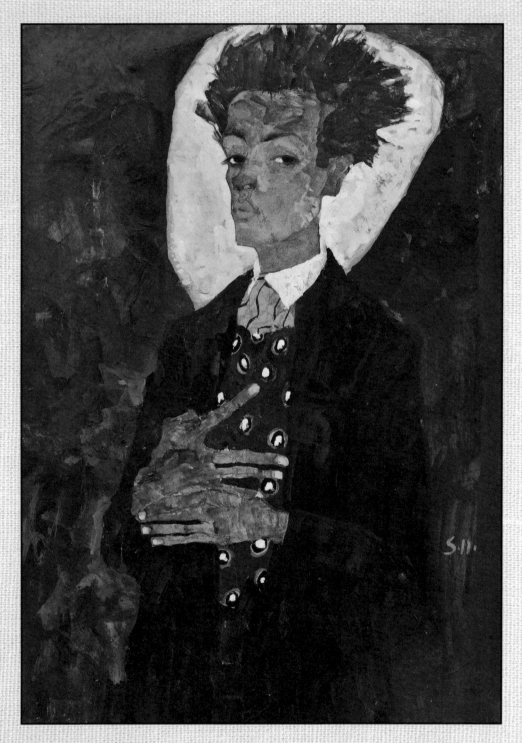

Egon Schiele, *Self-Portrait with Peacock Vest Standing*, 1911.

Schiele has moved many designers to create. John Galliano said in a 2000 *New York Times* article that the artist "has been a constant inspiration since my days as a student. There is a beauty in both the psychological aspect and in the color and line of his work." Schiele's influence is unmissable in Galliano's work at Dior: after his 2004 couture show, he said to Sarah Mower at *Vogue*, "I went on a research trip to Vienna, and then got to looking at Egon Schiele." Sarah Burton's 2013 collections at Alexander McQueen drew on the visual appeal of Schiele's mentor, Gustav Klimt; though, as she told Suzy Menkes, she was a big fan of Schiele, too, and used his work to kindle the collection.

Daniel Vosovic, who appeared on *Project Runway* and is now a member of the Council of Fashion Designers of America, turned to Schiele for his spring 2013 collection, printing a montage from an early work by him onto muddy yellow frocks. Reviewing the 2007 autumn/ winter menswear collection by Dries van Noten, Hamish Bowles called it

The London Underground refused to display advertisements for a 2015 exhibition of Schiele's paintings at the Courtauld Gallery, finding them too provocative.

"Egon Schiele meets bling." In a May 2017 shoot by Tim Walker for *i-D*, the models wore clothing by Gucci, Margiela, and Gosha Rubchinskiy on their ultra slim frames. The images are styled in the Schiele mode and reflect the non-stop appeal of his aesthetic.

In a 2011 *New York Times* review of his *Photographer of Influence* exhibition at the Nassau County Museum of Art, Richard Avedon summed up Schiele's twenty-first-century appeal, citing "a candour and complexity to Schiele's work that belies the tradition of flattery and lies in portrait making." The artist's vision, so progressive at the beginning of the twentieth century, also resonated at the end, when outsider and ugly beauty became new and interesting. As exemplified by the groundbreaking photography of Juergen Teller and Corinne Day in the 1990s, this new paradigm for fashion followed in Schiele's footsteps, opening our eyes to the possibility that different and odd could be desirable.

GEORGIA O'KEEFFE

O'Keeffe is supremely happy and painting, as usual, supremely swell things. When she goes out riding with a blue shirt, black vest, and black hat, and scampers around against the thunderclouds—I tell you it's something.

—Ansel Adams, in a letter to Alfred Stieglitz, 1937

Georgia O'Keeffe's work pares down any excess: it is bold, direct, and graphic in its message and aesthetic. She painted the same subjects over and over again. Her wardrobe was famously similar: she wore the same selection of clothes on rotation, and when she found something she was keen on, she used it again and again. She was born in Wisconsin in 1887; more than a century later, in 2015, American *Vogue* described the artist's elegant and minimalist style as "monastic simplicity by way of the southwest." In 2017, the Brooklyn Museum presented an exhibition around her outfits that was subtitled *Living Modern*, and curator Wanda Korn told *AnOther* that O'Keeffe's "mode was to look around closely at what women were wearing at the time because she never wanted to be contrary to fashion, she just wanted . . . a severe version of anything that was fashionable at the time."

Opposite: Georgia O'Keeffe, 1930.

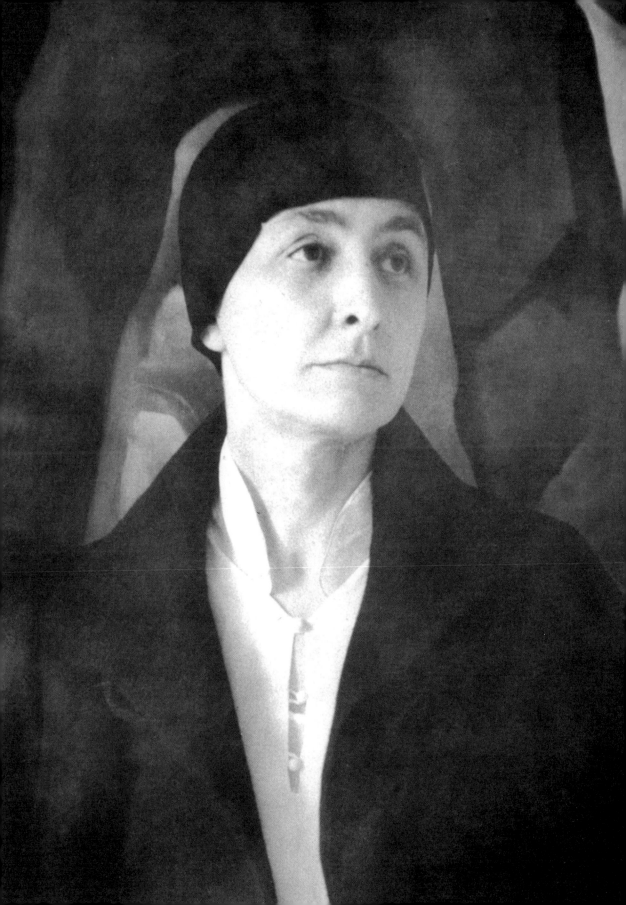

O'Keeffe can kill a rattlesnake,
even in her eightieth year. . . .
She rides from the new house in
Abiquiu to her first Western home,
the Ghost Ranch, in an air-
conditioned automobile like any
other sensible Westerner. She rises
early, eats lightly, has a figure
any woman more than half her age
would envy, dresses classically,
simply. . . . Not provincial in any
sense, but thoroughly sophisti-
cated, she has always been more
modern than her contemporaries.

— E. C. Goossen, "O'Keeffe," American *Vogue*, March 1967

Her favorite designer in the 1950s was Claire McCardell, the fashion pioneer who helped build the American clothing industry in rebellion to the ornate, overfeminized Parisian tradition and the emerging New Look. McCardell made womenswear that was simple yet elegant, easy to wear, and unfussy. Her style fit with O'Keeffe's sensibilities, especially McCardell's classic "popover" dresses, first designed in 1942, which inspired the artist's favored dress around the ranch in New Mexico. She wore this silhouette constantly, cinched at the waist with a Hector Aguilar silver belt made in Taxco. Often the dresses were surprising shades of yellow and pink—O'Keeffe's wardrobe was not limited to the black and white she preferred for her austere "public" portraits. Quite often she found a dress she liked and either had it copied or sewed a version of it herself. Painting and riding, she wore comfortable, practical workwear—double denim (top and pants) with Navajo design accents, or a traditionally printed blouse paired with a geometrically patterned fabric belt. In one of the most famous images of O'Keeffe, shown with the cowboy Orville Cox, Ansel Adams shot her wearing a wide-brimmed black gaucho hat. On the pages of a fashion magazine the hat was a striking statement piece, but it was a useful everyday accessory for protection from the beating New Mexico sun.

In 1929, O'Keeffe learned to drive and bought a Model A Ford. She named it Hello.

O'Keeffe owned a first edition copy of James Joyce's classic modernist novel *Ulysses*.

O'Keeffe's style legacy is distinct and clear-cut—she loved an unfaltering, strongly monochrome wardrobe and a silhouette cut away from the body, preferably with pockets and accessorized with a silver brooch or clasp. She could also make innovative and edgy choices. After the death in 1946 of her husband, Alfred Stieglitz, O'Keeffe traveled the world, and when she returned from Spain in the 1950s, she brought back an Eisa suit. Eisa was Cristóbal Balenciaga's first fashion house, launched before the Spanish Civil War. The suit is simple and plain but cut with the masterful precision for which Balenciaga was so admired. It was a radical, chic choice, showing how in tune O'Keeffe was with the direction of fashion.

O'Keeffe's dress sense stemmed from the confidence of knowing what she liked and going with it. Along with a few other forward-thinking style connoisseurs, O'Keeffe started collecting and wearing Japanese kimonos in the early 1900s, prefiguring the wrap dresses she would later adopt. Paul Poiret had begun making kimonos in Paris around the same time; the man who freed women from the corset has been lauded for leading the way Chanel would follow later in freeing women's fashion from its nineteenth-century restrictions. O'Keeffe herself threw out the corsets early in her life: they didn't work with the useful, easy shapes she preferred, even as a girl growing up in Wisconsin. Later in life she turned to the Viennese tailor Knize, who dressed Hapsburg archdukes, sewing each of their suits with seven thousand hand-done stiches. Always a menswear tailor, Knize didn't begin catering to women directly until the 1990s, although some, including Marlene Dietrich and O'Keeffe, had earlier commissioned them to create jackets, trousers, and skirts. In these garments, exquisitely made from beautiful plain wool fabrics, O'Keeffe found a style that harmonized with her own high standards. That it was menswear made no difference: it was the look she wanted.

The world of fashion and style became interested in O'Keeffe early in her career. *Vogue* featured her in 1924 with a photograph by Stieglitz. His famous images of O'Keeffe show a yin to her later yang: in these portraits she wears her hair untied, her body is voluptuously on show, and she looks as loose and free as she later appears austere and purposeful. Throughout her life, noted photographers—including Richard Avedon, Cecil Beaton, and Annie Leibovitz—continued to ask her to sit for them. After Stieglitz, however, O'Keeffe art-directed her own pose for the camera. She engineered a publicly spare and reserved image until she died in 1986 at age ninety-eight. In 1983, in a late interview with Andy Warhol, she admitted going to visit Elizabeth Arden, who put makeup on her, and confessed that afterward she "went home and saw myself and was so embarrassed. I couldn't wash my face fast enough."

Opposite:
Georgia O'Keeffe
in New Mexico,
April 1960.

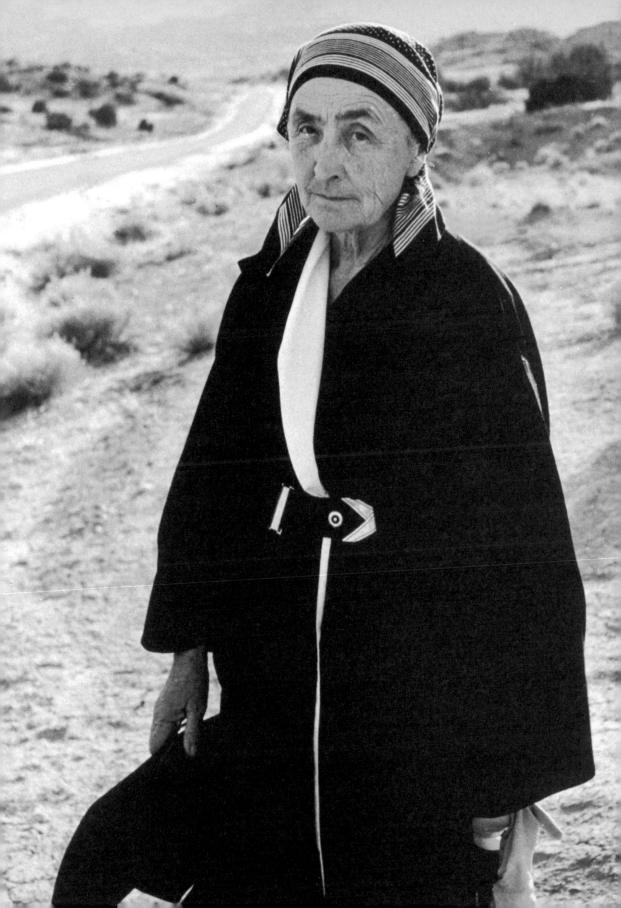

HENRI MATISSE

Those who will work with their soul and
the desire to express themselves . . . it is
these who will come out the best painters.

—Henri Matisse, *The Lost 1941 Interview* by Henri Matisse with Pierre Courthion

G rowing up in Bohain-en-Vermandois, France, surrounded
by the luxuriant silks created by the weavers of that region,
Matisse was understandably inspired by the vibrant qualities of
cloth. He kept what he called his "working library" of assorted
fabrics close at hand, using them as visual references and incor-
porating their textures and tones into the layers of the art he
created. The artist's collection of draperies, scraps of Parisian and
Turkish couture gowns, and exotic wall-hangings from Africa were
displayed at the Metropolitan Museum of Art in 2005; seen in
third dimension for the first time, they give clear evidence of his
compelling fascination with fabrics, as the titles of his paintings
reflect: *Red Culottes*, *Blue Hat*, *The Yellow Dress*, and *Woman with
Striped Pullover*.

What he termed his "greatest work"—the Chapelle du Sainte-
Marie du Rosaire in Vence, near Nice—was constructed entirely
to Matisse's direction, from the green, yellow, and blue stained
glass windows to the carved confessional doors. He designed it

Opposite:
Henri Matisse in
his studio, 1913.

Look at that portrait over there,
the young lady with the ostrich
feather in her hat. The feather
is put there as an ornament,
decorative, but it also has a
physical presence; you sort of
feel its lightness, the soft airy
down, which moves with a breath
of air. The material of the blouse
is a fabric of quite a particular
kind. The pattern has its own
wondrous character. I want to depict
the typical and the individual at
the same time, a distillation of
all I see and feel in a motif.

—Henri Matisse, describing his painting *White Plumes* in 1919,
 from *Matisse on Art* by Jack Flam, 1995

to be, as he explained in 1949 to *Vogue*, "a church full of gaiety—a place which will make people happy." The vestments he conceived for the chapel, in sprightly shades of purple, pink and green, were sewn by local craftsmen and the Dominican nuns of Les Ateliers des Arts Appliqués in Cannes. They are reminiscent of the gold, pink, and orange costumes he created for Serge Diaghilev's Ballets Russes production *Le Chant du Rossignol* in 1919. In a 1946 interview with Jerome Seckler, Matisse said, "One should keep the disagreeable, the unhappiness to himself. One can always find a pleasant thing," and all his works reflected this maxim.

In his late sixties, Matisse turned to cut paper as his primary medium; he had become ill with intestinal cancer, and the cutouts—which he described as "carving in color"—were his response to his increasing inability to paint easily. Inspired by his love of "geometric Kuba cloth from Zaire" and painted with gouache, these collages, sometimes huge, would become some of his most celebrated work as well as an enduring fashion motif. Their simple graphic strength inspired the autumn/winter 1980–81 couture collection by Yves Saint Laurent, who translated the artist's 1953 pieces *La Gerbe* and *The Snail* into satin appliqué leaves and blocks on black velvet evening gowns. The designer's Happy New Year Love card from 1983 also was directly inspired by the cut-outs. Saint Laurent adored Matisse and bought *Les Coucous, Tapis Bleu et Rose* (1911). Its imagery, showing the artist's emblematic love of nature, found its way into Saint Laurent's collections in the 1980s. The designer also paid homage to *La Blouse Roumaine* (1940), recreating the model's shirt identically and showing it with a matching sapphire blue velvet skirt, as in the portrait.

Matisse's *Woman with a Hat* was purchased by Gertrude and Leo Stein after a Fauve group exhibition in 1905. Matisse later gave Madame Stein a portrait of his wife, Amélie, adding a hat because Gertrude liked the way she pinned her headwear.

Other designers have taken cues from the painter as well. In 1982, Vivienne Westwood's catwalk show *Nostalgia of Mud, Buffalo Girls* included an ochre toga dress with a long train printed with a Matisse-informed chocolate brown print. Comme des Garçons's

autumn/winter 2012 collection confidently brought elements of Matisse into the twenty-first century. The artist surely would have commended the bold, brilliantly colored cutout dresses.

As a young man, according to biographer Hilary Spurling, Matisse was often seen wearing a "reddish brown suit" he kept for "polite" occasions as well as an untidy black sheepskin jacket worn inside-out and for outings around Montparnasse. At home, he typically wore pajamas during the day; a striped pair he used in his studio was immortalized in *The Conversation* (1909). Paint-splattered white overalls and tortoise-shell spectacles completed his look. By the time he reached his fifties, though, Matisse was able to afford finery. When the Swedish art historian Ragnar Hoppe interviewed him in 1919, he described Matisse as "elegantly dressed as an English gentleman . . . wearing a light-gray suit of the latest cut. . . . The color of his neckerchief and his soft silk shirt had been chosen with great care." In her book *Henri Matisse: Modernist Against the Grain*, Catherine Bock-Weiss suggests that, as he got older, Matisse was concerned with portraying himself as a serious "professorial"; photographs taken by his son, Pierre, when they visited the United States support this notion. The October 1930 cover of *Time* portrayed the artist at age sixty. Seen in profile and looking youthful, he is dressed in an open-necked white shirt, unusual for Matisse. Bock-Weiss speculates that he was trying to show the public an image of a man still capable, and with more art to offer.

Until the end, Matisse lived surrounded by and energized by color. He conducted the 1949 *Vogue* interview when he was eighty, "sitting up in a red bed, wearing a turquoise jumper and tie . . . a yellow and red blanket across his knees." After surgery for his cancer, he used a wheelchair, and his eyesight was failing—but he still painted, with a brush tied to the end of a long stick.

One of Matisse's first patrons was the Russian textiles entrepreneur and businessman, Sergei Shchukin—one of the most famous and taste-making collectors of all time. He bought numerous paintings from Matisse and supported the artist early in his career.

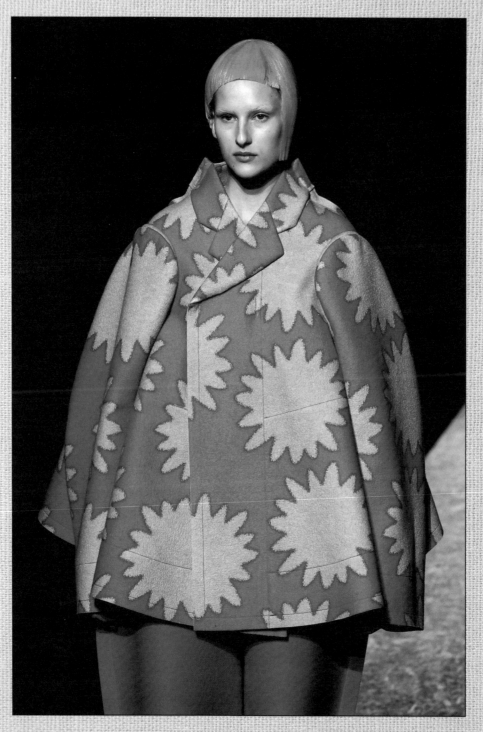

A model wears a creation inspired by Matisse's cut-outs in the Comme des Garçons fall/winter 2012–2013 ready-to-wear show, Paris, March 2012.

Bibliography

Abramović, Marina. "An Intellectual Fashion: Marina Abramović." *AnOther*, December 13, 2010. http://www.anothermag .com/fashion-beauty/680/marina-abramovic.

———. "Embracing Fashion: Marina Abramović." *Art 21*, May 11, 2012. https://art21.org/watch /extended-play/marina-abramovic-embracing-fashion-short/.

Adams, Britanny. "Spring 2013 Ready-to-Wear: Daniel Vosovic." *Vogue*, October 15, 2012. https://www.vogue.com/fashion-shows /spring-2013-ready-to-wear/daniel-vosovic.

Adams, Johnny. "Marina Abramović: 'I've Always Been a Soldier.'" *The Talks*, June 13, 2012. http://the-talks.com/interview /marina-abramovic/.

Adams, Tim. "Cindy Sherman: 'Why am I in these photos?'" *Guardian*, July 3, 2016. https://www.theguardian.com/artanddesign /2016/jul/03/cindy-sherman-interview-retrospective-motivation.

Adburgham, Alison. "Fashion archive: Cecil Beaton's testament of fashion." *Guardian*, September 22, 2014. https://www .theguardian.com/fashion/2014/sep/22 /fashion-cecil-beaton-anthology-v-a.

Ades, Dawn, and Daniel F. Hermann. *Hannah Höch: Works on Paper*. Munich: Prestel/Random House, 2014. https://www.randomhouse.de /leseprobe/Hannah-Hoech-Works-on-Paper /leseprobe_9783791353432.pdf.

Aitkenhead, Decca. "Steve McQueen: my hidden shame." *Guardian*, January 4, 2014. https://www.theguardian.com/film/2014/jan/04 /steve-mcqueen-my-painful-childhood-shame.

Alison Jacques Gallery. "Robert Mapplethorpe: Fashion Show." Alison Jacques Gallery, 2013. https://www.alisonjacquesgallery.com /exhibitions/98/overview/.

Allen, Greg. "This Louise Bourgeois Shackle Necklace By Chus Burés Has No Title." Greg.org, August 4, 2016. http://greg.org /archive/2016/08/04/this_louise_bourgeois_ shackle_necklace_by_chus_bures_has_no_ title.html.

Alloway, Lawrence. "The World Is a Painting: Rauschenberg." *Vogue*, October 15, 1965.

Allwood, Emma Hope. "Rick Owens: 'I have to contribute beauty to the world.'" *Dazed*, October 2, 2015. http://www.dazeddigital.com /fashion/article/26814/1/rick-owens-on-the-inspiration-behind-his-human-harnesses.

Anderson, Alexandra. "The Collectors: Robert Mapplethorpe—An Eye for Tomorrow's Taste." *Vogue*, March 1985.

Andersen, Corrine. "Remembrance of an Open Wound: Frida Kahlo and Post-revolutionary Mexican Identity." *South Atlantic Review* 74, no. 4 (2009): 119–130. www.jstor.org/stable /41337719.

Anderson, Kristin. "20 Surreal Fashions to Fall Hard For, From Dalí to Magritte." *Vogue*, November 20, 2015. https://www.vogue.com /article/surreal-fashion-runway-salvador-dali-schiaparelli.

Archives of American Art. Oral history interview with Louise Nevelson. January 30, 1972. https://www.aaa.si.edu/collections/interviews /oral-history-interview-louise-nevelson-13163.

Art Quotes. *Tamara de Lempicka Quotes*. Art Quotes. http://www.art-quotes.com/auth_ search.php?authid=6877#.W0NZ8vZFzIU.

Artspace. "Elizabeth Peyton." Undated. http://www.artspace.com/elizabeth_peyton.

———. "Robert Mapplethorpe: American Photographer." The Art Story. http://www .theartstory.org/artist-mapplethorpe-robert-artworks.htm#pnt_1.

Ascari, Alessio. "Cover Story: Vanessa Beecroft." *Kaleidoscope*, Winter 2016.

Bade, Patrick. *Lempicka*. New York: Parkstone International, 2006.

Bagley, Mark. *Marc Jacobs*. *W*, November 1, 2007. https://www.wmagazine.com/story/ marc-jacobs-2.

Baldwin, Thomas. "Depictions of and Challenges to the New Woman in Hannah Höch's Photomontage." *Things Created by People*, April 20, 2015. http://www .thingscreatedbypeople.com/zine/depictions-of-and-challenges-to-the-new-woman-in-hannah-hochs-photomontage.

Barbato, Randy, and Fenton Bailey. *Robert Mapplethorpe: Look at the Pictures*. HBO Documentary Films, 2016.

Barnett, Laura. "Portrait of the artist: Steve McQueen, artist and film-maker." *Guardian*, September 14, 2009. https://www .theguardian.com/artanddesign/2009/sep/14 /steve-mcqueen-artist-filmmaker.

Bartlett, Djurdja. *FashionEast: The Spectre that Haunted Socialism*. Cambridge: MIT Press, 2010.

Basquiat, Jean-Michel, Marc Mayer, and Fred Hoffman, eds. *Basquiat*. London and Brooklyn, NY: Merrell Publishers/Brooklyn Museum, 2005.

BBC-TV. Marcel Duchamp 1968 BBC interview. Posted by Dennis Liu, April 21, 2013. https:// www.youtube.com/watch?v=Bwk7wFdC76Y.

Beaton, Cecil. Fashion, "Spring Ball Gowns." *Vogue*, 1951.

Beecroft, Vanessa. *VB16 Piano Americano-Beige*. Jeffrey Deitch (blog post), January 1996. http: //deitch.com/deitch-projects/vb16-piano-americano-beige.

Belcove, Julie. "The Bazaar World of Dalí. The wildly imaginative Dalí led a life as surreal as his work." *Harper's Bazaar*, December 19, 2012. http://www.harpersbazaar.com/culture/features /g2436/salvador-dali-profile-1212/?slide=1.

Belinky, Beju. "Four things you never knew about Leigh Bowery." *Dazed*, May 28, 2015. http://www.dazeddigital.com/fashion/article /24888/1/four-things-you-never-knew-about-leigh-bowery.

Benezra, Neal David, Franz Schulze, Louise Rosenfield Noun, Christopher D. Roy, and Amy N. Worthen. *An Uncommon Vision: The Des Moines Art Center*. Manchester, VT: Hudson Hills, 1998.

Bernier, Rosamund. "People and Ideas: Matisse Designs a New Church." *Vogue*, 1949.

Bhattacharya, Sanjiv. "David Hockney: What I've Learned." *Esquire*, February 6, 2016. http://www.esquire.com/uk/culture/news /a10072/david-hockney-what-ive-learned/.

Bisson, Steve. "The Rodchenkos' Circle. Stylish People." *Urbanautica*, http://www .urbanautica.com/review/the-rodchenkoas-circle-stylish-people/39.

Blanco, Jose, Patricia Kay Hunt-Hurst, Heather Vaughan Lee, and Mary Doering. *Clothing and Fashion: American Fashion from Head to Toe*. Santa Barbara, CA: ABC-CLIO, 2015.

Blanks, Tim. Spring 2016 Menswear, "Rick Owens." *Vogue*, June 25, 2015. https://www.vogue.com/fashion-shows /spring-2016-menswear/rick-owens.

———. Spring 2018 Menswear, "Ann Demeulemeester." *Vogue*, June 30, 2007. https://www.vogue.com/fashion-shows /spring-2008-menswear/ann-demeulemeester.

Bock-Weiss, Catherine. *Henri Matisse: Modernist Against the Grain*. University Park: Pennsylvania State University Press, 2009.

Boré, Begüm Sekendiz. "Deconstructing Paris AW15: What does Joseph Beuys have in common with the Paris menswear shows?" *Dazed*, January 27, 2015. http://www .dazeddigital.com/fashion/article/23389/1 /deconstructing-paris-aw15.

Bowles, Hamish. The Individualists, "Poetic Bohemia." *Vogue*, May 1, 2007.

Bradley, Laura. "Marina and Tisci: Dancing on the Edge." *Dazed*, August 9, 2013. http://www.dazeddigital.com/artsandculture /article/16836/1/marina-and-tisci-dancing-on-the-edge.

Bravo, Tony. "The Wearable-Haring Pioneers: Keith Haring Continues to Draw Followers." *San Francisco Chronicle*, December 13, 2014. http://www.sfgate.com/living/article /The-wearable-Haring-pioneers-Keith-Haring-5949088.php.

Brockes, Emma. "Jeff Koons: 'People respond to banal things—they don't accept their own history.'" *Guardian*, July 5, 2015. https://www .theguardian.com/artanddesign/2015/jul/05 /jeff-koons-people-respond-to-banal-things-they-dont-accept-their-own-history.

Brown, Laura. "Cindy Sherman: Street-Style Star." *Harper's Bazaar*, February 9, 2016. http://www.harpersbazaar.com/culture /features/a14005/cindy-sherman-0316/.

Brown, Suzanne. "The Art of Yves Saint Laurent: Catherine Elkies' Perspective." *Denver Post*, May 17, 2012. http://blogs.denverpost.com /style/2012/05/17/art-yves-saint-laurent/16182/.

Bryant, Jr., Keith L. "Genteel Bohemian from Indiana: The Boyhood of William Merritt Chase." *Indiana Magazine of History*, March 1985. https://scholarworks.iu.edu/journals /index.php/imh/article/view/10601.

Burnley, Isabella. "Simone Rocha on Louise Bourgeois." *Dazed*, March 1, 2015. http://www .dazeddigital.com/fashion/article/17160/1 /exclusive-simone-rocha-vs-louise-bourgeois.

Camhi, Leslie. "Designed for Living." *New York Times*, April 15, 2007. http://www.nytimes .com/2007/04/15/style/tmagazine/15tlouise. html?mcubz=1.

———. "Grand Gestures." *Vogue*, November 2005.

Carter, Angela, ed. *Nothing Sacred: Selected Writings*. New York: Time Warner Books, 1982.

Casley-Hayford, Alice. "Top 10 Warhol Inspired Collections." *Hunger*, October 6, 2015. http://www.hungertv.com/feature/top-ten-andy-warhol-inspired-collections/.

Caws, Mary Ann. *Pablo Picasso*. London: Reaktion Books, 2005.

———. *Salvador Dalí*. London: Reaktion Books, 2008.

Chadwick, Alex, and Madeleine Brand. "The Legend of Leigh Bowery." *Day to Day*, NPR, November 28, 2003. https://www.npr.org /templates/story/story.php?storyId=1524768

Chan, Katherine. "Belle Haleine: Marcel Duchamp's Readymade Perfume Bottle." *Mad Perfumista*, April 16, 2012. http://madperfumista .com/2012/04/16/everything-is-coming-up-roses-marcel-duchamps-readymade-perfume-bottle/.

Chilvers, Simon. "Robert Rauschenberg: the quiet minimalism of a style hero." *Guardian*, August 1, 2016. https://www.theguardian.com /fashion/2016/aug/01/robert-rauschenberg-quiet-minimalism-style-hero.

Chipp, Herschel B., Peter Selz, and Joshua C. Taylor. *Theories of Modern Art: A Source Book by Artists and Critics*. Berkeley: University of California Press, 1984.

Christobel, Sarah. "24 Hours with artist Marina Abramović." *Harper's Bazaar Australia*, February 1, 2017. https://www.pressreader.com /australia/harpers-bazaar-australia/20170201 /281698319397863.

Chu, Christie. "8 Things That Will Change the Way You Think About Egon Schiele." *Artnet News*, June 12, 2015. https://news.artnet.com /market/7-things-to-know-egon-schiele-305958.

Claridge, Laura. *Tamara de Lempicka: A Life of Deco and Decadence*. New York: Clarkson Potter, 1999.

Clarke, Nick. "Show's lost berets at the ICA paint a picture of Pablo Picasso's influence on Britain." *Independent*, November 24, 2013. http://www.independent.co.uk/arts-entertain ment/art/news/show-s-lost-berets-at-the-ica-paint-a-picture-of-pablo-picassos-influence-on-britain-8960894.html.

Colacella, Bob. "When Robert Mapplethorpe Took New York." *Vanity Fair*, March 2016. https://www.vanityfair.com/culture/2016/03 /robert-mapplethorpe-new-york.

Collins, Amy Fine. "Diary of a Mad Artist." *Vanity Fair*, September 1995. https://www .vanityfair.com/culture/1995/09/frida-kahlo-diego-rivera-art-diary.

Cook, Rachel. The Observer, Louise Bourgeois, "My Art Is a Form of Restoration." *Guardian*, October 14, 2008. https://www .theguardian.com/artanddesign/2007/oct/14 /art4.

Cotter, Holland. Art Review, "Fluffing Up Warhol: Where Art and Fashion Intersect." *New York Times*, November 7, 1997. https://www.nytimes.com/1997/11/07/arts /art-review-fluffing-up-warhol-where-art-and-fashion-intersect.html.

Cox, Neil. "Picasso and Politics." *Tate Etc.*, Issue 19 (Summer 2010), May 1, 2010. http://www.tate.org.uk/context-comment /articles/peace-and-politics-freedom.

Crane TV. "Egon Schiele: The Radical Nude." *Crane.tv*. http://crane.tv/egon-schiele.

Crimmens, Tamsin. "Five minutes with Marina Abramović?" *Elle*, July 11, 2014. https://www.elle.com/uk/fashion/celebrity-style/articles/a22301/five-minutes-with-marina-abramovic-performance-artist-serpentine-gallery-512-hours/.

Cumming, Laura. The Observer: Art, "Hannah Höch—Review." *Guardian*, January 13, 2014. https://www.theguardian.com/artanddesign /2014/jan/13/hannah-hoch-whitechapel-review.

Cutler, E. P., and Julien Tomasello. *Art + Fashion: Collaborations and Connections Between Icons*. San Francisco: Chronicle Books, 2015.

The Daily Beast. "Neil Winokur: 1980s Portraits." *Daily Beast*, October 28, 2009. https://www.thedailybeast.com/neil-winokur-1980s-portraits.

Dalí, Paris. *Dalí & Fashion*. Espace Dalí. http://daliparis.com/en/salvador-dali/dali-and-fashion.

Dalí, Salvador. "Costume do ano 2045, 1949–1950." MASP (Museu de Arte de São Paolo). https://masp.org.br/busca?search=Dali.

———. *Diary of a Genius*. Chicago: University of Chicago Press, 2007.

———. *The Secret Life of Salvador Dalí*. London: Vision Press, 1976. New York: Dial Press, 1942.

Danchev, Alex. "Picasso's Politics." *Guardian*, May 8, 2010. https://www.theguardian .com/artanddesign/2010/may/08/pablo-picasso-politics-exhibition-tate.

Dannatt, Adrian. "Dalí in Manhattan." *Beyond: The St. Regis Magazine*, 2017. http://magazine .stregis.com/the-surreal-life-of-dali-in-new-york/.

Darwent, Charles. Obituary, "Louise Bourgeois: Inventive and influential sculptor whose difficult childhood informed her life's work." *Independent*, June 1, 2010. http://www .independent.co.uk/news/obituaries/louise-bourgeois-inventive-and-influential-sculptor-whose-difficult-childhood-informed-her-lifes-1988691.html.

De Lempicka, Tamara. artquotes.com. http://www.artquotes.com/auth_search .php?authid=6877#.WmIbxVKcbR1.

Deitch Projects. "Paradise Garage." From the *Paradise Garage* exhibition catalogue, 2001. Keith Haring Foundation. http://www.haring .com/!/selected_writing/paradise-garage# .WhiQEFVl_IU.

Dillon, Brian. "Hannah Höch: art's original punk." *Guardian*, January 9, 2014. https://www .theguardian.com/artanddesign/2014/jan/09 /hannah-hoch-art-punk-whitechapel.

D'Orgeval, Domitille. "Macaparana: Chus Burés, A Dialogue between Art & Design." *Marlborough Monaco Gallery* (exhibition catalogue), March 31, 2014. http://abstractioninaction.com/happenings /macaparana-chus-bures-dialogue-art-design/.

Dorment, Richard. "Matisse the materialist." *Telegraph*, March 9, 2005. http://www.telegraph .co.uk/culture/art/3638423/Matisse-the-materialist.html.

Duchamp, Marcel, edited by Michel Sanouillet and Elmer Peterson. *The Writings of Marcel Duchamp*. Boston: Da Capo Press, 1973.

Duffy, Eleanor. "Scots designer to launch pop art fashion line with Kanye West." STV News, November 2, 2016. https://stv.tv/news /features/1371635-scots-designer-to-launch-pop-art-fashion-line-with-kanye-west/.

Duffy, Jean H. *Reading Between the Lines: Claude Simon and the Visual Arts*. Liverpool: Liverpool University Press, 1998.

Editors of *ARTnews*. "Artist, Academic, Shaman: Joseph Beuys on His Mystical Objects, in 1970." *ARTnews*, March 20, 2015. http://www.artnews.com/2015/03/20/academic-artist-scholar-shaman-joseph-beuys-on-his-mystical-objects-in-1970/.

Edwards, Gwynne. *Lorca, Buñuel, Dalí: Forbidden Pleasures and Connected Lives*. London: I.B.Tauris, 2009.

Elkann, Alain. "Elizabeth Peyton." Alain Elkann Interviews, August 25, 2014. http://alainelkann interviews.com/elizabeth-peyton/.

Epps, Philomena. "Why Egon Schiele is one of art's greatest provocateurs." *Dazed*, June 19, 2017. http://www.dazeddigital.com/artsandculture /article/36384/1/why-egon-schiele-is-one-of-arts-greatest-provocateurs.

"Erdem Takes a Stroke from Jackson Pollock." *Interview*, February 22, 2011. https://www .interviewmagazine.com/fashion/erdem-fall-2011-london.

Fage, Chloë. "Who is Vanessa Beecroft, the artist adored by Kanye West and the fashion world?" *Numero*, March 13, 2017. http://www. numero.com/en/art/who-is-vanessa-beecroft-the-artist-adored-by-kanye-west-and-the-fashion-world.

Fashion Institute of Technology. "2009 Couture Council Award for Artistry of Fashion: Dries van Noten." The Museum at FIT, 2009. https:// www.fitnyc.edu/museum/support/couture-council/dries-van-noten.php.

Feitelberg, Rosemary. "Q&A: Yayoi Kusama, Pop Artist." *WWD*, July 10, 2012. http://wwd .com/fashion-news/designer-luxury/kusama-returns-to-new-york-6063142/.

Feitelberg, Rosemary, and Alessandra Turra. "Costume National in Collaboration With Marina Abramović." *WWD*, December 29, 2014. http://wwd.com/fashion-news/fashion-scoops /just-heavenly-8086056/.

Felder, Rachel. "Beyond Studio 54: Halston and Andy Warhol." *Financial Times*, May 9, 2014. https://www.ft.com/content/6d42c4ee-d21c-11e3-97a6-00144feabdc0.

Ferrier, Morwenna. "Louise Bourgeois—the reluctant hero of feminist art." *Guardian*, March 14, 2016. https://www.theguardian.com /lifeandstyle/2016/mar/14/louise-bourgeois-feminist-art-sculptor-bilbao-guggenheim-women.

Fondazione Prada. "On 9 May 2015, Fondazione Prada Opens Its New Permanent Milan Venue and Presents a New Exhibition in Venice." Fondazione Prada, 2015. http://www .fondazioneprada.org/wp-content/uploads /Fondazione-Prada_In-Part_Press-release.pdf.

Freeland, Cynthia. *Portraits and Persons*. Oxford: Oxford University Press, 2010.

Fretz, Eric. *Jean-Michel Basquiat: A Biography*. Greenwood Publishing Group. Westport, CT: 2010.

Friedman, B. H. "An Interview with Lee Krasner Pollock." In *Jackson Pollock: Black and White* (exhibition catalogue). New York: Marlborough-Gerson Gallery, 1969. Available at https://www.moma.org/documents /moma_catalogue_226_300198614.pdf.

Frigeri, Flavia. "How Matisse made his master-piece: the Vence Chapel." *Tate*, September 1, 2014. http://www.tate.org.uk/context-comment /blogs/how-matisse-made-his-masterpiece-vence-chapel.

Frowick, Lesley. "Fashion Forward Leadership: Halston for the Girl Scouts of the USA." Halston Style on Display, October 8, 2017. https://www.halstonstyle.com/halston-archives-girlscouts-blog/.

Fuentes, Carlos. *The Diary of Frida Kahlo: An Intimate Self-Portrait* (Introduction). New York: Harry N. Abrams, 1995.

Futurism. Didier Ottinger, ed. Milan: Centre Pompidou / 5 Continents Editions, 2008.

Gajo, Patricia. "Q&A: 5 minutes with Erdem." *Fashion*, August 31, 2011. https://fashionmagazine .com/fashion/5-minutes-with-erdem/.

Geldzhaler, Henry. "Basquiat, From the Subways to Soho." *Interview*, January 1983. Reposted as "New Again, Jean-Michel Basquiat," April 18, 2012. https://www.interviewmagazine.com/art /jean-michel-basquiat-henry-geldzhaler.

George, Boy. "Leigh Bowery by Boy George." *Paper*, November 1, 2005. http://www.papermag .com/leigh-bowery-by-boy-george-1425181672 .html.

Gingeras, Alison. "Takashi Murakami." *Interview*, July 15, 2010. https://www.interview magazine.com/art/takashi-murakami.

Girst, Thomas, Luke Frost, and Therese Vandling. *The Duchamp Dictionary*. London: Thames & Hudson, 2014.

———. "Marcel Duchamp: a riotous A-Z of his secret life." *Guardian*. April 7, 2014. https://www .theguardian.com/artanddesign/2014/apr/07 /marcel-duchamp-artist-a-z-dictionary.

Glimcher, Arnald. "Oral history interview with Louise Nevelson," January 30, 1972. Smithsonian Archives of American Art. https://www.aaa .si.edu/download_pdf_transcript/ajax?record_ id=edanmdm-AAADCD_oh_212133.

Goodyear, Anne Collins, and James W. McManus. *aka Marcel Duchamp: Meditations on the Identities of an Artist*. Washington, DC: Smithsonian Institution Scholarly Press, 2014.

Gould, Hannah. "The journey towards more sustainable rubber leads to Russian dandelions." *Guardian*, November 6, 2015. https://www .theguardian.com/sustainable-business/2015 /nov/06/rubber-tyres-russian-dandelions-sustainability-timberland-shoes-waste.

Green, Adam. People Are Talking About: Theater. "Outtakes." *Vogue*, November 2003.

Gruen, John. *Keith Haring: The Authorized Biography*. Englewood Cliffs, NJ: Prentice Hall & IBD, 1992.

Gumble, Andrew. "Julian Schnabel: Art of the possible." *Independent*, February 23, 2008. http://www.independent.co.uk/news/people /profiles/julian-schnabel-art-of-the-possible-786136.html.

Gurewitsch, Matthew. "David Hockney and Friends." *Smithsonian*, August 2016. https: //www.smithsonianmag.com/arts-culture /david-hockney-and-friends-124133487/.

Haden-Guest, Anthony. "Burning Out." *Vanity Fair*, April 2, 2014. https://www.vanityfair.com /news/1988/11/jean-michel-basquiat.

Hannan, Jessica. "Dries van Noten on the Art that Inspired Him." *Sleek* 54, summer 2017. http://www.sleek-mag.com/2017/06/21/dries-van-noten-favorite-artworks/.

Harding, Luke. "My granddad the clown." *Guardian*, February 10, 2010. https://www .theguardian.com/artanddesign/2009/feb/10 /tate-modern-modernism.

Haring, Keith, with Robert Farris Thompson (Introduction) and Shepard Fairey (Foreword). *Keith Haring Journals* (Penguin Classics Deluxe Edition). New York: Penguin Random House, 2010.

Harper, Gillian. "Five Things You Might Not Know About Louise Bourgeois." *AnOther*, March 20, 2015. http://www.anothermag.com /art-photography/7170/five-things-you-might-not-know-about-louise-bourgeois.

Harris, Luther S. *Around Washington Square: An Illustrated History of Greenwich Village*. Baltimore, MD: Johns Hopkins University Press, 2003.

Harvey, Mark. "Costume drama: photographer Fergus Greer talks about capturing the bold, pioneering work of the late performance artist Leigh Bowery." *Advocate*, October 29, 2002.

Heide Education. *Louise Bourgeois at Heide*. Heide Museum of Modern Art, 2012. https: //d2x6fvmwptmao1.cloudfront.net/cdn/farfuture /vTV-tVDKv4K2i9PuzzAqLKpIis_5gxwxRY gOkI1qJoQ/mtime:1444181197/sites/default/files /HeideEdResourceLouiseBourgeoisAtHeide_ opt.pdf.

Hellyer, Isabelle. "Calvin Klein just secured access to totally unseen Warhol artworks." *i-D*, November 29, 2017. https://i-d.vice.com/en_uk /article/mb3mmb/calvin-klein-just-secured-access-to-totally-unseen-warhol-artworks.

Henestrosa, Circe. "Appearances Can Be Deceiving: Frida Kahlo's Wardrobe." Museo Frida Kahlo. http://www.museofridakahlo.org .mx/assets/files/page_files/document/133 /FILE_2_4.pdf.

Henri Matisse.org. "Henry Matisse Biography." https://www.henrimatisse.org.

Herrera, Hayden. Art View,"Why Frida Kahlo Speaks to the 90's." *New York Times*, October 28, 1990. http://www.nytimes.com/1990/10/28 /arts/art-view-why-frida-kahlo-speaks-to-the-90-s.html?pagewanted=all.

———. *Frida: A Biography of Frida Kahlo.* New York: Harper Perennial, 2002.

Höch, Hannah. "A Few Words on Photomontage." In *Art of the Twentieth Century: A Reader*, edited by Jason Gaiger and Paul Wood. New Haven: Yale University Press, 2003.

Hodge, David. "Joseph Beuys: Felt Suit 1970." The Tate website. http://www.tate.org.uk/art /artworks/beuys-felt-suit-ar00092.

Holgate, Mark. View, "Dancer from the Dance." *Vogue*, September 2011.

Horyn, Cathy. "The Real Cindy Sherman." *Harper's Bazaar*, January 11, 2012. http://www .harpersbazaar.com/culture/art-books-music /interviews/g1802/cindy-sherman-artist-interview-0212/?slide=1.

———. "Givenchy's Spectacular 9/11 Fashion Show Actually Worked." *The Cut*, September 12, 2015.https://www.thecut.com/2015/09 /givenchys-spectacular-911-fashion-show worked.html.

Howard, Jane. "A Host with a Genius for Jarring Juxtapositions." *Life*, December 9, 1966.

Huntsman Savile Row. "A Life in Fashion: The Wardrobe of Cecil Beaton." Undated. https://www.huntsmansavilerow.com/a-life-in-fashion-the-wardrobe-of-cecil-beaton/.

Hyde, Sarah. "How Egon Schiele Went From Radical Punk to Respected Artist." *Artnet News*, February 27, 2017. https://news.artnet.com /exhibitions/new-vienna-exhibition-challenges-our-perception-of-egon-schiele-871616.

Hyland, Véronique. "Watch a Day at London Fashion Week With Leigh Bowery in 1986." *The Cut*, April 21, 2015. https://www.thecut. com/2015/04/watch-a-day-at-lfw-with-leigh-bowery-in-1986.html

Interview contributors. "Cindy Sherman." *Interview*, November 23, 2008. https://www .interviewmagazine.com/culture/cindy-sherman#_.

Jackson, Benjamin. "Rei Kawakubo and Louise Bourgeois Come Together In Our Newest Window Installation." The Window, Barneys.com, May 1, 2017. http://thewindow. barneys.com/rei-kawakubo-louise-bourgeois-comme-des-garcons/.

Jacobs, Laura. "See Karlie Kloss, Cate Blanchett, and More in These Breathtaking Watercolors." *Vanity Fair*, August 10, 2015. https://www.vanityfair.com/culture/2015/08 /david-downton-illustrations-fashion-karlie-kloss-cate-blanchett.

Jana, Rosalind. "The powerful personal style of Frida Kahlo." *Dazed*, April 28, 2017. http://www .dazeddigital.com/fashion/article/35745/1/frida-kahlo-fashion-style-clothing-nikolas-muray-portraits.

The Joan Rivers Show. Club kids interview [Leigh Bowery et al.]. Posted by Carrie, S., February 20, 2006. https://www.youtube.com /watch?v=aAm1RcsCOEg.

Johnson, Ken. "Beautiful People Caught in Passivity by Peyton and Warhol." *New York Times*, August 2008. http://www.nytimes.com /2006/08/18/arts/design/18peyt.html?n=Top /Reference/Times%20Topics/People/P /Peyton,%20Elizabeth?ref=elizabethpeyton.

———. "Niki de Saint Phalle, Sculptor, Is Dead at 71." *New York Times*, May 23, 2002. http://www .nytimes.com/2002/05/23/arts/niki-de-saint-phalle-sculptor-is-dead-at-71.html.

Johnstone, Nick. The Observer, "Dare to bare." *Guardian*, March 13, 2005. https://www.the guardian.com/artanddesign/2005/mar/13/art.

Jones, Jonathan. "'He took sex to the point of oblivion': Tracey Emin on her hero Egon Schiele." *Guardian*, June 16, 2017. https://www .theguardian.com/artanddesign/2017/jun/16 /tracey-emin-vienna-expressionist-egon-schiele-all-his-angst-made-sense.

———. "Joseph Beuys: Bits and Pieces." *Guardian*, April 2, 2002. https://www.theguardian.com /artanddesign/2002/apr/03/art.artsfeatures1.

Kaplan, James. "Big." New York, August 12, 1996.

Karmel, Pepe, ed. *Jackson Pollock: Interviews, Articles, and Reviews.* New York: Museum of Modern Art, 1999. https://www.moma.org /documents/moma_catalogue_226_300198614 .pdf.

Karimzadeh, Marc. "Wearable Art." *W*, October 1, 2008. https://www.wmagazine.com /story/versace-jewels.

Keh, Pei-Ru. "Who's hue: Warby Parker puts Robert Rauschenberg in the frame." *Wallpaper*, May 25, 2017. https://www.wallpaper.com /fashion/warby-parker-robert-rauschenberg-roci-sunglasses-collection.

Kimmelman, Michael. "Dada Dearest: An Artist Alone with Her Work." *New York Times*, February 28, 1997. http://www.nytimes. com/1997/02/28/arts/dada-dearest-an-artist-alone-with-her-calling.html?mcubz=1.

———. "Robert Rauschenberg, American Artist, Dies at 82." *New York Times*, May 14, 2008. http://www.nytimes.com/2008/05/14 /arts/design/14rauschenberg.html.

———. "The Secret of My Excess. Robert Rauschenberg, America's Most Irrepressible Artist, Spills the Beans to Michael Kimmelman." The *Guardian*, September 9, 2000.

Kolesnikov-Jessop, Sonia. "Julian Schnabel Painting Inspired Victoria Beckham's Latest Collection." *Blouin Artinfo*, May 11, 2014.

Kotz, Mary Lynn. *Rauschenberg: Art and Life.* New York: Harry N. Abrams, 1990.

LaBouvier, Chaédria. "The meaning and magic of Basquiat's clothes." *Dazed*, February 16, 2017. http://www.dazeddigital.com/fashion/article /34691/1/jean-michel-basquiat-fashion-and-sense-of-style.

Larocca, Amy. "The Bodies Artist." *The Cut*, August 9, 2016. https://www.thecut.com/2016 /08/vanessa-beecroft-bodies-artist.html.

La Ferla, Ruth. "Art, and Handbags, for the People." *New York Times*, July 23, 2014. https: //www.nytimes.com/2014/07/24/fashion/hm-and-jeff-koons-collaborate-on-a-handbag.html.

———. "For Your Distorted Pleasure." *New York Times*, June 19, 2008. http://www.nytimes .com/2008/06/19/fashion/19ROW.html.

L.A. Times Staff and Wire Reports. "Keith Haring; Subway Pop Graffiti Artist." *Los Angeles Times*, February 17, 1990. http://articles.latimes .com/1990-02-17/news/mn-439_1_keith-haring.

Laverty, Lord Christopher. "Pollock: Ed Harris in paint splattered clothing." *Clothes on Film*, February 15, 2011. http://clothesonfilm .com/pollock-ed-harris-in-paint-splattered-jeans/11059/.

Lavin, Maud. *Cut with the Kitchen Knife: The Weimar Photomontages of Hannah Höch*. New Haven: Yale University Press, 1993.

Lavrentiev, Alexander N. *Aleksandr Rodchenko: Experiments for the Future*. New York: The Museum of Modern Art, 2004.

Leaper, Caroline. "V&A announces 2018 exhibition dedicated to Frida Kahlo's Wardrobe." *Telegraph*, September 6, 2017. http://www.telegraph.co.uk/fashion/people /va-announces-2018-exhibition-dedicated-frida-kahlos-wardrobe/.

Leopold, Elisabeth. *Egon Schiele: Poems and Letters 1910-1912*. New York and London: Prestel, 2008.

Kiaer, Christina. "Rodchenko in Paris." MIT Press, *October* 75 (Winter 1996): 3–35.

Leung, Anna. "Hannah Höch at the Whitechapel Art Gallery." *The Art Section*, March 2014. http://www.theartsection.com/hannah-hoch.

Levasseur, Allison. "Ten Creative Talents Tell *AD* How Matisse Has Influenced Their Work." *Architectural Digest*, September 30, 2014. https://www.architecturaldigest.com/gallery/ten-creatives-inspired-by-matisse-slideshow/all.

Levy, Adam Harrison. "Henri Matisse: The Lost Interview." *Design Observer*, January 22, 2015. https://designobserver.com/feature/henri-matisse-the-lost-interview-part-ii/38739.

Levy, Ariel. "Beautiful Monsters: Art and Obsession in Tuscany." *The New Yorker*, April 18, 2016. https://www.newyorker.com/magazine/2016/04/18/niki-de-saint-phalles-tarot-garden.

L'Heureux, Catie. "Inside Cecil Beaton's Impeccable Wardrobe." *The Cut*, February 28, 2016. https://www.thecut.com/2016/02/cecil-beaton-life-in-fashion.html.

Life. "Pockets for No Purpose Are Fashion's Newest Decoration." Time Inc., January 22, 1940.

Lisle, Laurie. *Louise Nevelson, A Passionate Life*. New York: Summit/Simon & Schuster, 1990.

Macaulay, Alastair. "Rauschenberg and Dance: Partners for Life." *New York Times*, May 14, 2008. http://www.nytimes.com/2008/05/14/arts/dance/14coll.html.

Mackrell, Judith. *Tamara's Story*. (Extracted from *Flappers: Six Women of a Dangerous Generation*.) London: Pan Macmillan, 2013.

MacSweeney, Eve. "Footnotes." *New York Times*, July 2, 2000. http://www.nytimes.com/2000/07/02/magazine/footnotes-975311.html?mcubz=3.

Madsen, Anders Christian. "When Raf Met Robert." *i-D*, June 17, 2016. https://i-d.vice.com/en_uk/article/9kypg5/when-raf-met-robert.

Mail on Sunday Reporter. "Grayson Perry hat trick boosts his hearing: Artist wears a bonnet as a 'sort of ear trumpet.'" *Daily Mail*, February 10, 2015. http://www.dailymail.co.uk/health/article-2924576/Grayson-Perry-hat-trick-boosts-hearing-Artist-wears-bonnet-sort-ear-trumpet.html.

Margiela, Martin. "Interview with *Sphere*." *Knack*, March 2, 1983. Appeared in *6+Antwerp Fashion* by Geert Bruloot and Debo Kaat, *Ludion Editions*, 2007.

Marriot, Hannah. "Sense and sensuality: Dior embraces female artists while Saint Laurent sparkles." *Guardian*. September 26, 2017. https://www.theguardian.com/fashion/2017/sep/26/christian-dior-yves-saint-laurent-paris-fashion-week-spring-summer-2018-collections.

Marshall, Richard. *Jean-Michel Basquiat*. New York: Whitney Museum of American Art/Harry N. Abrams, 1992.

Martin, Richard. *Fashion and Surrealism*. London: Thames & Hudson, 1987.

Martin, Richard, and Harold Koda. *Christian Dior*. New York: Metropolitan Museum of Art, 1996.

Martineau, Paul, and Britt Salvesen. *Robert Mapplethorpe: The Photographs*. Los Angeles: J. Paul Getty Museum, 2016.

Martinez, Alanna. "Can You Guess the Famous Artists Behind This Jewelry?" *Observer*, April 19, 2017. http://observer.com/2017/04/artist-designed-jewelry-portable-art-project-hauser-wirth-exhibition/.

———. "The Many Notable Times Julian Schnabel Has Worn Pajamas in Lieu of Real Clothes." *Observer*, May 30, 2016. http://observer.com/2016/05/the-many-notable-times-julian-schnabel-has-worn-pajamas-in-lieu-of-real-clothes/.

"Matisse: The Fabric of Dreams—His Art and His Textiles." Press release, Metropolitan Museum of Art, 2005. https://metmuseum.org/press/exhibitions/2005/matisse-the-fabric-of-dreamshis-art-and-his-textiles.

Matisse, Henri, and Jack D. Flam, ed. *Matisse on Art*. Berkeley: University of California Press, 1995.

Matthews, Harry. "Living with Niki." *Tate Etc.*, Issue 12 (Spring 2008), January 1, 2008. http://www.tate.org.uk/context-comment/articles/living-niki.

McAteer, Susan. Commentary on *Louise Bourgeois* by Robert Mapplethorpe. *Tate*, February 2013. http://www.tate.org.uk/art/artworks/mapplethorpe-louise-bourgeois-ar00215.

McAuley, James. "The Artists and Their Alley, in Postwar France." *New York Times*, September 22, 2016. https://www.nytimes.com/2016/09/22/t-magazine/art/impasse-ronsin-artists-montparnasse-constantin-brancusi.html.

McCarthy, Fiona. "Artist of the Fascist superworld: the life of Tamara de Lempicka." *The Guardian*, May 15, 2004. https://www.theguardian.com/artanddesign/2004/may/15/art.

McCorquodale, Sarah. "How Warhol's work influenced our wardrobes." *BBC Culture*, April 27, 2015. http://www.bbc.com/culture/story/20150427-soup-cans-that-changed-fashion.

Mead, Rebecca. "Robert Mapplethorpe's Intimate Gifts to His Lover and First Male Model, David Croland." *New Yorker*, September 5, 2017. https://www.newyorker.com/culture/photo-booth/robert-mapplethorpes-intimate-gifts-to-his-lover-and-first-male-model-david-croland.

Meisler, Stanley. "Restoring the Portrait of an Artist: How a New Exhibition is Giving William Merritt Chase His Due." *Los Angeles Times*, June 23, 2016. http://www.latimes.com/entertainment/arts/la-ca-mn-william-merritt-chase-20160526-snap-htmlstory.html.

Menkes, Suzy. "Designers Dip into Klimt's Well." *New York Times*, November 12, 2012. http://www.nytimes.com/2012/11/13/fashion/13iht-fklimt13.html?mcubz=3.

———. "Ode to the Abstract: When Designer Met Dance." *New York Times*, January 8, 1998. http://www.nytimes.com/1998/01/08/style/ode-to-the-abstract-when-designer-met-dance.html.

———. "Positive Energy: Comme at 40." *New York Times*, June 8, 2009. http://www.nytimes.com/2009/06/09/fashion/09iht-fcomme.html.

———. "#SuzyPFW: Dior's Modern Muse, Artist Niki de Saint Phalle." *Vogue*, September 26, 2017. http://www.vogue.co.uk/article/suzypfw-diors-modern-muse-artist-niki-de-saint-phalle.

Mercurio, Gianni. "Keith Haring: In the Moment." The Keith Haring Foundation, 2005. http://www.haring.com/!/selected_writing/keith-haring-in-the-moment#.Wh1OgVVL_IU.

Metropolitan Museum of Art, Brooklyn Museum Costume Collection. "Shades of Picasso," dress by Gilbert Adrian. Metropolitan Museum of Art. https://www.metmuseum.org/art/collection/search/158903.

Metropolitan Museum of Art, Costume Institute. "Dali," dress by Christian Dior, 1949–1950. Metropolitan Museum of Art. https://metmuseum.org/art/collection/search/83745.

Mistry, Meenal. Fall 2012 Ready-to-Wear, "A. F. Vandevorst." *Vogue*, March 1, 2012. https://www.vogue.com/fashion-shows/fall-2012-ready-to-wear/a-f-vandevorst.

Miller, David C., ed. *American Iconology: New Approaches to Nineteenth-Century Art and Literature*. New Haven: Yale University Press, 1993.

Milligan, Lauren. "King Of Anarchy." *Vogue*, April 9, 2010. http://www.vogue.co.uk/gallery/malcolm-mclaren-vivienne-westwood-pays-tribute.

Moran, Justin. "Meet the Queer New York Designer Championing Upcycled Fashion." *Out*, February 5, 2017. https://www.out.com/fashion/2017/5/02/meet-queer-new-york-designer-championing-upcycled-fashion.

Mower, Sarah. Fall 2004 Couture, "Christian Dior." *Vogue*, July 6, 2004. https://www.vogue.com/fashion-shows/fall-2004-couture/christian-dior.

———. "Vetements Is a No-Show—Demna Gvasalia Announces He's Stepping Away From the Fashion Show System." *Vogue*, June 2, 2017. https://www.vogue.com/article /vetements-steps-away-from-fashion-shows.

Murphy, Mekado, and Laura Van Straaten. "Basquiat Before He Was Famous," video interview with Alexis Adler. *New York Times*, February 13, 2017. https://www.nytimes .com/2017/02/13/arts/design/jean-michel-basquiat-artwork.html.

Murphy, Tim. "Julian Schnabel Gives Us a Schnug." *New York*, February 1, 2008. http://nymag.com/daily/intelligencer/2008 /02/julian_schnabel_gives_us_a_sch.html.

Nelson, Karin. Pulse, "The Man Made the Clothes." *New York Times*, July 25, 2010. https://archive.nytimes.com/query.nytimes .com/gst/fullpage-9B07E6DF1230F936A-15754C0A9669D8B63.html

Nemser, Cindy. Interview in *Eva Hess*, edited by Mignon Nixon. Cambridge: MIT Press, 2002.

Nevelson, Louise. *Dawns and Dusks: Conversations with Diana MacKown*. New York: Macmillan & Co., 1976.

Newell-Hanson, Alice. "Elizabeth Peyton on Painting David Bowie from YouTube." *i-D*, December 14, 2016. https://i-d.vice.com/en_us /article/xwd8wj/elizabeth-peyton-on-painting-david-bowie-from-youtube.

Newman, Arnold. *Life* cover photograph of Niki de Saint Phalle. Time Inc., September 26, 1949.

Newman, Judith. "The Roving Eye: Lee Miller, Artist and Muse. *The New Yorker*, June 21, 2008.

New York Times. "The Very Best of Vanessa Beecroft," slideshow. May 19, 2016. https: //www.nytimes.com/slideshow/2016/05/19 /t-magazine/the-very-best-of-vanessa-beecroft /s/19tmag-beecroft-slide-X2YG.html.

Ng, David. "Bruce Nauman Wins a Golden Globe at Venice Biennale." Culture Monster, a *Los Angeles Times* blog, June 6, 2009. http: //latimesblogs.latimes.com/culturemonster /2009/06/bruce-nauman-topological-gardens-venice-biennale-.html.

Nikkah, Roya. "New exhibition reveals Picasso's love affair with English style." *Telegraph*, February 5, 2012. http://www.telegraph.co.uk /culture/art/art-news/9061282/New-exhibition-reveals-Picassos-love-affair-with-English-style .html.

Nobel, Phillip. "Julian Schnabel, The Reluctant Decorator." *New York Times*, August 3, 2006. http://www.nytimes.com/2006/08/03/garden /03hotel.html?mcubz=3.

Norell, Norman, Louise Nevelson, et al. "Is Fashion an Art?" n.d. *Metropolitan Museum of Art Bulletin*. https://www.metmuseum.org /pubs/bulletins/1/pdf/3258881.pdf.bannered.pdf.

O'Brien, Glenn. "Andy Warhol." Interview conducted June 1977. *Interview*, December 1, 2008. https://www.interviewmagazine.com/art/ andy-warhol.

———. Marc Jacobs interview. *Interview*, November 30, 2008. https://www.interviewmagazine.com/fashion/marc-jacobs

———. "Basquiat: Dressing to Conjure." *Nowness*, April 28, 2010. https://www.nowness .com/story/basquiat-dressing-to-conjure.

O'Hagan, Sean. "Canvassing support." *Guardian*, October 26, 2003. https://www .theguardian.com/film/2003/oct/26/features .magazine.

Ono, Yoko. "Over 1,057,000 people have been killed by guns in the USA since John Lennon was shot and killed on 8 Dec 1980." Twitter. March 20, 2013. https://twitter.com /yokoono/status/314339147672322050?lang=en

Paley, Maggie. "On Being Photographed." *Vogue*, November 1985.

Parker, Ian. "A Bizarre Body of Work." *Independent*, February 26, 1995. http://www .independent.co.uk/arts-entertainment /a-bizarre-body-of-work-1574885.html.

Parmal, Pamela A. "Dress in the Paintings of William Merritt Chase." Video of lecture. Museum of Fine Arts, Boston, December 30, 2016. https://www.youtube.com/watch?v= vOX1jIXFs00.

Pasori, Cedar. "Interview: Barbara Kruger Talks Her New Installation and Art in the Digital Age." *Complex*, August 21, 2012. http: //www.complex.com/style/2012/08/interview-barbara-kruger-talks-her-new-installation-and-art-in-the-digital-age.

Pernet, Diane. "Alex Van Gelder and How He Met Louise Bourgeois." A Shaded View on Fashion (blog), December 20, 2016. https: //www.youtube.com/watch?v=3ttsPnh2WtM.

Perreault, John. Art: What's News, What's Coming, "Willem de Kooning in East Hampton/Frida Kahlo." *Vogue*, February 1978.

Phelps, Nicole. "From N.E.R.D to Bella Hadid—Off-White's Virgil Abloh Talks Influences." *Vogue*, August 17, 2017. https: //www.vogue.com/article/off-white-virgil-abloh-forces-of-fashion-interview.

Pinnington, Mike. "Jackson Pollock: Separating Man from Myth." *Tate*, July 22, 2015. http://www.tate.org.uk/context-comment /articles/jackson-pollock-man-myth.

Pisano, Ronald G., completed by Carolyn K. Kane and D. Frederick Baker. *William Merritt Chase: Portraits in Oil*. New Haven: Yale University Press, June 2017.

Pithers, Ellie. "David Hockney: back on the fashion map." *Telegraph Fashion*, January 25, 2012. http://fashion.telegraph.co.uk/columns /ellie-pithers/TMG9037761/David-Hockney-back-on-the-fashion-map.html.

Planet Group Entertainment. "The Billy Name Interview" (from the "Factory People" Notebook). http://planetgroupentertainment. squarespace.com/the-billy-name-interview/.

———. "The Victor Bockris Interview" (from the "Factory People" Notebook). http: //planetgroupentertainment.squarespace.com /the-victor-bockris-interview.

Pogrebin, Robin, and Scott Reyburn. "A Basquiat Sells for 'Mind-blowing' $110.5 Million at Auction." *New York Times*, May 18, 2017. https://www.nytimes.com/2017/05/18/arts /jean-michel-basquiat-painting-is-sold-for-110-million-at-auction.html.

Poiret, Paul. *King of Fashion: The Autobiography of Paul Poiret*. London: V&A Publishing, 2009.

Porter, Charlie. "American Graffiti." *Guardian*, March 30, 2001. https://www.theguardian.com /lifeandstyle/2001/mar/30/fashion1.

Prickett, Sarah Nicole. "Who Is Marc Jacobs?" *New York Times*, August 20, 2015. https://www .nytimes.com/2015/08/20/t-magazine/who-is-marc-jacobs.html?mcubz=0&mcubz=0.

Reed, Brian M. "Hand in Hand: Jasper Johns and Hart Crane." *Modernism/Modernity* 17, Issue 1, 2010: 21–45.

Reily, Nancy Hopkin. *A Private Friendship part 1. Walking to the Sun Prairie Land*. Santa Fe, NM: Sunstone Press, December 1, 2014.

Ricard, Rene. "The Radiant Child." *Artforum*, December 1981. https://www.artforum.com /print/198110/the-radiant-child-35643.

Richardson, John. "Leigh Bowery, 1961–94." *The New Yorker*, January 16, 1995. https: //www.newyorker.com/magazine/1995/01/16 /leigh-bowery-1961-94.

Rigg, Natalie. "Robert Rauschenberg's Million Dollar Window Displays." *AnOther*, August 8, 2016. http://www.anothermag.com/fashion-beauty/8943/robert-rauschenbergs-million-dollar-window-displays.

Rodman, Selden. *Conversations with Artists*. New York: Devin-Adair Publishing Company, 1957.

Roux, Caroline. "The Exceptional Portrait Painter." *The Gentlewoman*, Issue 8, Autumn and Winter 2013. http://thegentlewoman. co.uk/library/elizabeth-peyton.

Rose, Barbara. "A Garden of Earthly Delights." *Vogue*, December 1, 1987.

———. "The Individualist American Sculptor, Louise Nevelson." *Vogue*, June 1, 1976.

——. People Are Talking About, "Rauschenberg: The Artist as Witness." *Vogue*, February 1, 1977.

Rosenbaum, Ron. "Barbara Kruger's Artwork Speaks Truth to Power." *Smithsonian*, July 2012. http://www.smithsonianmag.com/arts-culture/barbara-krugers-artwork-speaks-truth-to-power-137717540/.

Rubin, William. "Violence? Yes, and Passion, Joy, Exuberance; Pollock Was No Accident." *New York Times*, January 27, 1974. http://www.nytimes.com/1974/01/27/archives/pollock-was-no-accident-violence-yes-and-passion-joy-exuberance.html?mcubz=0&mcubz=0.

Saatchi Art. "There are no miracles, there is only what you make." —Tamara de Lempicka. Twitter. May 16, 2015. https://twitter.com/SaatchiArt/status/599711061684662272.

Saint Phalle, Niki de. "Niki de Saint Phalle: the artist's workshop" (English-speaking archive footage). *Grand Palais*, November 25, 2014. https://www.youtube.com/watch?v=jDxpIKqks6o.

Salvador Dalí Foundation. "Salvador Dalí I Domènech," biografy of Dalí. https://www.salvador-dali.org/en/dali/bio-dali/.

San Francisco Museum of Modern Art. Artwork Guide: "Robert Rauschenberg." San Francisco Museum of Modern Art. https://www.sfmoma.org artwork-guide-robert-rauschenberg/.

Scaasi, Arnold. *Women I Have Dressed (and Undressed!)*. Simon & Schuster, 2007.

Scaggs, Austin. "Madonna Looks Back: The Rolling Stone Interview." *Rolling Stone*, October 29, 2009. http://www.rollingstone.com/music/news/madonna-looks-back-the-rolling-stone-interview-20091029.

Schiaparelli.com. Pablo Picasso: *Hands painted in trompe-l'oeil imitating gloves*. Maison Schiaparelli. http://www.schiaparelli.com/en/maison-schiaparelli/schiaparelli-and-the-artists/pablo-picasso/hands-painted-in-trompe-l-oeil-imitating-gloves/.

Schnabel, Julian. "The Artistry of Alaïa." *Interview*, "December 30, 2013. http://www.interviewmagazine.com/fashion/the-artistry-of-alaia/#_.

Schneier, Matthew. "Raf Simons salutes Robert Mapplethorpe, a Fellow Provocateur." *New York Times*, June 17, 2016. https://www.nytimes.com/2016/06/18/fashion/mens-style/raf-simons-robert-mapplethorpe-spring-2017-mens-fashion.html.

Schroder, Klaus Albrecht. "Egon Schiele—Self-portrait with peacock vest," video of lecture. Albertina Museum, February 22, 2017. http://www.castyourart.com/2017/05/09/egon-schiele-selbstbildnis-mit-pfauenweste/.

Schulz, Beatrice. "Well Cut: Hannah Höch at the Whitechapel Gallery." *Apollo*, January 30, 2014. https://www.apollo-magazine.com/well-cut-hannah-hoch-whitechapel-gallery/.

Schwendener, Martha. "Avedon, Breaking Through the Artifice of Celebrity." *New York Times*, June 25, 2011. http://www.nytimes.com/2011/06/26/nyregion/richard-avedon-photographer-of-influence-review.html?mcubz=3.

Searle, Adrian. "Dream weaver." *Guardian*, March 8, 2005. https://www.theguardian.com/culture/2005/mar/08/1.

Secher, Benjamin. "Alexander Rodchenko: a man who took life lying down." *Telegraph*, February 9, 2008. http://www.telegraph.co.uk/culture/art/3671028/Alexander-Rodchenko-A-man-who-took-life-lying-down.html.

——. "Andy Warhol TV: maddening but intoxicating." *Telegraph*, September 30, 2008. http://www.telegraph.co.uk/culture/film/3561451/Andy-Warhol-TV-maddening-but-intoxicating.html.

Seed, John. The Blog: "Driving Mr. Basquiat." *Huffington Post*, July 29, 2010. https://www.huffingtonpost.com/john-seed/driving-mr-basquiat_b_658553.html.

Selsdon, Esther, and Jeanette Zwingenberger. *Egon Schiele*. London: Parkstone Press International, 2011.

Sen, Raka, and Vanessa Castro. "12 Things to Know About Vanessa Beecroft, Kanye West's Visual Art Collaborator." *Complex*, December 5, 2013. http://www.complex.com/style/2013/12/kanye-west-vanessa-beecroft/.

Shafrazi, Tony. "Keith Haring. A Great Artist, A True Friend." Essay in *The Keith Haring Show* (exhibition catalogue). Milan: Skira, 2005. Via Keith Haring Foundation website. http://www.haring.com/!/selected_writing/keith-haring-a-great-artist-a-true-friend#.WhwVPlVl_IU.

Shanes, Eric. *The Life and Masterworks of Salvador Dalí*. London: Parkstone Press Ltd, 2010.

Shapiro, David. Interview, "Vanessa Beecroft." *Museo*, 2008. http://www.museomagazine.com/VANESSA-BEECROFT.

Sheff, David. "Keith Haring, An Intimate Conversation." *Rolling Stone*, August 1989. Via Keith Haring Foundation website. http://www.haring.com/!/selected_writing/rolling-stone-1989#.WhwLoVVl_IU.

Sidhu, TJ. "Raf Simons debuts Mapplethorpe-inspired SS17 campaign." *Dazed*, January 31, 2017. http://www.dazeddigital.com/fashion/article/34538/1/raf-simons-debuts-mapplethorpe-inspired-ss17-campaign.

Sischy, Ingrid. "Kid Haring." *Vanity Fair*, 1997. Via Keith Haring Foundation website. http://www.haring.com/!/selected_writing/kid-haring#.Wh100IVl_IU.

Smith, Patti. *Just Kids*. New York: Ecco Press/HarperCollins, 2010.

Smith, Roberta. Critics' Notebook, "Standing and Staring, Yet Aiming for Empowerment." *New York Times*, May 6, 1998. https://www.nytimes.com/1998/05/06/arts/critic-s-notebook-standing-and-staring-yet-aiming-for-empowerment.html.

——. Art in Review, "Raoul Dufy—'Fashion Drawings for Paul Poiret and Other Works.'" September 3, 1999. http://www.nytimes.com/1999/09/03/arts/art-in-review-raoul-dufy-fashion-drawings-for-paul-poiret-and-other-works.html.

Smithgall, Elsa, and John Davis. *William Merritt Chase: A Modern Master*. New Haven: Yale University Press, 2016.

Smithsonian Magazine. In Conversation with Patti Smith: "How Frida Kahlo's Love Letter Shaped Romance for Punk Poet Patti Smith." *Smithsonian*, January 2016. https://www.smithsonianmag.com/smithsonian-institution/how-frida-kahlos-love-letter-shaped-romance-punk-poet-laureate-patti-smith-180957682/.

Solomon, Deborah. *Jackson Pollock: A Biography*. New York: Simon & Schuster, 1987.

Sooke, Alistair. "Miuccia Prada Interview: Fondazione Prada, Milan." *Telegraph* online, May 5, 2009. https://www.telegraph.co.uk/culture/art/5277507/Miuccia-Prada-interview-Fondazione-Prada-Milan.html.

Spero, Nancy, and Helmut Lang. "Dear Louise." *Tate Etc.*, Issue 11 (Autumn 2007). http://www.tate.org.uk/context-comment/articles/dear-louise.

Spindler, Amy M. "Patterns: Call it Deconstruction." *New York Times*, June 14, 1994. http://www.nytimes.com/1994/06/14/style/patterns-389765.html?mcubz=3.

Spivack, Emily. "Yayoi Kusama, High Priestess of Polka Dots." *Smithsonian*, September 28, 2012. https://www.smithsonianmag.com/arts-culture/yayoi-kusama-high-priestess-of-polka-dots-53981061/.

Spurling, Hilary. *The Unknown Matisse: A Life of Henri Matisse: The Early Years, 1869–1908*. New York: Knopf/Random House, 1998.

Spurling, Hilary, Ann Dumas, and Norman Rosenthal. *Matisse, His Art and His Textiles: The Fabric of Dreams* (exhibition catalogue). London: Royal Academy of Arts, 2004.

Stafford, Jerry. "'Do you find beauty in horror?' Peter Philips, Creative and Image Director of Christian Dior Make-up, meets The Queen of Art-Gore, Cindy Sherman." *System*, Issue 4, October 16, 2014. http://system-magazine.com/issue4/cindy-sherman-peter-philips/.

Stansfield, Ted. "Cindy Sherman turns mock street-style star for Harper's." *Dazed*, February 12, 2016. http://www.dazeddigital.com/fashion/article/29782/1/cindy-sherman-turns-mock-street-style-star-for-harper-s.

———. "The dA-Zed guide to Gosha Rubchinskiy." *Dazed*, June 15, 2016. http://www.dazeddigital.com/fashion/article/31582/1/the-da-zed-guide-to-gosha-rubchinskiy.

Steiner, Reinhard. *Egon Schiele, 1890–1918: The Midnight Soul of the Artist*. Cologne: Taschen, 2000.

Stone, Bryony. "Grayson Perry's Dresses are going on display in Liverpool." *It's Nice That*, October 26, 2017. https://www.itsnicethat.com/news/grayson-perry-dresses-walker-art-gallery-liverpool-art-261017.

Studio International. "Mondrian in London," December 1966. Via Snap-dragon.com. http://www.snap-dragon.com/PMStudioInt.html.

Sturgis, Alexander, Rupert Christiansen, Lois Oliver, and Michael Wilson. *Rebels and Martyrs: The Image of the Artist in the Nineteenth Century*. (exhibition catalogue). New Haven: Yale University Press/National Gallery Publications, 2006.

Sunnucks, Jack. "Rockstud Untitled: Vanessa Beecroft Collaborates with Valentino." *i-D /Vice*, May 3, 2016. https://i-d.vice.com/en_uk/article/59g4yq/rockstud-untitled-vanessa-beecroft-collaborates-with-valentino.

Swanson, Carl. "Marina Abramović at 70." *New York*, October 17, 2016. https://www.thecut.com/2016/10/marina-abramovic-walk-through-walls-c-v-r.html.

Szmydke-Cacciapalle, Paulina. "Edeline Lee RTW Fall 2017." *WWD*, February 19, 2017. http://wwd.com/runway/fall-ready-to-wear-2017/london/edeline-lee/review/.

Teodorczuk, Tom. "Julian Schnabel: the artist and film director makes his London come-back." *Evening Standard*, May 1, 2014. https://www.standard.co.uk/lifestyle/esmagazine/julian-schnabel-the-artist-and-film-director-makes-his-london-comeback-9306876.html

Tilley, Sue. *Leigh Bowery: The Life and Times of an Icon*. London: Hodder & Stoughton, 1997.

Tomkins, Calvin. "The Artists of the Portrait; The Deliverance of Elizabeth Peyton." *The New Yorker*, October 6, 2008. http://www.newyorker.com/magazine/2008/10/06/the-artist-of-the-portrait.

———. "Western Disturbances: Bruce Nauman's Singular Influences." *The New Yorker*, June 1, 2009. https://www.newyorker.com/magazine/2009/06/01/western-disturbances.

Topshop blog. "Six Times David Hockney Collided with Fashion." February 9, 2015. http://www.topshop.com/blog/2016/02/six-times-david-hockney-collided-with-fashion-2.

Toynton, Evelyn. *Jackson Pollock*. New Haven: Yale University Press, 2012.

Trebay, Guy. "The Oscar For Best Provocateur . . ." *New York Times*, November 18, 2011. https://www.nytimes.com/2011/11/20/fashion/marina-abramovics-crossover-moment.html?m.

Tscherny, Nadia. "Beautiful People." *Art in America*, February 23, 2009. https://www.artinamericamagazine.com/news-features/magazines/elizabeth-peyton/.

Tulloch, Carol. *The Birth of Cool: Style Narratives of the African Diaspora*. London: Bloomsbury, 2008.

Umland, Anne, ed.; text by Stephanie D'Allesandro, Michael Draguet, and Claude Goormans. *Magritte: The Mystery of the Ordinary 1926–1938* (exhibition catalogue). New York: Museum of Modern Art, 2013. https://macaulay.cuny.edu/eportfolios/calirmanfall2013/files/2013/08/Magritte-Catalogue2.pdf; https://www.moma.org/interactives/exhibitions/2013/magritte/#/featured/1.

Umland, Anne, and Adrian Sudhalter, eds. *Dada in the Collection of the Museum of Modern Art*. New York: Museum of Modern Art, July 2008.

Vidal, Susana Martinez. *Frida Kahlo: Fashion as The Art of Being*. New York: Assouline Publishing, 2016.

Vogue. Arts and Entertainment, "All Hail Hockney." January 30, 2017. http://www.vogue.co.uk/article/david-hockney-exhibition-from-vogue-february-issue.

———. Fashion, "Dali Prophesies 'Mobile' Jewels." January 1939.

———. Fashion, "Picasso paintings on display." January 1, 1940.

———. Fashions in Living, "Vogue's Decorating Finds and Ideas for Fashions in Living: Action Decorating: Cecil Beaton's Idea." 1968.

———. Living, "2 Design(er)s For Living: Marc Bohan and Calvin Klein." 1975.

Volandes, Stellene. Fashion: Vogue's View, "Puff Pieces: Rei Kawakubo's Designs for the Merce Cunningham Dance Company May Find a New Generation Doing the Bump." October 1, 1997.

———. Fashion: News: "Exports to Paris, American Designs." *Vogue*, February 1950.

Wakefield, Neville. "Vanessa Beecroft: South Sudan." *Flash Art*, December 2006. http://www.flashart.com/article/vanessa-beecroft-2/.

Walker, Tim. "An Egon Schiele–Inspired Shoot by Tim Walker." *i-D*, May 17, 2017. https://i-d.vice.com/en_uk/article/vbdekx/an-egon-schiele-inspired-shoot-by-tim-walker.

Warhol, Andy. *The Philosophy of Andy Warhol from A to B and Back Again*. New York: Penguin Modern Classics, 2007 (Harcourt Brace Jovanovich, 1975).

Warhol, Andy, Emilia Petrarca, and Halston. "Interview with Keith Haring." *Interview*, 1984. Reposted as "New Again: Keith Haring," August 6, 2013. https://www.interviewmagazine.com/art/new-again-keith-haring.

Welters, Linda. "Matisse: the fabric of dreams." *Textile* 4, no. 3: 376–382, 2006. https://www.tandfonline.com/doi/abs/10.2752/147597506778691503.

Whitechapel Gallery. "Elizabeth Peyton: Live Forever." Whitechapel Gallery, 2009. http://www.whitechapelgallery.org/exhibitions/live-forever-elizabeth-peyton/.

Widdicomb, Ben. "Now Fawning: Vanity Fair's International Best-Dressed List." *New York Times*, July 29, 2008. http://tmagazine.blogs.nytimes.com/2008/07/29/now-fawning-vanity-fairs-international-best-dressed-list/.

Wilcox, Claire. *The Golden Age of Couture. Paris and London 1947–1957*. London: V&A Publishing, 2007.

Wild, Benjamin. *A Life in Fashion: The Wardrobe of Cecil Beaton*. London: Thames & Hudson, 2016.

Wilson, Laurie. *Louise Nevelson: Light and Shadow*. London: Thames and Hudson, 2016.

Wilson, Megan Ann. "The Complete Guide to Jean-Michel Basquiat References in Hip-Hop." *Complex*, June 28, 2013. http://www.complex.com/style/2013/06/jean-michel-basquiat-hip-hop/.

Wiseman, Eva. Profile: Marc Jacobs, "A designer with bags of talent." *Guardian*, August 2008. https://www.theguardian.com/lifeandstyle/2008/aug/31/fashion.celebrity1.

Wolfe, Bertrand D. Features, "Rise of Another Rivera." *Vogue*, November 1, 1938.

Wroe, Nicholas. "David Hockney: a life in art." *Guardian*, January 13, 2012. https://www.theguardian.com/culture/2012/jan/13/david-hockney-life-in-art.

Wullschlager, Jackie. "Seven Exhibitions Inaugurate Milan's Prada Foundation." *Financial Times*, May 8, 2015. https://www.ft.com/content/fe403bdc-f3dd-11e4-99de-00144feab7de.

WWD Staff. "Comme des Garçons, Vogue Fete Tokyo Store." May 2009. http://wwd.com/fashion-news/fashion-scoops/comme-des-garcons-vogue-fete-tokyo-store-2147500/.

Young, Joan, and Susan Davidson. "Chronology." Rauschenberg Foundation. https://www.rauschenbergfoundation.org/artist/chronology-new.

Zahm, Olivier. "In the Skin of the Artist." *Purple*, Issue 27 (Spring/Summer 2017). http://purple.fr/magazine/ss-2017-issue-27/vanessa-beecroft-2/.

Photography Credits

Front cover photograph: Nickolas Muray © Nickolas Muray Archives.

Alamy Stock Photo: Agencja Fotograficzna Caro/Alamy Stock Photo: 86; Art Collection 2/Alamy Stock Photo: 144; Dominic Dibbs: 50; Granger Historical Picture Archive: 119; WorldPhotos/Alamy Stock Photo: 141.

Bridgeman: Allen Memorial Art Museum, Oberlin College, Ohio, USA/Gift of Helen Hesse Charash/Bridgeman Images: 53.

DACS 2018: © Hannah Höch: 123.

Getty Images: Barbara Alper/Contributor: 52, bottom; Austrian Archives/Imagno/Getty Images: 181; Bettmann: 30, 39, 129, 172; Lee Black Childers/Redferns: 15; Bloomberg/Contributor: 85; Stephane Cardinale/Corbis via Getty Images: 110; Gareth Cattermole/Staff: 148; Michele Crosera/Stringer: 118; Robert Doisneau/Gamma-Rapho/Getty Images: 89; Nick Elgar/Corbis/VCG via Getty Images: 79; Fine Art Images/Heritage Images/Getty Images: 149, 184; Sean Gallup/Staff: 52, top; Yann Gamblin/Paris Match via Getty Images: 64; Pierre Guillaud/AFP/Getty Images: 92; Jacques Haillot/Sygma/Sygma via Getty Images: 157; Evelyn Hofer/Getty Images: 21; Martha Holmes/The LIFE Picture Collection/Getty Images: 113; Hulton Archive/Getty Images: 27; Kim Jae-hwan/AFP/Getty Images: 71; Imagno/Getty Images: 169; Michael Kappeler/AFP/Getty Images: 67; Keystone-France/Gamma-Keystone via Getty Images: 107; King Collection/Photoshot/Getty Images: 33; Alexander Klein /AFP/Getty Images: 197; Pascal Le Segretain/Getty Images: 152; Michael Loccisano: 45; Shaun Mader/Patrick McMullan via Getty Images: 24; Gabriela Maj: 49; Jack Manning/Contributor: 87; Guy Marineau/Conde Nast via Getty Images: 116; Chris Moore/Catwalking/Contributor: 76; Lusha Nelson/Condé Nast via Getty Images: 132; Arnold Newman/Getty Images: 120; Rindoff Petroff/Dufour/Getty Images: 151; Print Collector/Getty Images: 142; Kerstin Rodgers/Redferns: 73; Steve Russell/Contributor: 84; Nancy R. Schiff/Getty Images: 95; Schütt/Ullstein Bild via Getty Images: 127; Bert Stern/Condé Nast via Getty Images: 135; Allan Tannenbaum/Getty Images: 83; The Royal Photographic Society Collection/National Science and Media Museum/SSPL/Getty Images: 193; Antonello Trio: 18; Ullstein Bild/Contributor: 146; Ullstein Bild/Ullstein Bild via Getty Images: 40; Universal History Archive: 163; Tony Vaccaro/Hulton Archive/Getty Images: 191; Pierre Verdy/AFP/Getty Images: 121; Willy Vanderperre/Conde Nast via Getty Images: 179; Victor Virgile/Gamma-Rapho via Getty Images: 138, 160; Oscar White/Corbis/VCG via Getty Images: 99.

François Le Diascorn: © François Le Diascorn: 147.

The Norman Parkinson Archives/Iconic Images: © Iconic Images/Norman Parkinson: 120, 166.

Dusan Reljin: © Dusan Reljin: 175.

Shutterstock: AP/Shutterstock: 34; Granger/Shutterstock: 187; Greg Mathieson/Shutterstock: 55; John Aquino/Penske Media/Shutterstock: 58; Sipa Press/Shutterstock: 61; Startraks Photo/Shutterstock: 101; Unimediaimages Inc–ADC/Shutterstock: 104; © Shutterstock/Abstractor: gray paint texture throughout; © Shutterstock/LUMIKKSSS: blue painted background throughout.

WireImage: Antonio de Maraes Barros Filho/WireImage: 42.

HarperCollins books may be purchased for educational, business, or sales promotional use. For information please e-mail the Special Markets Department at SPsales@harpercollins.com.

First published in 2019 by
Harper Design
An Imprint of HarperCollins*Publishers*
195 Broadway
New York, NY 10007
Tel: (212) 207-7000
Fax: (855) 746-6023
www.hc.com
harperdesign@harpercollins.com

Distributed throughout the world by
HarperCollins*Publishers*
195 Broadway
New York, NY 10007

ISBN 978-0-06-284418-7
Library of Congress Control Number: 201893870

Book design by Lynne Yeamans and Tanya Ross-Hughes
Printed in China

First Printing, 2019

Acknowledgments

This book is dedicated to William, Freddie, and Andrew.

Huge thanks to Hayley Harrison, Naeemah Miah, Francesca Rose, Jennifer Sesay Barnes, Gina Gibbons, Diane Rooney, Lulu Guinness, Jo Unwin, Pippa Healy, Francine Bosco, Carrie Kania, Elizabeth Viscott Sullivan, Lynne Yeamans, Tanya Ross-Hughes, Tricia Levi, and Dani Segelbaum.

About the Author

Terry Newman worked in the fashion industry for more than twenty-five years, both as an editor at *i-D*, *Attitude*, and *Self Service* and as a contributing writer for newspapers including the *Guardian*, the *Independent*, the *Times*, and the *Sunday Times*. She has also written and presented fashion programs in the United Kingdom for Channel 4 (*She's Gotta Have It* and *Slave*). The author of *Legendary Authors and the Clothes They Wore* (Harper Design), she has contributed to books including *i-D*'s *Fashion Now*, *Fashion Now 2*, and *Soul i-D*. She currently lectures at the University for the Creative Arts in Epsom, England, and lives in London with her husband and two children.